THE TALL SHIP
IN ART

Merry Christmas, Jeff!
I hope this book reminds
you of the fun you had
last summer. Love, Aunt Marcia & Uncle Bill

THE TALL SHIP IN ART

Roy Cross – Derek Gardner – John Groves — Geoff Hunt – Mark Myers

FOREWORD BY ALEX A. HURST

CASSELL

Cassell
Wellington House, 125 Strand, London WC2R 0BB

First published 1998
This edition 1999

British Library Cataloguing-in-Publication Data:
a catalogue record for this book is available from the British Library

ISBN 0-304-35296-9

Distributed in the USA by Sterling Publishing Co. Inc.,
387 Park Avenue South, New York, NY 10016-8810.

Designed and edited by DAG Publications Ltd.
Designed by David Gibbons; edited by Michael Boxall;
printed and bound in Hong Kong.

CONTENTS

The Foreword was contributed by Alex Hurst who, prior to the last war, served in sail, including the four-masted barques *Moshulu* and *Pommern*. During hostilities, when in the Merchant Service, he was taken prisoner by the Germans and, on arrival at Yokohama, was handed over to the Japanese. Due to the effects on his eyesight, he had to come ashore and subsequently founded the publishing house of Teredo Books, producing (and sometimes writing) a number of books on Merchant Sail and Marine Art.

FOREWORD

BY
ALEX. A. HURST

When asked to write the Foreword to this book, which consists of specimen works of five marine artists of the top-class, I was as astonished as I was flattered. It was represented that I was well acquainted with each of them, and that I have an interest in marine art, both of which premises are true but, since I understand that these five men have not only applied their brushes to their canvases to demonstrate their genius, and have also put their pens to paper, expanding on both their aims and subjects, some of which merit a book of their own, I shall content myself with some of the thoughts which passed through my mind on seeing much of the pictorial content of this work.

It was only in the early nineteenth century that marine painters suddenly broke away from the convention of painting stiff seas, apparently made of solid putty, to achieve their flow and the reality of their sense of wetness and movement. Who was the first to do so, we shall never know, but until recently it was a mystery to me how the new style of 'realistic and wet' seas became adopted and practised by so many artists in different parts of the world in such a relatively short time – Ivan Aivazovsky in and around the Black Sea; Somerscales in Valparaiso, the Melbye brothers in Denmark and by so many others, although unconnected and in disparate parts of the world. It was as if all were actuated by a common morphic resonance as, indeed, they probably were, though this hypothesis was still unknown. Now the evidence is overwhelming. Much later in 1921, when birds first discovered the advantage of pecking through the tops of milk bottles, the practice immediately spread across Europe, mainly among tits, although their territories seldom exceed some 12–14 miles, and it became ingrained on what used to be termed their 'instinct' since, after some years of war with virtually no milk bottles and a new generation of tits, the practice immediately started again on their reappearance. There are innumerable similar examples. So it must have been that marine art was suddenly transformed by wet and flowing seas, taking the place of furrows, as if formed by gigantic ploughshares across lifeless oceans. The artists in this book are splendid exponents of this classic leap forward.

The contributors have, wisely in my view, confined themselves to portrayals of sail over the span of the last millennium. These, for the greater part, consist of three major elements, namely: sky, sea and sails, each of which has its form dictated by the effects of the wind. It is in the delineation of these effects that all five have achieved incomparable mastery but, if they have failed to paint the wind itself, they are in good company. They all spend long hours researching their subject matter to ensure its accuracy, yet not one of them possesses a single pig. Perhaps I should clarify this statement.

Whether the average man is aware of hearing the wind is a moot point. He may hear its effects in high gale as it plays on the rigging like some demoniac harpist, or ashore in some similar manner, yet, as Joseph Conrad registered when in the *Loch Etive*, a deaf man will always underestimate its strength, whatever its force. I can testify to this from my own observation, and believe that we all hear the wind, if sub-consciously, even if we cannot see

it. The Ancients, however, were convinced that both pigs and goats could *see* the wind. They lived closer to nature and, not wasting their time inventing such evils as the internal combustion engine, television and like abominations, may very well have been right. I shall not speak of goats, with whom I have never achieved much *rapport,* but, when I was young, I had much experience of pigs. All our sows were named after my great-aunts (of whom I had a surfeit) and all were highly intelligent animals, with far greater mental capacities than their namesakes. They lived in conditions now virtually unknown to the modern domestic pig and certainly understood much that we said to them, as we could frequently divine their thoughts. Often they would turn into the wind, their snouts twitching, and... who knows what they saw?

Is it so unreasonable to suppose that, down in the Southern Ocean, when a glacial wind sometimes comes off Antarctica, it is tinted with ice blue? and that, when it finally backs, its tint changes, only to exhibit a quite different shade of the spectrum in, say, the splendour of a steady south-east trade wind? Is its very composition different then? How long will it be before artists are painting the wind itself, as distinct from its effects? Only in our life-time has the old belief that the space within our solar system was a vacuum been exploded, for now we know that there are electrical fields as far as our astronomers can probe. A complaisant pig is a rewarding companion and, duly encouraged within its own spheres of ability, might yield as much to marine artists as the Public Record Office's profusion of information and be the means of the next great leap forward in their medium!

I have nothing but praise for the pictures in this volume, so many of which could provide the material for whole books! The naval wars of the late seventeenth and early eighteenth centuries have a fascination for many marine artists, and this book contains its quota. On occasions when there was little wind, it is doubtful if a spectator of a battle would have seen as much as we are shown, due to the palls of smoke hanging over the scene, whether on land or sea, and although this did not apply at Quiberon Bay in that most dramatic of all sea battles, I suspect that the lashing rain would have obscured much of the action for the greater part of the time. No-one will cavil at a licence permitting us to see what was really happening.

The human race being what it is, blowing the enemy to smithereens satisfies its *egos* and illuminates its history books. Artists do not achieve fame and fortune by painting the squalid aspects of their subjects. When viewed at sea, big square-rigged ships under sail vie with the great Gothic cathedrals to rank amongst the most beautiful creations of man but there is a *caveat.* In the men o' war we do not see the swathes of carnage in the paths of chain and bar shot: we are unaware of the vast death rolls, greater from disease than from battle, neither of the stench of the bilges nor the revolting state of the ballast, on which some men slept.

Less thought goes to the conditions of the long blockade of the French ports, often on a lee shore in all the spite of the North Atlantic in winter time. Imagine a freezing night in a gale of wind with snow whipping over the ship; the tacks boarded down as she pitches into a head sea, flinging the icy sprays all over her fore-part. The heads? Is it any wonder the ballast was foul? The health of the crews was never a prime consideration. When efforts were made to get rid of the revolting bilge water which accumulated, the object was purely for the better preservation of the timbers. It was not until the latter part of the seventeenth century that windmills were installed to replace the stale air in the ships' bottoms, with immediately beneficial results, not only for the timber preservation but, one would have thought more importantly, deaths from disease were reduced by *over 90 per cent!* The incredible result of this dramatic finding was that, in a relatively short time, the Admiralty discontinued the practice!

Much more can be said in the same vein. If one considers the overcrowding and the factionalism for'ard between volunteers

and pressed men, the general standard of *esprit de corps* can only be explained by comparison with conditions ashore. Yet it was an age of brilliant officers and superb feats of seamanship, despite insensate conservatism in both ship design and improvements by the British. When Sir Samuel Bentham advocated the use of shells, he was ignored and, to prove his point, had to join the Russian navy for whom he destroyed a vastly superior Turkish fleet off the mouth of the Dnieper by this means. As to ship design, after the Battle of St. Vincent, when two captured Spanish 112-gun ships were sailing under jury rig and prize crews, they out-pointed the entire British fleet, despite their low length/beam ratios. If this congenital conservatism was confined to the British Admiralty in this period, during the ensuing age of the final fling of merchant sail it spread to all nations. With a very few enlightened exceptions, *all* the merchant sailing ships could, and should, have provided better conditions and been worked both more easily and comfortably with improved performance for no extra, and often less, expenditure. These comments are not to decry the pictures in this book one whit, but to emphasise the axim that *All is not gold that glitters!*

An exception to the above comment appears in this book. The *Star Clipper* flouts all previous conventions (as does her sister). Since her square sails are set or furled by pressing the appropriate buttons on a portable board, one might presume them to be an advance of hitherto undreamt proportions. If the sails roll up *inside* the yards, how, I wonder, does one repair a split seam while the sail is still aloft? Are the sails rolled up inside the yard when still wet? And what is the point of a sailing ship of any sort if her angle of heel must be kept so low that passengers'

drinks do not slop out of their glasses? (This seems to be an unwarranted extension of the rule which obtained in the *L'Avenir*'s Baltic cruises before the war that she be kept on one tack while the passengers were dancing!) Further, I believe that her engines are running frequently, if silently enough, even when she is sailing. However, like the school-ships, this vessel runs to schedules, vitiating any clear judgement on her true worth as a sailing ship. It would be interesting to remove her engines and sail her round the Horn to Oregon!

Whatever the queries she raises, Geoff Hunt's picture of her shows her at her best and, if I quibble at anything in this book, it is at the use of the term 'Tall Ships' which only came into common currency due to a silly incident. It was seldom used in the age of sail. Is the big *Omrinn Laugi,* shown in the Battle of the Svöld, tall? Or the *Pinta* and *Nina?* or the craft in Lymington? Anyone who described many of the final flush of four-masted barques as 'tall' in the days of their trading would have been laughed out of court, although they were often big ships! A few 'lofty' ships <u>are</u> included in these pages, but the indiscriminate use of the word 'tall' to describe anything that sails is analogous to speaking of 'horse riding'. It is high time for this point to be made in this age when we hear so much about sail-training ships, even though not a single one has been in commission for more than half a century! 'Sail-training ships' are totally different from 'school-ships', with which we are still familiar. These terms are as inaccurate as they are 'Non-U'!

Alex. A. Hurst

ROY CROSS
RSMA

My first marine painting – I must have been about ten years old – was of a Spanish galleon, sails emblazoned with the arms of Leon and Castile and all pennants flying! I still have the colour drawing and fail to detect any great genius or outstanding ability therein! My experience, however, has shown that enthusiasm is a great spur to budding talent and keeps one plugging away during the many disappointments lying in wait for every artist as he strives to improve his artistic vision and technique. Most professional artists have had the occasional letter from some hopeful, seeking personal tuition in the old style. My reply has always been that we artists need all our working hours to make a living anyway, and that there are no 'magic' formulae, no easy gimmicks or quick tips one can pick up by looking over a painter's shoulder, that can replace a good, solid art education.

This preamble is prompted by the thought that the two most common questions asked by the viewer or potential purchaser of a picture are: 'How long did it take?' and 'From whence did you get your ideas and information?' The classic answer to the first question is, of course, forty years (or however long one has been a professional artist!). In other words, irrespective of painting medium or subject matter the learning and experimenting curve never stops. Regarding the second question, I have made things particularly difficult for myself by specialising in a period of maritime history occurring mainly before the advent of photography. Some good photographs would make things almost too easy! Like the historian, recourse has to be made to original documents and records as well as ships' plans, old prints and maps,

maritime paintings and museum models, and the many books and manuals, past and present, containing technical information and the in-depth researches of experts.

It is almost essential to visit the locale depicted in the proposed painting even though the scene may have changed out of all recognition in the intervening years. At least the light and local colour can be authentic. Take Boston, USA, for example, which has formed the background for some of my work. Originally a peninsula dominated by its Trimountain, Boston today would be virtually unrecognisable to its eighteenth-century inhabitants, as a consequence of the levelling of all but a vestige of Beacon Hill and an accelerating programme of landfill ending with the construction of the modern airport. From its seaward aspect, therefore, Boston poses grave problems for the present-day historical artist, even though inland some of the old town, with its buildings and monuments, remains.

New York, too, features in many of my paintings. Among the forest of church spires which once dominated the skyline of this and other American cities, the Battery Rotunda was and remains one of its most famous landmarks, and in itself poses problems in the historical sense. The site of original fortifications protecting the entrance to the East and Hudson Rivers, it remained unfinished as Castle Clinton, was developed as a theatre and place of public entertainment, and in 1855 was leased as a reception and processing establishment for the flood of immigrants into the United States. Account has to be taken, therefore, of its changing aspect brought about by these various uses at different times.

The historic port of Salem, Massachusetts, on the other hand, is easily identifiable with old prints. The original Customs House and Derby Wharf still exist and have formed the focal points of many of my pictures. Likewise, with St Paul's Cathedral and the Tower of London still surviving, historical scenes of London's river could easily be reconstructed with the help of many old prints and paintings still available in museum archives.

One of my tasks for the 1976 American Bicentenary year was a series of paintings depicting the early ships constructed for the emerging US Navy, and right away I encountered a basic problem unearthing authentic original source material. On the European continent and in Britain, where the various navies had a long tradition of fighting in innumerable conflicts, the practice had grown up of recording in paint the great battles and personalities of more than two hundred and fifty years of almost continual warfare. Royalty, naval officers, wealthy patriots and sometimes even the naval ministries employed an international band of specialist marine artists to record and immortalise the epics of national maritime history for posterity. As well as these, there was the vast store of naval documents and administrative records,

dockyard and other models and so on, upon which future historians could draw.

No such tradition existed in the North American Colonies, naturally, and when the new Continental Navy of the United States was created in 1775, scant thought could be spared even for the creation of such a necessity as the national naval flag, let alone comprehensive records which the modern researcher would find so useful. Thus a far better record exists of the American merchant ships of the period 1765 to 1814, as far as contemporary and accurate colour representations of actual named ships are concerned, than of the famous vessels which contributed so much to the success of the American Revolution.

This was because of the activities of what one researcher and author has named 'the Pierhead painters', local artists available at every major port, and thriving especially in the Mediterranean basin. Their employment was to portray, for ship owners or visiting captains, officers or crew accurate portraits of their ships, as mementoes, gifts, ex-voto offerings or merely for decorative or nostalgic reasons. Whatever their artistic merits (and often these were substantial), those examples that have survived offer accurate contemporary information as to rig, colouring, house, signal and national flags, and sometimes background. Perhaps the best-known of this breed of journeyman artists were the Roux family of Marseilles – from Joseph to François Geoffroi – who, apart from

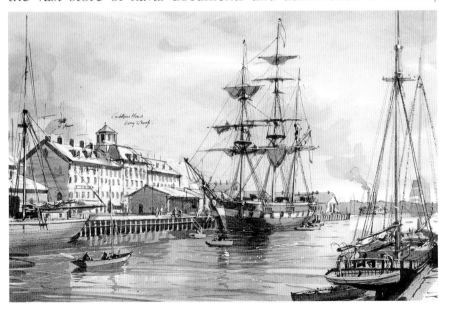

Left:

Long Wharf and the old Customs House, Boston Harbour, in the 1850s.

Black ink and wash, 8in x 12in.

This was just before the period when excellent photographs were beginning to be taken of the city and harbour and so the final painting had to be an amalgam of old maps, artists' impressions and the later photographic record.

engaging in the hydrographic business, for well over a hundred years recorded the local shipping. So skilled, accurate and beautifully rendered were their efforts – mostly in watercolour – that their pieces were and are now highly prized (and highly priced) as works of art as well as historical references.

Reverting to source material for pictures of the early American warships, this will be discussed further along in this section, but mention must be made of the practice employed by the British Admiralty of 'taking off' the hull lines of captured vessels for the obvious reason of comparisons in

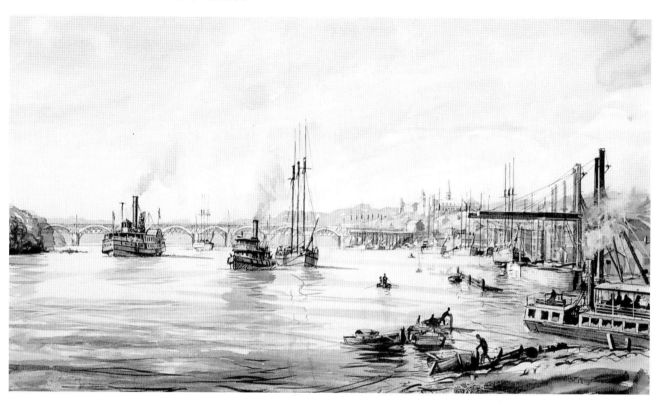

design and sailing performance. Many of these draughts are in existence and afford hard evidence of a named vessel's precise appearance, manna for the historical marine artist, who, it seems to me, encounters many of the problems of the dedicated model shipwright. This is not to say that the respective creative tasks are of the same magnitude, for the marine artist has many ploys to ease his labours should there be gaps in research or sources. For example, many small details of rigging can be hidden by a full spread of sails, heeling of the ship can avoid the need for copious deck detail, as can a liberal dose of sea spray, or gun smoke in a battle scene. In older vessels, the complexity of bow detail, figureheads, headrails, etc., can be hidden by setting single or double spritsails where appropriate. On the other hand, the artist, having obtained his references – sail and hull plans, old paintings which he cannot just copy for obvious reasons – has to visualise this

material in three-dimensional form and transmute it into a realistic two-dimensional image. Add to this an artistic rendering of sky, sea and an authentic background and it becomes apparent why competent historical marine painters are fairly thin on the ground.

Above: **Compositional sketch** – the port of Georgetown in the latter half of the nineteenth century, settled some fifty years before the Federal Capital a mile or two distant. This is a compositional drawing, cobbled together from an enormous amount of research material gathered during a visit to the locality. A large section was added on the right to include more foreground detail, but the general view was sketched and photographed at the present waterside and then equated with the historic research material. Old photographs did help a great deal in this instance. Line and wash, 8in x 12in.

THE ROYAL NAVY

For reasons explained in my biographical note, I have had few opportunities to produce historical paintings depicting ships of the Royal Navy, some fine examples of which appear elsewhere in this book. One such opportunity came when deciding upon my Diploma work for the Society, much influenced by viewing again the fine film about the mutiny on the *Bounty* produced in the early 'sixties by Metro-Goldwyn-Meyer.

The *Bounty*.

It was decided to show the vessel hove to off her eventual destination, Pitcairn Island, even though this was one locale which I had not visited nor was likely to. A fascinating aspect of the *Bounty* story was not so much the well-known saga of the mutiny itself and Bligh's fabulous voyage with loyal crew members in an open boat, but the tragic record of the mutinous crew and native passengers as they strove to create a small civilisation of their own on the tiny uninhabited island. Instead, all

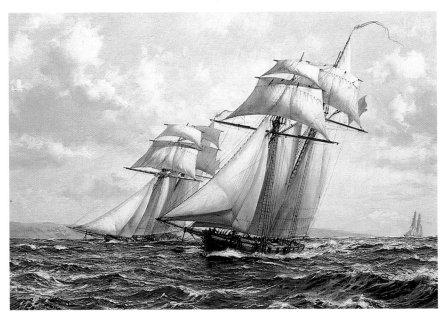

the worst human instincts gradually surfaced, with racial disharmony and quarrels over the native women leading to murder and mayhem, and the death from various causes of all but one of the original mutineers. (The full story is recounted in Richard Hough's *Captain Bligh and Mr Christian* (Arrow Books)). The fate of the islanders was unknown for some eighteen years until, in September 1808, Captain Mayhew Folger in the American ship *Topaz* anchored in Bounty Bay to take on water and provisions. He was to learn from survivor John Adams and the families the whole tragic story.

A replica of the *Bounty* was built for Metro-Goldwyn-Meyer in 1960 by Smith and Rhuland Ltd of Lunenburg, Nova Scotia, at the cost of some $700,000. Based on original plans, she was actually 30 feet longer than the original vessel to provide extra space for the film crew and equipment.

Left:

Decatur and HMS *Dominica*, 5 August 1812.

Oil on canvas, 26in x 36in. (Private collection)

The history of the Royal Navy resounds with innumerable great fleet actions over the centuries, many of them changing the fortunes of nations and indeed continents. But behind these first-line fleets sailed a multitude of smaller fighting vessels – brigs, sloops, schooners, cutters – used as patrol vessels, fleet messengers, convoy escorts and in countless other roles to protect and ease the passage of Britain's great maritime enterprises. Typical of the adventures of many of these small vessels is the incident pictured here. South of Bermuda, on the morning of 5 August 1812, while escorting a British mail packet, HM schooner *Dominica* was intercepted by the American privateer schooner *Decatur* (223 tons) commissioned in Charleston, South Carolina. *Dominica* succeeded in drawing the privateer away from her charge, but was captured in the ensuing action and changed sides later as the privateer *Dominique* in American service.

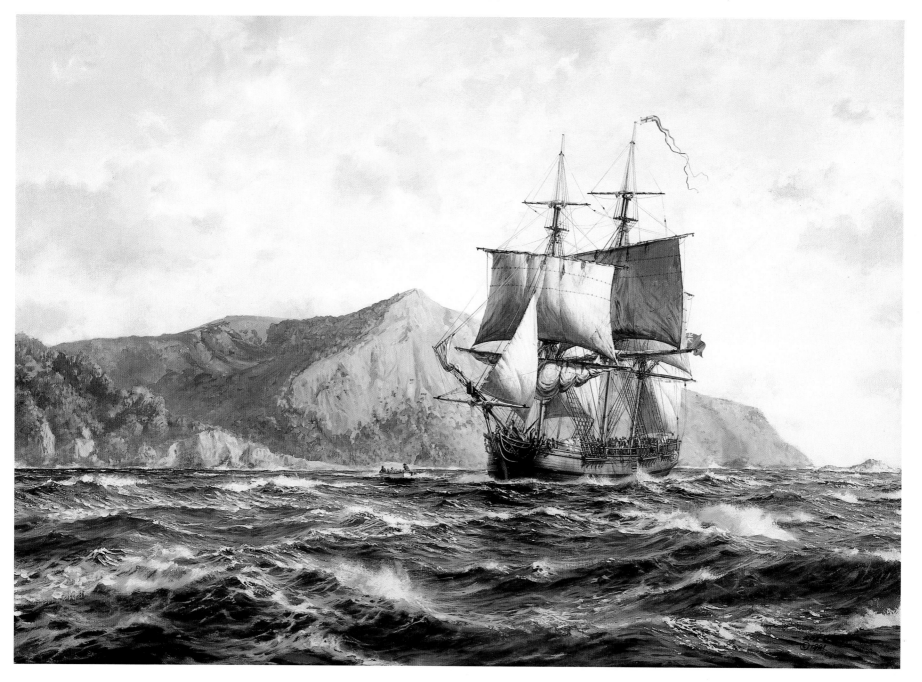

The *Bounty* off Pitcairn Island, 5 January 1790.
Oil on canvas, 26in x 36in. (RSMA Diploma Collection)

Fletcher Christian rows across to the rugged island destined to be the permanent home of all but one of the white men aboard.

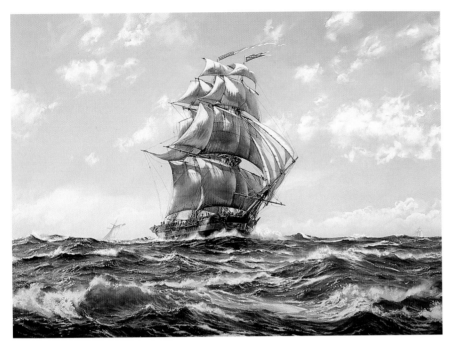

THE SMALL TRADERS

Even in the heyday of the great East Indiamen the bulk of the world's commerce was still carried in the workhorses of the ocean and coastwise trade, the brigs, sloops, schooners and quite small ships and barques of 200–300 tons burthen. Little of the romance of the later great packets and clippers attaches to these ubiquitous craft and I have derived a great deal of pleasure in illustrating them, often for modern collectors who resided near the ports from which they originally sailed and thus have a special interest in these otherwise anonymous vessels. Like the largest ships, these small fry had to be well armed and amply crewed to combat the depredations of the swarms of pirates infesting the world's oceans.

Again a great source of authentic information about these craft is the work of the quayside painters, who operated in major ports as far afield as China. Were it not for the dedicated work of these unsung craftsmen, we should know little of these vessels apart from brief mentions in dusty volumes of sailing records.

Left:
The Trading Brig *Hannah*, 1798.
Gouache on board, 22in x 30in. (Private collection*)*
Typical of the small trading vessels that forged American commerce with the rest of the world in the early days of the United States was the brig *Hannah* of Salem, Massachusetts. Salem was a premier trading and whaling port at the turn of the eighteenth/nineteenth centuries, and *Hannah* was a popular name for her vessels, some 33 being listed even before 1768. Few details are recorded of this particular vessel, but during the naval war with Napoleonic France she sailed from Salem for Europe in May 1798, well-armed to protect her from French, Spanish and Mediterranean privateers and pirates.

Below:
Old Baltimore
Oil on canvas, 24in x 40in. (Private collection)
Flying the house flag, and distinctive black royal on the mainmast, of owner William Wilson, the barque *Paladian* leaves the inner harbour of Baltimore early in the 1850s. Baltimore built, she was of 460 tons burthen and traded out to China.

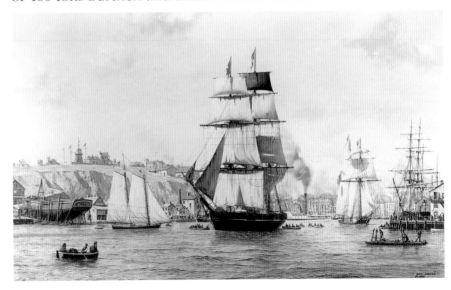

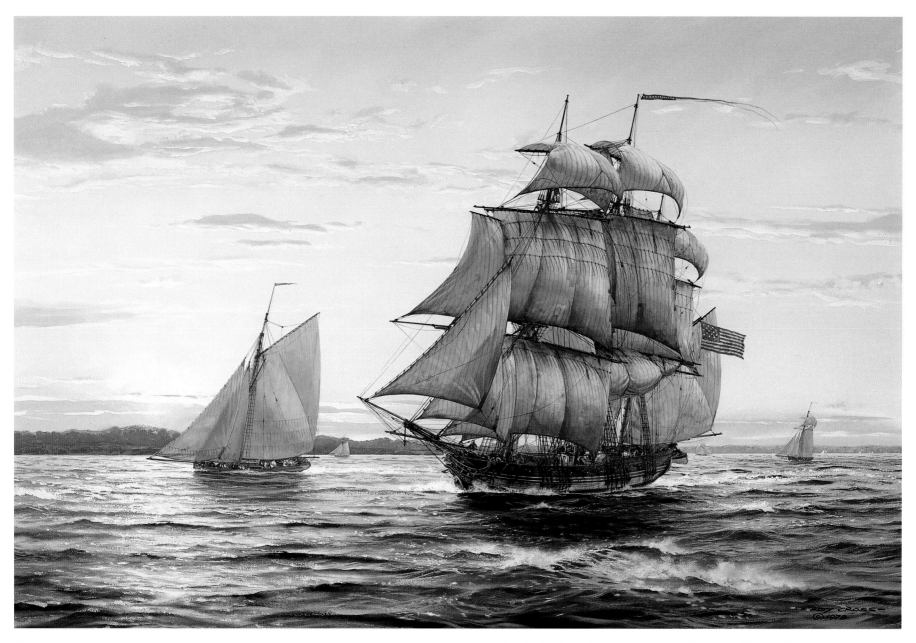

Above:

Salem Harbour

Gouache on board, 20in x 30in. (Private collection)

A fine little merchantman in the Mediterranean trade, *Margaret* was built in her home port of Salem, Massachusetts, in 1800, grossing 295 tons. She was well armed with eighteen or more long guns for defence against the notorious Barbary pirates and other seafaring marauders.

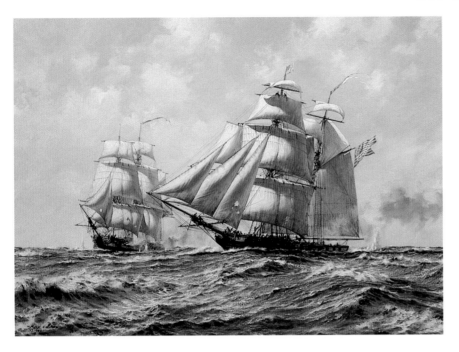

THE FIGHTING SHIPS

Above: The *Prince de Neufchâtel* was a noted privateer of 1813 with a good tally of British prizes to her credit, owned initially in New York by a Madame Flory Charreton and sailing under a letter-of-marque issued in that same city. So good were the vessel's design and sailing qualities that she escaped capture on several occasions, including an unsuccessful attempt to board. Oil on canvas, 24in. x 36in. (Private collection)

Right: One of America's most famous naval heroes, John Paul Jones, was appointed first lieutenant in the Continental Navy in December 1775. In August 1776, made up to acting captain, he was ordered to embark on a cruise 'against our Enemies' in the vicinity of Bermuda to take prizes and gather intelligence information. His ship was the 12-gun sloop *Providence* which he had commanded since May. On 1 September *Providence* was sighted and chased by HBM frigate *Solebay* (28 guns) which was escorting a small convoy bound from Jamaica to New York. After a 10-hour race the powerful frigate had almost overhauled *Providence*, whereupon Jones, relying on his little ship's greater agility, suddenly cut sharply across *Solebay*'s bows and setting all spare sails before the wind, sped away out of cannon-shot range before the larger vessel could complete the complicated manoeuvre of changing course.

So far as is known, no pictures of *Providence* exist, but she may well have been a typical vessel of the Bermudian sloop pattern, well documented and familiar then all along the American Eastern seaboard, and this is how she appears in my reconstruction of the incident. Gouache on board, 22in x 30in. (Private collection)

Opposite page: Here a British brig, the *Frolic*, battles to protect her convoy from a marauding American cruiser, the *Wasp*, during the naval war of 1812 between the United States and Great Britain. The date is 18 October 1812. The 450-ton *Wasp* was rated

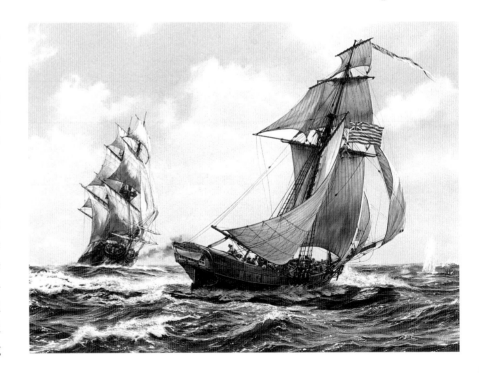

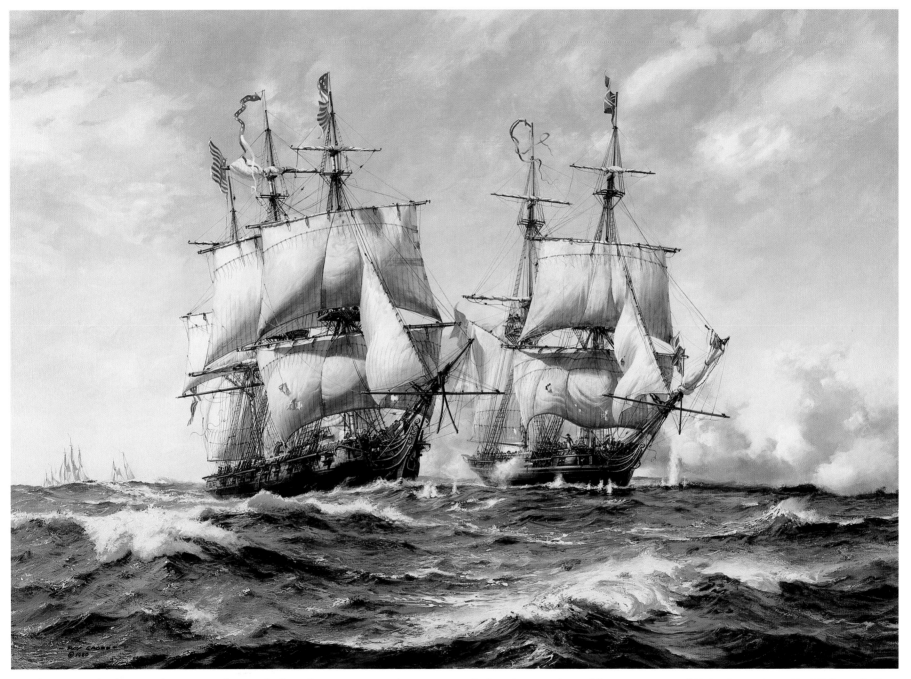

18 guns and the 384-ton *Frolic*, of the famous Royal Navy 'Cruizer' class, was similarly armed; an even match and a hard fight. (Reproduced by courtesy of Felix Rosenstiel's Widow & Son Limited) Oil on canvas, 24in x 36in. (Private collection)

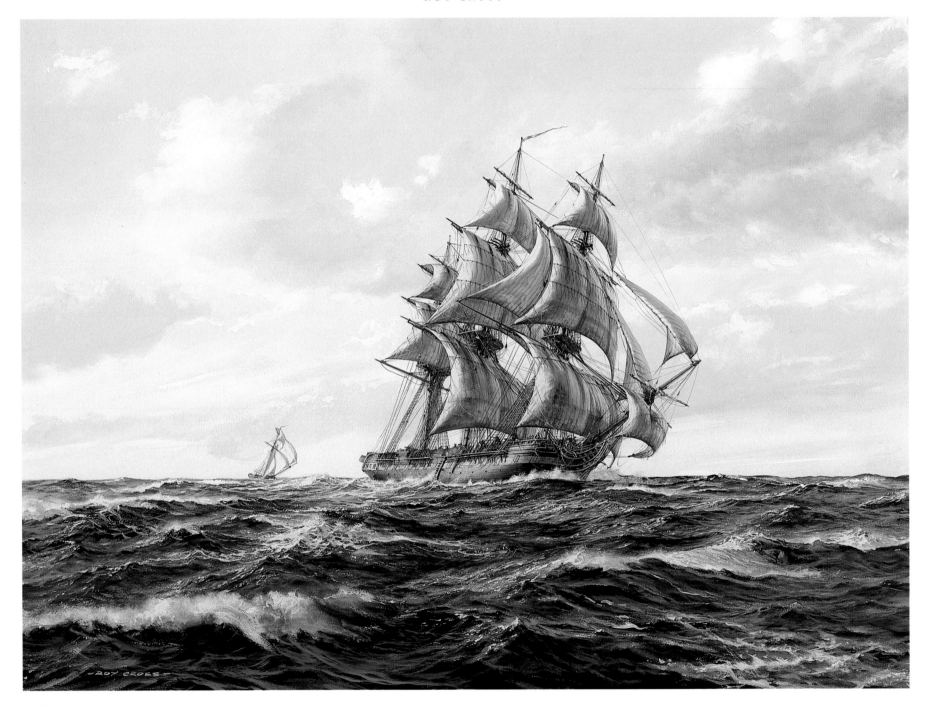

Opposite page:

The Ocean Sentinel.

Gouache on board, 22in x 30in. (Private collection)

A fine naval frigate drives along before the wind in the glow from the setting sun, accompanied by a small cutter as her tender. Well before the 1740s the French had been instrumental in introducing the classic frigate configuration, sleeker, lower, with the main armament on the upper deck, and with plenty of freeboard so that the guns would not be swamped during fighting in heavy seas. These gradually replaced the two-gun deck 'fifth rates' of the early 1700s which in general were clumsier and less seaworthy vessels.

The frigate became the maid-of-all-work of the navies, ranging world-wide on multifarious duties, escorting, scouting, preying on enemy commerce and in general acting as the eyes of the main fighting fleets. The vessel depicted here is a 36-gun frigate of about 1780, of medium size, say 130 feet long on the gun deck and 35 feet in the beam, probably mounting a main armament of twenty-eight 12- or 18pdr long cannon. Such is the inevitable struggle for technical equality or supremacy in every branch and facet of warfare, however, that frigates became larger and more heavily armed between the 1770s and early 1800s, until the American *Constitution* in about 1803, mounting anything between 44 and 55 heavy guns, and 175 feet in length on the gun deck with a 43ft 6in

maximum beam, grossing 1,576 tons, was more than a match for any other frigate she might encounter. (Reproduced by courtesy of Royle Publications Ltd.)

Below:

The Frigate *John Adams*.

Ink and wash, 7½in x 16in.

The waterfront at Charleston, South Carolina, USA, seems basically to have altered little since the scene depicted (below) of the frigate *John Adams* departing from the crowded harbour – the date is 1799. The illustration is typical of the detailed preliminary black-and-white working drawings I prepare for most of the more complicated compositions, and already incorporates much of the basic information on locale, buildings and contemporary craft as well as the vessel herself. *John Adams* mounted 28 guns and was financed by the merchants and citizens of the area and built locally.

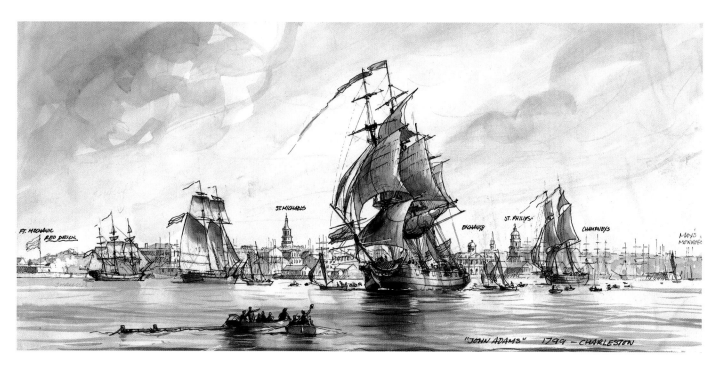

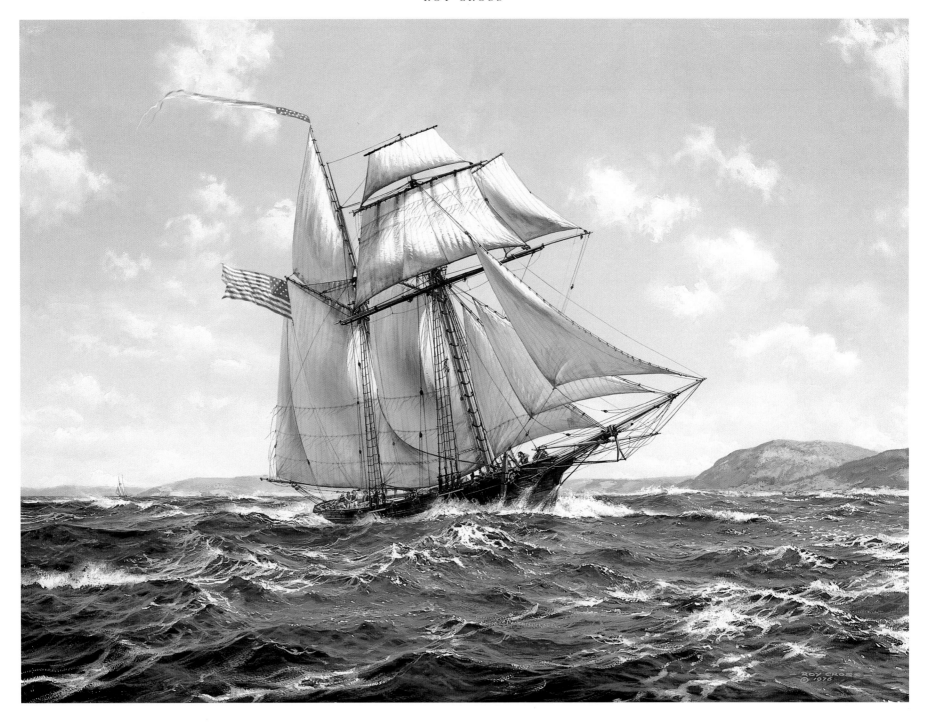

SCHOONERS

A simple two-mast (or more) sailplan, efficiency and ease of management are the characteristics of the schooner rig which in its basic form goes back well over four centuries.

Opposite page:
The privateer *Lynx* off the Maine coast, USA.
Gouache on board, 22in x 30in. (Artist's collection)
Lynx was among the paintings which earned me membership of the Royal Society of Marine Artists in 1976. Researching in Maine, we had a fine cruise off Mount Desert Island, whose coast forms the background to the *Lynx.* For reasons of nostalgia, the painting has become a family heirloom. An amusing comment from my good friend and agent, Malcolm Henderson, concerned the two sailors holding hands on the tiller!

This picture was reproduced in a yachting magazine and received fulsome praise from the reviewer who challenged

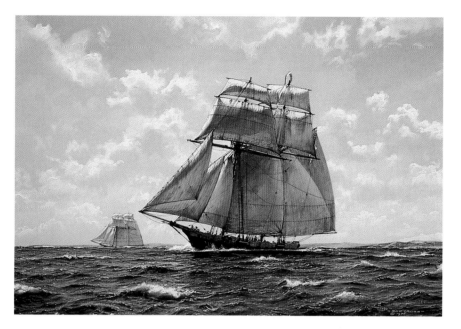

readers to find any part of the rigging missing. Looking at the reproduction, I realised with dismay that the topmast forestay was absent! Since then I always use a detailed checklist of all the categories of rigging and hull detail, and features such as sail shadows, mooring lines, ship's names and even seabirds. Seabirds and the odd buoy or piece of driftwood are hackneyed ploys of the marine painter, but of inestimable value to fill in an empty space in the composition, in fact almost irreplaceable!

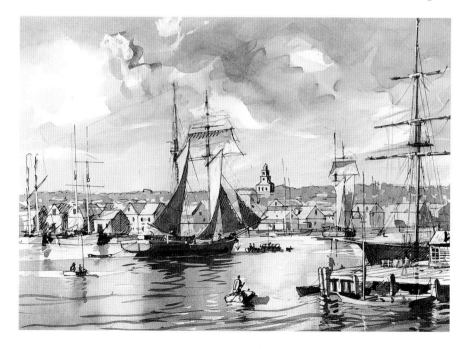

Above:
A Baltimore Clipper.
Gouache on board, 22in x 30in. (Private collection)
One of the most beautiful vessels of her day, *Grecian* was a fast blockade-runner captured and used by the Royal Navy in 1814. She was a notably fast sailer, with low bulwarks and therefore curiously arched rails over the gunports, nine per side.

Left: A compositional sketch for a painting of a whaling schooner in Nantucket harbour *c.* 1840.

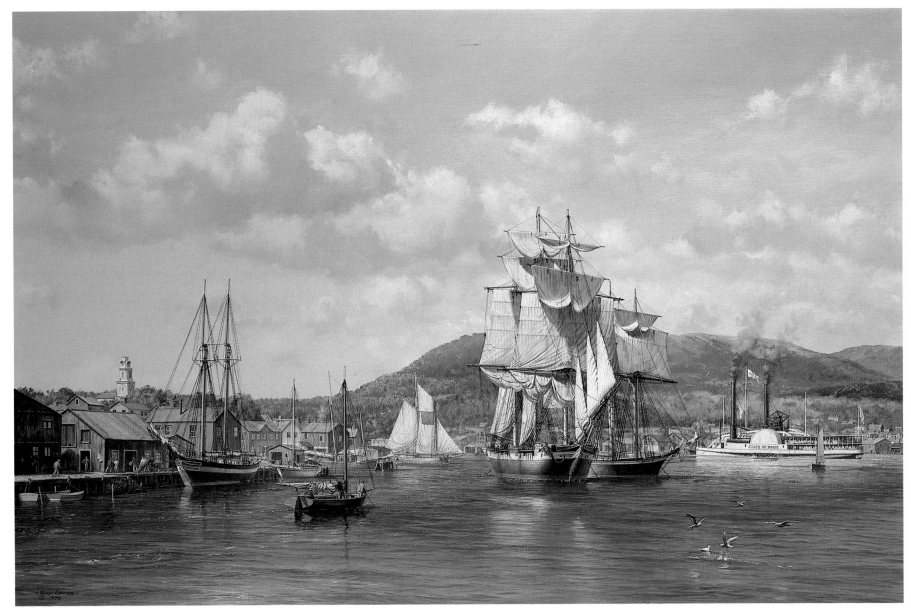

PORTS AND HARBOURS

From the first crude water craft, there gradually evolved rudimentary sea-going vessels, the vehicles for man's insatiable thirst for discovery and exploration. Waterways and the sea, too, provided a way round impenetrable mountains and forests. Intrepid voyagers gradually established new colonies in still virgin territories inhabited by primitive peoples. The resources of the new territories were exploited and shipped back to more civilised shores in exchange for novelties, artefacts and implements

common enough in their countries of origin. Thus seaborne trade grew, sea routes evolved and suitable anchorages eventually expanded into established harbours and ports through which the two-way trade flourished. It would hardly be an exaggeration to say that ships and harbours formed the very foundation of the expanding civilised world.

Traditionally, then, marine paintings presented shipping as an integral part of a coastline, port or harbour scene (leaving aside the portrayal of naval engagements already mentioned). The vessel itself as the central theme of a major oil painting, the 'ship portrait', reached the height of its popularity in the middle part of this century as typified by the work of Jack Spurling and Montague Dawson, reinforced by the more modest activities of the 'pierhead painters', whose efforts have already been discussed. Now, the trends seem to have returned to the customary 'marine landscape' type of painting, with the vessel an integral part of a recognisable and accurately rendered background scene. Not good news for the artist whose historical researches, therefore, are multiplied many times.

Just one interesting facet of the extended research necessary for my marine paintings was the appearance during the first part of the nineteenth century of the first crude working steamboats. There are few manuals or reference works that adequately record the appearance and activities of these craft, and I have amalgamated my own studies into a chronological survey of the steam vessel, using photocopies as well as original photographs of models and other material. The same has been done with sailing craft large and small, and thus can be ascertained, given a specific date, just how the main subject relates to all the contemporary auxiliary vessels and background shipping. This material, ever growing and relating mainly to my own period of interest, already has reached ten ring-bound volumes, a most useful research tool.

Opposite page:
Camden, Maine
Oil on canvas, 32in x 50in. (Private collection)
A view of the old harbour of Camden, Maine, as it would have appeared in the mid-nineteenth century. Readying to slip her moorings is the barque *Aurelia* bound for the Mediterranean. She was built in Camden in 1855 and owned in Boston. Mounts Baffie and Megunticook can be seen overlooking the harbour, now a noted yachting centre and home to a fleet of two-masted cruise schooners. (Reproduced by courtesy of Felix Rosenstiel's Widow & Son Ltd.)

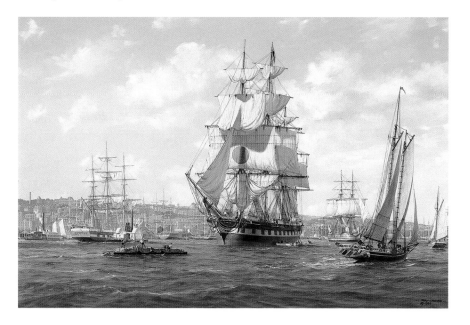

Left:
The Atlantic packet *New York*.
View from the East River of New York's busy waterfront with, in the background, South Street and the piers of such famous shipping lines as the Swallow Tail, Black X and the Black Ball. Taking aboard last-minute passengers is the Liverpool-bound Black Ball sailing packet *New York*, built in 1839.
Oil on canvas, 24in x 36in. (Private collection)

WHALERS AND WHALING

Opposite page:

The Nantucket whaler *Atlas* in southern waters.

Oil on canvas, 26in x 36in. (Private collection)

Even before the thirteenth century the Franco–Spanish Basques were expert European whalers, and their example was followed from the fifteenth century onwards by the first Dutch, British, Scandinavian and other continental fleets.

In much earlier times, the Phoenicians and other Mediterranean sea-going peoples probably hunted the whale. Early settlers in North America observed the local Indians hunting with primitive 'sea anchors' attached to their harpoons to slow the whale for the final kill and developed their own off-shore whaling industry. Early in the eighteenth century, deep-sea whaling expanded in search of the sperm whale and its superior oil and spermaceti, and numerous whaling as well as fishing ports prospered from Long Island to North of Cape Cod. Nantucket and

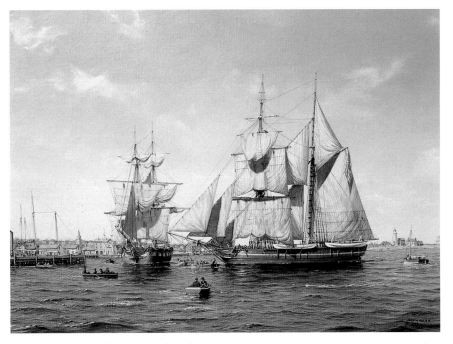

then New Bedford south of Boston were early participants in the whaling industry and rapidly opened up the Pacific whaling grounds pioneered by the British. The boom years of the sailing whalers were from the 1830s until the late 1860s after which steam whalers began to dominate the industry.

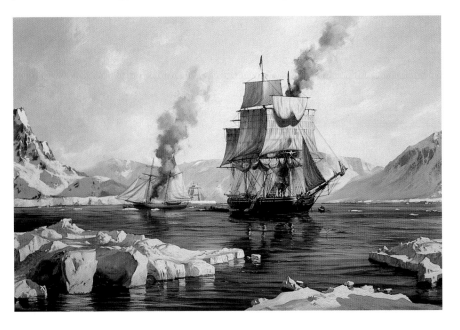

Above: A fine schooner, typical of the smaller whalers of the 1840s, drifts towards her mooring among the wharves of old Nantucket. Old North Church is a landmark in the distance, and on the right is the harbour entrance with the wooden lighthouse and the marine railway on Brant Point. Oil on canvas, 26in x 36in. (Private collection)

Left: The Nantucket whaler *Harvest* busy 'cutting in' a large whale securely moored alongside, with a large slice of blubber cut from the beast being hoisted aboard. Cut into strips, the blubber is loaded into the smoking try works where it is boiled and the oil drawn off into casks for stowage below. Oil on canvas, 24in x 36in. (Private collection)

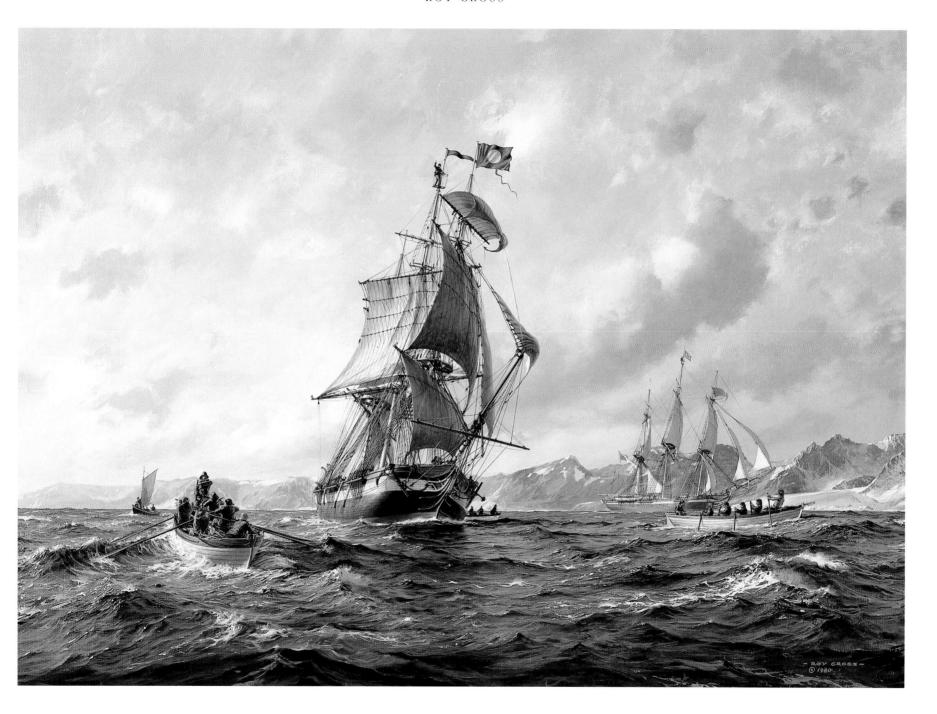

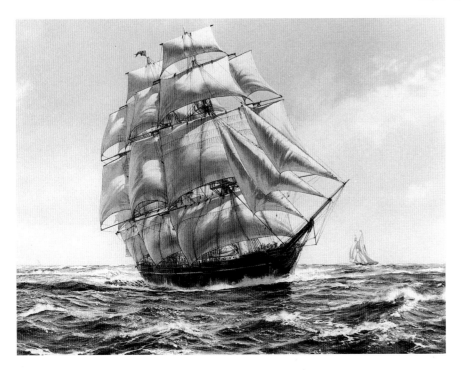

CLIPPERS, PACKETS AND CAPE HORNERS

The brigs, the schooners and small ships and barques, these were the work-horses of ocean and coastwise trade, but the public imagination was and still is caught by the great sailing clippers and ocean packets of the nineteenth century. Since the advent of Napoleon, Europe had been torn almost continuously by wars and blockades. Food and raw materials, let alone luxuries, were in short supply, and the arrival of peace brought a brief unprecedented period of expanding trade reflected in increased ship-building and new commercial ventures by ship-owners. The enhanced freedom of movement and growing emigration from Europe, especially to the New World, brought extra demand for passenger accommodation, one result being the rise of the specialised packet ship, better furnished, strongly constructed, harder driven and running to a regular schedule, 'full or not full'. One of the earliest operators was the Black Ball Line, formed in

1817 from Wright & Thompson's packet service between New York and Liverpool. The Line's *James Munroe* initiated the venture on 5 January 1818, arriving at Liverpool on 2 February. Throughout the next 35 years the packet lines flourished. *James Munroe*'s passengers numbered a mere 30; on 20 May 1851 the *Isaac Webb* arrived in New York with 760 steerage plus cabin passengers.

Left: *Isaac Webb* was built in New York in 1850 by William H. Webb, from whose yard came many fine clippers and packets including *Challenge*, *Young America*, *New York* and *Yorkshire*. Gouache on board, 21in x 30in. (Private collection)

Below: Speed and good cargo capacity were the essential ingredients of great clippers like *Henry B. Hyde*, built to battle round the Horn with cargoes of wheat from San Francisco to America's North-east coast. Gouache on board, 21in x 30in. (Private collection)

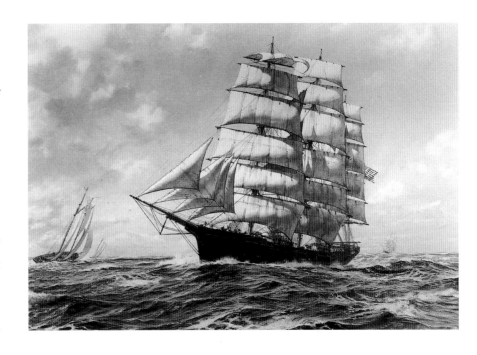

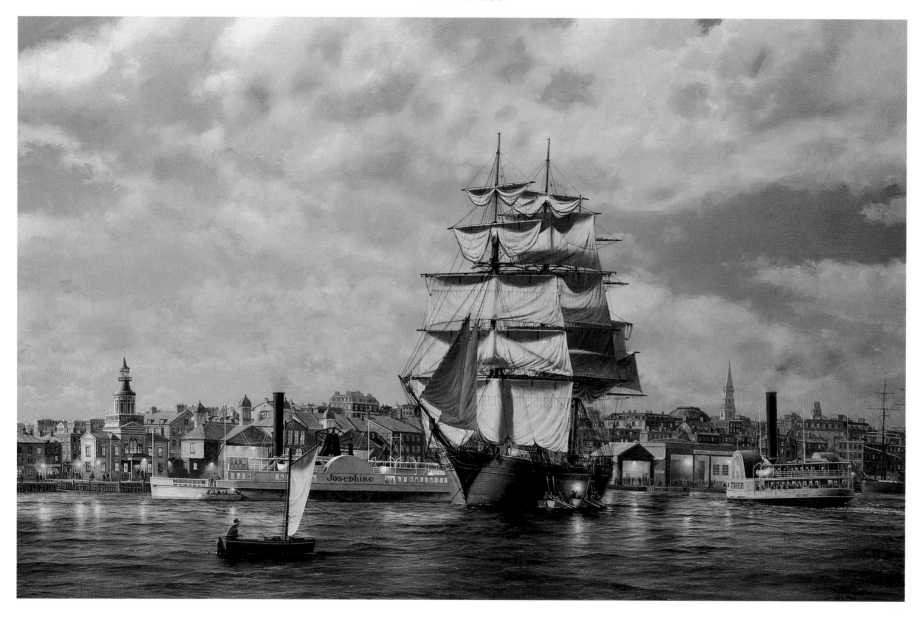

Above:

Dusk on the East River, New York City, highlights the sails of the Atlantic packet *Ocean Monarch* as she takes on last-minute passengers for Liverpool. The steamer *Josephine* stands by to give her a tow to open waters. *Ocean Monarch* was a masterpiece built by the famed New York shipbuilder William H. Webb, founder of the Webb Institute of Naval Architecture. (Reproduced by courtesy of Felix Rosenstiel's Widow & Son Ltd.) Oil on canvas, 32in x 50in. (Private collection)

During the late 1850s, however, unhealthy overcrowding aboard, reckless over-speculation in construction, world-wide financial depression and the advent of steam caused the packets gradually to relinquish the first-class passenger trade.

While the commodious packets were speedy and hard-sailed, the real ocean racehorses were the clippers, fine-lined and heavily sparred for record passages. Speed was of the essence both with passengers and freight, and the fastest vessels were assured of prime cargoes and premium fares and prices.

Fast ships of varying sizes were the essence of the tea trade with China, the tender 'first-picking' teas rushed to British, Continental and American ports being assured of sale at a premium. These vessels always were a compromise between cargo space and the finest hull lines for fast sailing, and the distinction between the types was fine drawn, as instanced for example by the terms medium clipper, extreme clipper, etc. They represent perhaps the peak of sailing ship design and construction and certainly of aesthetic and romantic appeal, and therefore are a favourite subject of marine artists past and present.

Left:

***Challenge* leaving New York in the 1850s.**

Oil on canvas, 20in x 30in. (Private collection)

'Build a mammoth clipper, regardless of cost, the best and fastest in the world'. That was the brief given to master shipbuilder William H. Webb by merchants N. L. & G. Griswold. When she went down the slips at Webb's New York yard in May 1851, *Challenge* was indeed reported to be the largest and longest merchant sailing vessel built to date: a three-decker of 2,006 tons, fully 224 feet long. (Reproduced by courtesy of Felix Rosenstiel's Widow & Son Ltd.)

Below:

Thermopylae

Gouache on board, 22in x 30in. (Private collection)

In the great days of the sailing clippers many were the claims of record passages and fabled sailing powers, but more often than not, among the British seafaring fraternity at least, the claim of 'fastest sailing clipper afloat' was awarded to the famous *Thermopylae*.

Above:

The *Southern Cross*

The medium clipper *Southern Cross* leaving Boston in the 1850s. Baker & Morrill, Boston shipping owners, ordered the *Southern Cross* from builders E. & H. O. Briggs for launch in 1851, destined for the East Coast to San Francisco route. Here she is leaving the Boston wharves with the Capitol building silhouetted on the skyline. Oil on canvas, 32in x 50in. (Private collection)

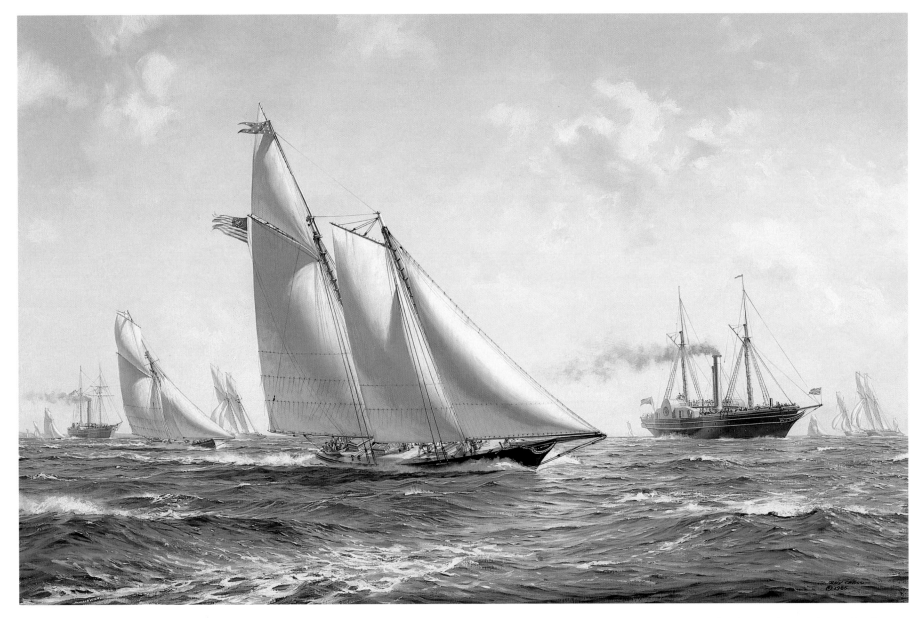

AMERICA

Along with the USS *Constitution*, the yacht *America* must be the best known of all American historical sailing craft, since she gave her name to what has become perhaps the premier international

yachting competition. *America* was built to the order of John C. Stevens, a lifelong sportsman and patron of outdoor recreational pursuits, including the introduction of cricket in the USA, and chief instigator in 1844 of the creation of the New York Yacht Club, of which he was the first Commodore. Living on the banks of the

Hudson opposite Manhattan, all the Stevens family were noted yachtsmen. Stevens and George L Schuyler, another prominent NYYC member, had drawn to their attention a letter from a correspondent in England. It suggested that one of the renowned American pilot boats should be sent over to compete with British yachts in the racing to be held at Cowes as part of the 1851 Great Trade Fair celebrations. It was characteristic of both gentlemen that they should warm to the idea, form a syndicate and place an order for a specially built contender with the shipyard of William H. Brown.

Designing and overseeing the construction of the vessel at the yard was George Steers, from a family of marine constructors and engineers, with a number of notably fast boat designs to his credit and previously a partner in the shipbuilding firm of Hawthorne & Steers. Steers drew not only on his own experience (he had recently constructed the fast pilot boat *Mary Taylor* which caused a stir even among the cracks of the New York pilot boat fleet), but on the latest ideas propounded for example by John Scott Russell (designer of the *Great Eastern*) and the American naval architect John W. Griffiths. Steers obviously was talented and well up with all the latest technical and design fads, but according to the noted writer Howard I. Chapelle, in no way was *America*'s hull form unique except in the sense that Steers imprinted his personal hallmark, especially during the laying down of the lines full scale on the mould loft floor, at which stage the designer's eye and experience were at a premium.

The schooner was launched on 3 May 1851, and of her voyage across the Atlantic one of her passengers wrote, 'She is the best sea boat that ever went out of the Hook. The way we have passed every vessel we have seen must be witnessed to be believed.' This promise was realised when, upon arrival at Cowes, *America* challenged all comers to a contest. The eventual race, on 22 August 1851, around the Isle of Wight for the prize of a cup offered by the Royal Yacht Squadron, was, of course, won handsomely by *America*.

Opposite page:
The first *America*'s Cup Race.
Oil on canvas, 24in x 36in. (Private collection)
Steer's commission as designer was simply to create the fastest yacht afloat, and in the 22 August 1851 Royal Yacht Squadron Cup race round the Isle of Wight, *America* certainly proved she could beat a fleet of British cracks handsomely in their own waters.

Below:
Two Steers masterpieces.
Oil on canvas, 16in x 22in. (Private collection)
Soon after her launch on 3 May 1851, *America* began competitive trials with the sloop *Maria*, owned by Commodore Stevens of the New York Yacht Club. In several days of mixed sailing fortunes, *Maria* proved herself generally faster than the new yacht. Here the two vessels speed past the Battery and Castle Gardens on their way to Sandy Hook.

THE *AMERICA*'S CUP

In 1975 1 embarked upon a series of paintings of the *America*'s Cup races, beginning with the original 1851 competition pictured on a previous page. Over the years, I have portrayed most of the races up to 1930 when the J-class boats were introduced and the Bermudian rig was well established.

Well before this date, fine marine photographers on both sides of the Atlantic had created some memorable images of the yachts concerned. As I say elsewhere, photographs for reference purposes make the task of the marine painter so much easier, but on the whole I have preferred to stick to an earlier period when imagination, based of course on solid research, can be given full play and a gap in the pictorial record filled.

In 1870, nineteen years after the winning of what became known as the *America*'s Cup, a Londoner, Mr James Ashbury, challenged Cup holders the New York Yacht Club to a race with his schooner *Cambria*. Just as *America* had done, the lone challenger competed with a large fleet of local vessels, this time over a course in New York's Upper and Lower bays, one of the opposing yachts being *America* herself. As depicted opposite, the race was won by the smaller and handier schooner *Magic*. Nothing daunted, Ashbury again challenged for a race in 1871 and thus began the series of classic races which continues to the present day, albeit with changes in rules and locations along the way. For example, the 1881 races heralded a scaling down in size of the competing yachts, headed by

Canadian designer and builder Alexander Cuthbert's *Atalanta* with an overall length of only 67 feet and a single-masted rig. For 1885, the length began to creep up again at 94–96 feet overall, but the single-mast sloop rig was permanently established.

Below: The 1885 *America*'s Cup challenge came from the fast English cutter *Genasta*, to meet which two American contenders were built, the Boston-owned *Puritan* and James Gordon Bennett's *Priscilla*. As a result of competitive trails, *Puritan* finally was chosen and beat *Genasta* on 12 and 16 September in some fairly close racing. In this painting *Puritan* and *Genasta* are trying out their paces over the NYYC inner course in preparation for the racing. Gouache on board, 21in x 30in. (Private collection)

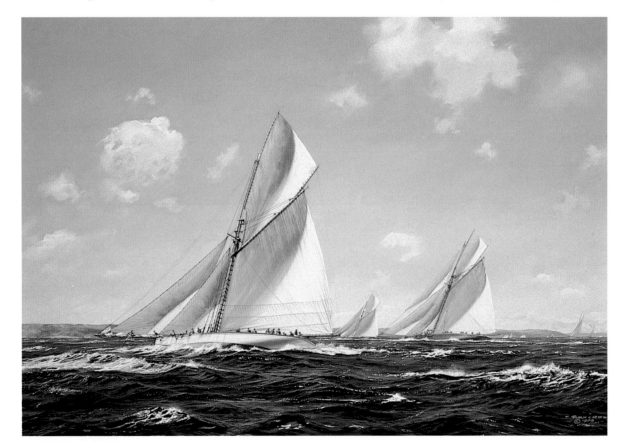

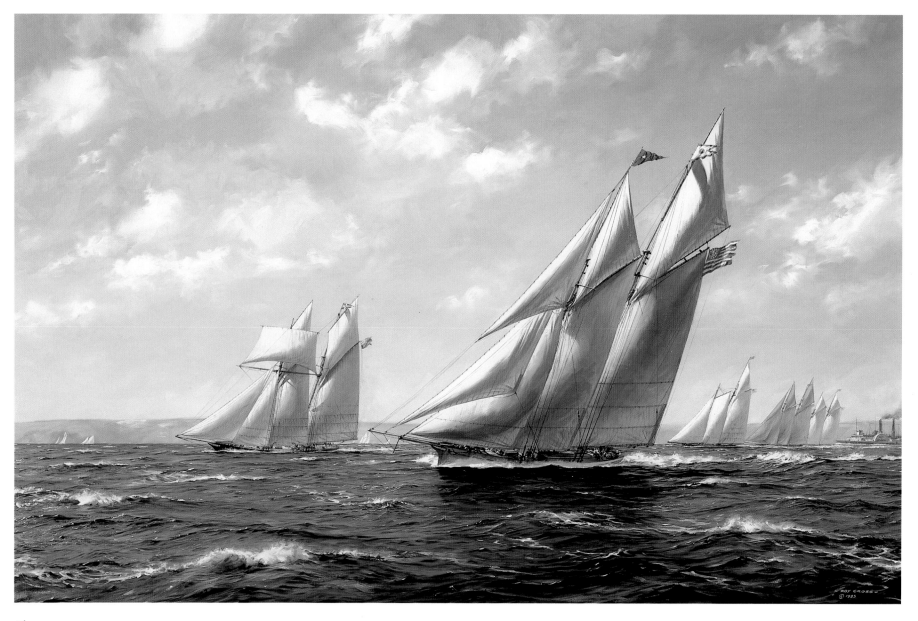

Above:

Magic v. _Cambria_, 1870.

Oil on canvas, 26in x 40in. (Private collection)
The centre-board schooner _Magic_ is already outpacing the British challenger _Cambria_, a larger, heavier keel schooner, over the New York Yacht Club course past Staten Island. In the background is the original _America_, which came fourth to _Magic_'s first and _Cambria_'s tenth in the final corrected result.

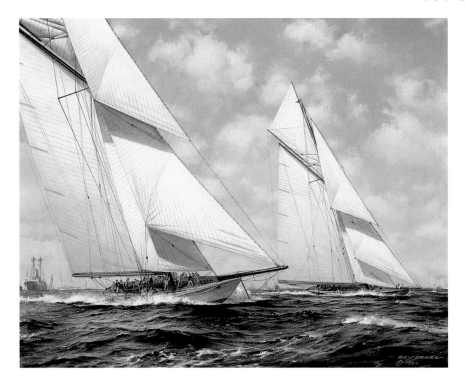

Above: Sir Thomas Lipton's British challenger in the 1920 races was actually built in 1914 for the event cancelled on the outbreak of the Great War. *Shamrock IV* remained in New York for the duration and was refurbished to compete with the Herreshoff-designed *Resolute*, also dating from 1914 but refined and honed in wartime racing.

Shamrock IV actually won the first two races in 1920, but lost the final three and all hope of acquiring the coveted Cup. Then aged 70, Lipton made one more challenge which led to the 1930 races between *Shamrock V* and America's *Enterprise*. Oil on canvas, 16in x 22in. (Private collection)

Right: Defeated in the 1899 races by *Columbia*, Sir Thomas Lipton gamely challenged again for the 1901 competition, engaging veteran designer George L. Watson to design *Shamrock II*. Three defenders competed on the American side, the refurbished 1899

Columbia finally being chosen on general performance and handling.

The first race proper on 28 September 1901 was sailed skilfully by both contenders and narrowly won by *Columbia*, as was the second and the third and last. So close had been the racing, however, that Sir Thomas optimistically maintained his challenge for the next races in 1903. Oil on canvas, 16in x 22in. (Private collection)

Right: For the 1901 series no less than three great American yachts were in competition to defend the Cup. The previous winner, *Columbia*, was still in contention with the great Charlie Barr at the helm, and two fine new vessels were built. *Constitution* was a Nat Herreshoff creation built for the New York Yacht Club, while *Independence* was built at the Atlantic Works, East Boston, for Thomas L. Lawson. *Columbia* still proved to be the superior boat overall and went on successfully to win the 1901 Cup races. Here the three contenders, from left to right: *Constitution*, *Columbia* and *Independence*, are racing off Newport in the July 1901 trials. Oil on canvas, 32in x 50in. (Private collection)

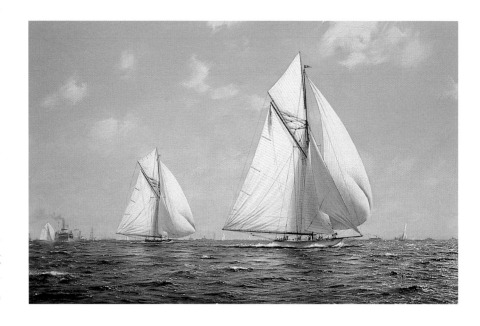

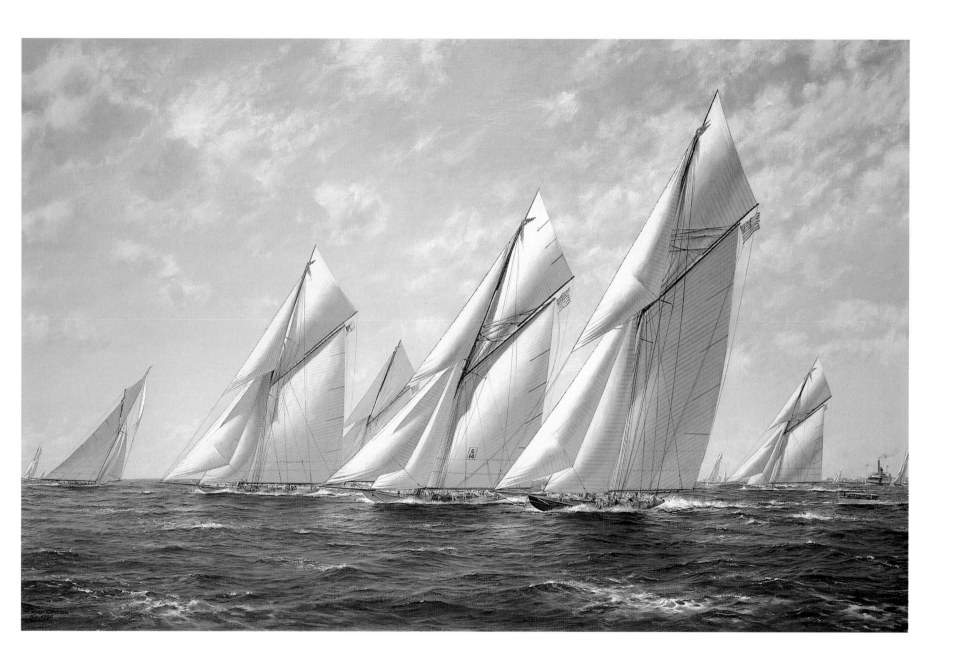

DEREK G. M. GARDNER
VRD, RSMA

As an artist I am entirely self-taught. Looking back over some fifty years of painting I can see that sound technical advice early on would have saved me a lot of unnecessary experiment with colour mixing and so on, but even so I am convinced that no one can

teach you to be an artist; that is something you have to develop yourself from such interests and enthusiasms as you have within you. Having said that, sound drawing with an understanding of the laws governing perspective is the foundation of good marine painting. Such work covers a broad spectrum from studies of the sea, sky and ships of all kinds to harbour, beach and coastal scenery, but as the following plates will show my chief and abiding interest is in those magnificent wind-driven ships as they evolved in Europe and America during the final two centuries before the coming of steam propulsion made them obsolete.

My father, an eminent civil engineer, was Docks Engineer to the old Great Central Railway and later became Chief Engineer of the Port of Glasgow and the Clyde Navigation Trust, so ships and the sea were my background from boyhood days. I have always enjoyed drawing and am indeed thankful in being blessed with such a gift. Nowadays a good deal of emphasis in our schools seems to be placed on Art, but when I was a schoolboy it was very much an also-ran subject and was referred to simply as Drawing which is just about as far as it went. Even so I seem to have been handy enough with a pencil as I still have a handsome red leather-bound book with the school crest embossed on the cover which I won at the age of fourteen for Drawing. The book, *Notes on the Science of Picture Making*, by Sir Charles Holmes, one-time Director of the National Gallery, was an inspired choice on somebody's part because in the years ahead it became a source of much interest and understanding when, in my twenties, I began to experiment with paint. My first attempts were in watercolour,

that most difficult of mediums as I was soon to discover. They were mostly of warships because in 1934 I joined the Royal Naval Volunteer Reserve as a midshipman and ships of the Navy became my maritime painting interest. Such painting as I managed to do in those days was very much secondary to my studying to qualify as a civil engineer, but it was somewhere about that time that I read Robert Southey's *Life of Nelson* which began what was to become a life-long interest not only in Nelson and his remarkable career, but in the broad scope of naval history and especially that pertaining to the French wars of the eighteenth and early nineteenth centuries

A week or so before war broke out in September 1939 I was called up and for the next seven years served in the Navy. I was in small ships, trawlers to begin with and later destroyers, serving in the Atlantic, Arctic and Mediterranean where doubtless I absorbed the colours and run of the sea in those varied waters which have been of enormous value in my later career as a marine artist.

After the war I joined the Colonial Service and went to Kenya as a chartered Civil Engineer. It is now many years since that career ended and I have sometimes been asked if my engineering background has been useful in my later and much longer career as a professional artist. I think perhaps it has been because in painting I work whenever possible from old ships' plans and have developed a way of interpreting them to give a true perspective result. It was during my years in Kenya that in my spare time I got down to the business of teaching myself to paint. Working in oil, watercolour and sometimes pastel, I exhibited both landscape and marine paintings at the lively shows of the Kenya Arts Society in Nairobi. In 1958, while still in East Africa, I had the good fortune and encouragement of having for the first time two of my paintings accepted for the annual exhibition in London of the Society of Marine Artists

During the war I lost the hearing in one ear, and twenty years later in Kenya I contracted a tropical illness which left me almost totally deaf. As a result I had to retire and in 1963 came home to England with my wife Mary and our two children to embark on an entirely new life as an artist, dropping anchor in Dorset where we have lived ever since.

I work in both oil and watercolour and enjoy them equally. With watercolour my preference has always been to paint in the traditional transparent way where the colours rely for their luminosity on the whiteness of the paper, rather than in body colour or gouache as it is often called nowadays

When working in oils I paint usually with solid pigment and then build on that with glaze on dry glaze. This is a slow process, and a painting takes months rather than weeks to complete, but it allows the most subtle effects of colour and depth which is what marine painting calls for.

Whether in watercolour or oil, I paint the sky, the sea and those splendid ships because I enjoy doing so.

'You've got to get a Glory in the work you do,
 An Hallelujah chorus in the heart of you,
Sing or paint a picture, dig or shovel coal,
 You've got to have a Glory or the job lacks soul.'

So said that old Negro in his Mississippi steam-boat. And how right he was!

Finally let me say that one of the greatest assets an artist can have is someone who can offer constructive criticism. My debt to my wife Mary for that and all her other help, is incalculable.

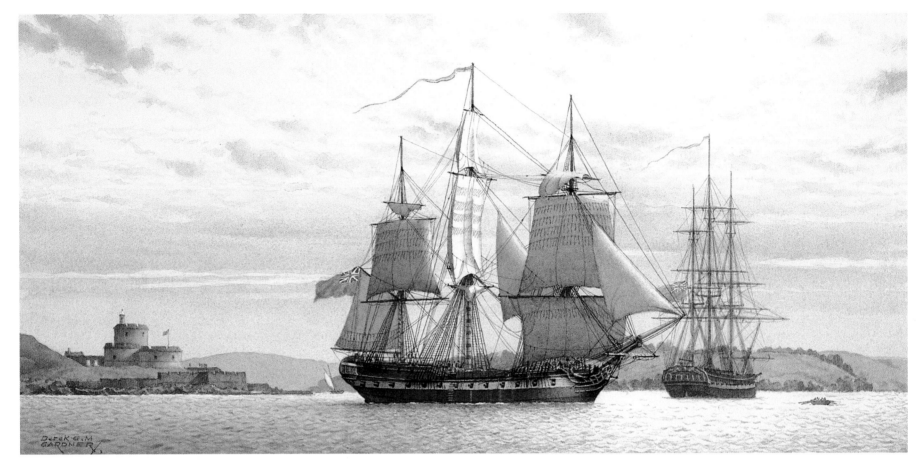

The *Indefatigable.*

Watercolour, 10in x 20in.

This famous ship, seen here off St. Mawes Castle, Falmouth, in May 1795, will always be associated with Captain Sir Edward Pellew who, many years later, became an admiral and was raised to the peerage as Lord Exmouth.

Built as a 64-gun ship-of-the-line at Bucklers Hard in Hampshire and launched in 1784, she was of the same class as Nelson's *Agamemnon.* In 1794, however, she had an entire gun deck removed to convert her into a powerful frigate, while retaining her twenty-six 24pdrs on her lower deck with 18pdrs on her quarterdeck and forecastle.

Pellew took command of the *Indefatigable* in February 1795. At that time he was the most distinguished frigate captain in the Navy, his capture early in the war of the French frigate *Cléopâtre* when commanding the frigate *Nymphe* having earned him a knighthood. The highlight of his four adventurous years in command of the *Indefatigable* came in January 1797. With the frigate *Amazon* in support, he brought the French 74-gun *Droits de l'Homme* to action and after a chase of 150 miles in a gale drove her ashore in the night on the French coast where she became a total loss. Pellew succeeded in getting the badly damaged *Indefatigable* clear of the danger and four days later reached Falmouth. The damaged *Amazon* was not so fortunate

and was wrecked near the French ship; but her officers and men got safely ashore and, of course, were taken prisoner.

Below:
The *Nymphe* and the *Cléopâtre*, 18 June 1793.
Watercolour, 9in x 13½in.
This is the action referred to above for which the king conferred on Pellew the first naval knighthood of the wars. It was a hard-fought encounter, the French ship only surrendering after all her officers were casualties and her gallant captain mortally wounded. The *Cléopâtre* was taken into the Royal Navy and renamed *Oiseau*, serving until 1810.

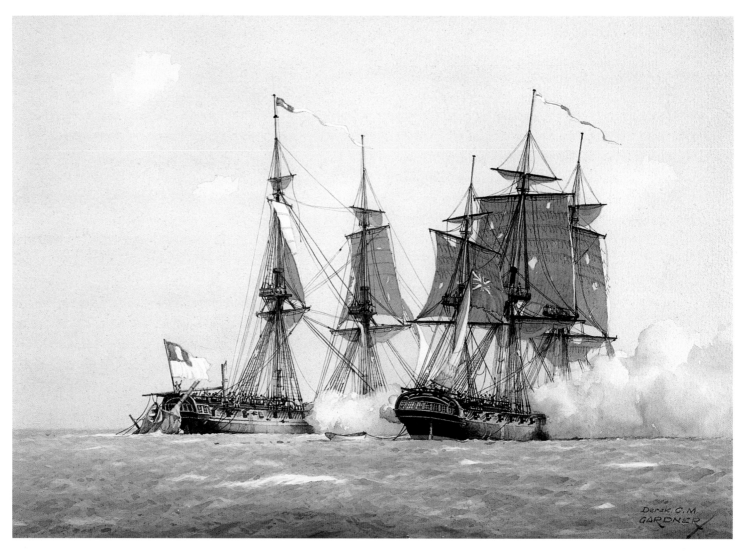

Opposite page:

Setting Topgallants: the China Clipper *Ambassador*, 1870.

Oil on canvas, 16in x 24in.

The 1850s and 1860s were the years which saw the tea clippers in all their racing glory. The China tea trade was a seasonal affair. The first teas of the season came down from the plantations ready for loading into the clippers at Foochow and other ports on the China coast in about May or June of each year. The ships judged to be the fastest among those awaiting cargoes were the first to be loaded as the London market, anxiously awaiting the new season's teas, paid a handsome premium to the first clipper to land them.

Many of the races which took place each year have become legendary and the names of many of the clippers in the trade are still remembered today almost a hundred and fifty years later. The famous *Cutty Sark*, still to be seen in her dry dock at Greenwich, is the only one of the many tea-clippers to have survived and brings back to us something of those stirring races which in their

day created so much excitement even among people who had no connection with ships or the tea trade.

The races were not in any sporting sense organised events; there was no starting-gun. The contest began when the first clipper headed out to sea, quickly to be followed by others as soon as their teas had been safely stowed.

My painting is of the clipper *Ambassador* at the start of her outward-bound passage to China as a new ship in 1870. The tug which has brought her round the Foreland into the Channel is seen in the distance returning to the Thames. She was a late comer to the trade, as within the space of a few years the transporting of tea by sail was rendered unprofitable with the Suez Canal's opening to steamers in 1869 so ships like the *Ambassador* and the *Cutty Sark* had to earn their keep in other trades.

Left:

Rising Gale: The *Ben Voirlich* Shortening Sail.

Oil on wood panel, 7¼in x 11in.

The wool-clipper *Ben Voirlich*, launched at Glasgow in 1873, made a name for herself with a passage from the Channel to Melbourne in 64 days, a record for an iron-hulled sailing ship which was never broken.

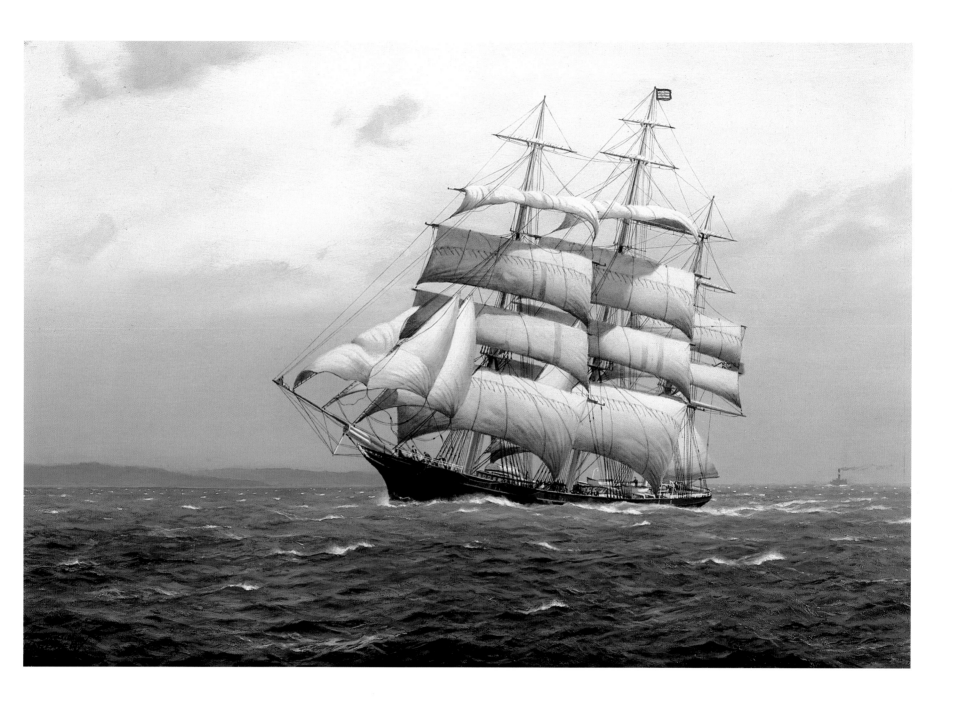

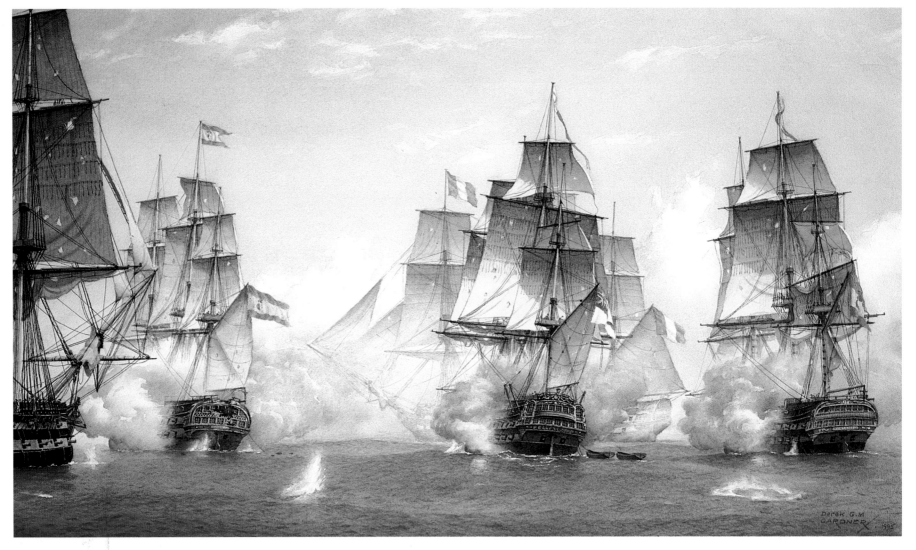

The Battle of Trafalgar: The *Bellerophon* Opens Fire.
Watercolour, 14in x 24in.

The Battle of Trafalgar, fought on 21 October 1805, is one of the great milestones in our long history. In four and a half hours the British Fleet under Vice-Admiral Lord Nelson utterly defeated the combined fleets of France and Spain under Admiral Villeneuve.

The battle began shortly before noon when Vice-Admiral Collingwood's flagship, the *Royal Sovereign*, leading the lee divi-sion, broke through the enemy line astern of the 112-gun *Santa Ana*. The fifth ship in Collingwood's line was the famous *Bellerophon* which had already made a name for herself at the battles of the Glorious First of June (1794) and the Nile (1798). At Trafalgar she again fought with great distinction but with severe damage and casualties including her captain, John Cooke, who was killed. The *Bellerophon* is seen as she broke through the enemy line and opened her broadside fire at 12.30 p.m. under the

stern of the Spanish *Monarca* before going on to engage the French *Aigle* seen through the smoke ahead. The Spanish ship on the right is the *Montanes*, 74, while on the extreme left is the British *Colossus*, 74, which went on to engage the French *Argonaute*.

Nineteen ships out of thirty-three were taken, but when news of the victory reached England the nation's triumph was dulled by the irreplaceable loss of the heroic and beloved Nelson who was struck down on the *Victory*'s deck at the height of the battle.

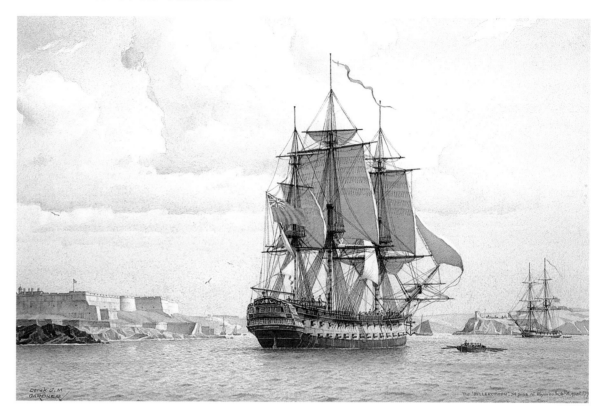

Above:

The *Bellerophon* is seen entering Plymouth Sound from the Hamoaze on 6 August 1793, after repairs to collision damage at the Plymouth Dockyard, prior to rejoining the Channel Fleet. The *Bellerophon* was built on the Medway and launched in 1786. She had a distinguished war career and finally, in 1815, set her name in the pages of history when off La Rochelle on 15 July Captain Maitland "Received on board Napoleon Bonaparte (late Emperor of France) and his suite", and conveyed him to England.

Opposite page:

The Surrender of the *Renommée* to the Alfred, 13 July 1796.

Oil on canvas, 20in x 30in.

This painting depicts an incident in the career of the 74-gun ship-of-the-line *Alfred* during the Revolutionary War when, under Captain Thomas Drury, she captured the French 36-gun frigate *Renommée* off San Domingo. It is recorded that the *Alfred* came up with the frigate, engaged her with two broadsides, several shot striking below the waterline and flooding the magazine, which resulted in her speedy surrender. No doubt Captain Pitot made a token resistance by firing a few guns before hauling down his ensign, because not to have done so would have made him liable to the severest penalty had he been exchanged as a prisoner and returned to France.

The *Alfred* was named in honour of Alfred the Great (849–901), often referred to as the Father of the British Navy. She was built at the Royal dockyard at Chatham and launched in 1778. In the course of her thirty-six years of service, until she was broken up in 1814, she had a distinguished record. Battle Honours were awarded to her for St. Vincent (1780); Chesapeake (1781); St. Kitts (1782); The Saintes (1782); The Glorious First of June (1794); St. Lucia (1796) and Guadaloupe (1810). The *Alfred* was also at Copenhagen in 1801 but there was no Battle Honour recorded for this. The capture of the *Renommée* though a comparatively minor affair was not untypical of many such happenings in the course of the French wars and in this case resulted in the purchase into the Royal Navy of a fine ship which served for many years after her capture.

The *Alfred* is flying the blue ensign because at this time she was under the orders of Rear-Admiral Charles Pole who as Sir Charles Pole became a full Admiral in 1805. In 1796 he was a Rear-Admiral of the Blue so ships under his orders would have worn the blue ensign.

Left:

The *Victorious* and the *Rivoli*, 22 February 1812.

Watercolour, 13in x 19in.

The new 74-gun ship *Rivoli* surrendered to the 74-gun *Victorious* after a severe four-hour encounter in foggy weather off Venice. Both were heavily damaged, the *Victorious* with her rigging cut to pieces and the French ship losing her mizen mast and sustaining much damage to her hull. The *Rivoli* was afterwards repaired and taken into the Royal Navy.

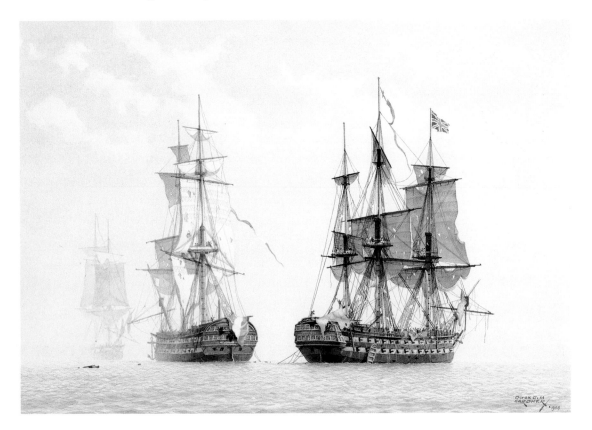

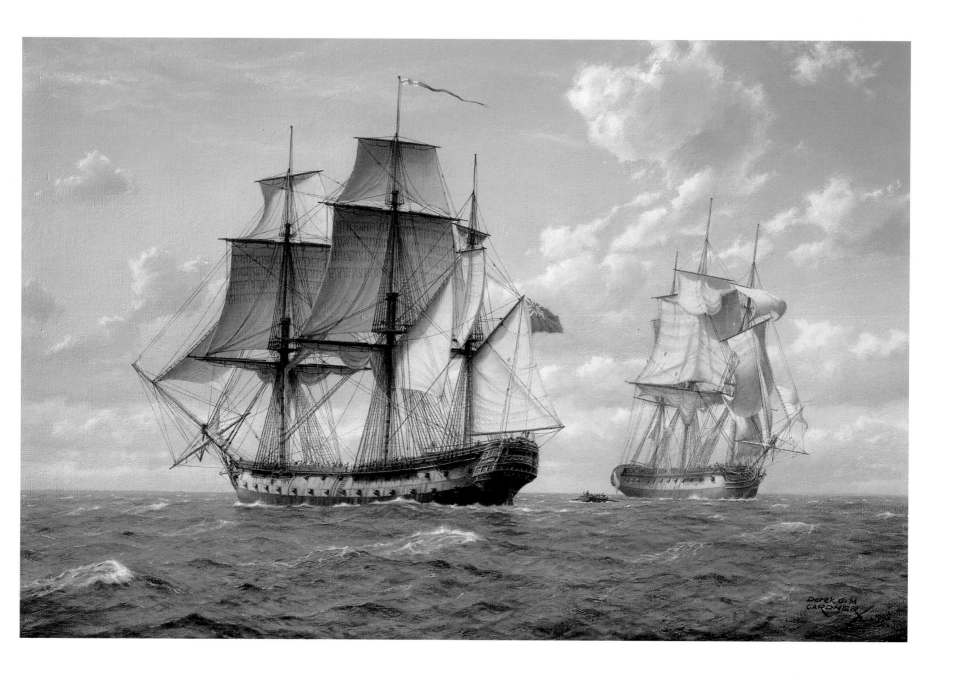

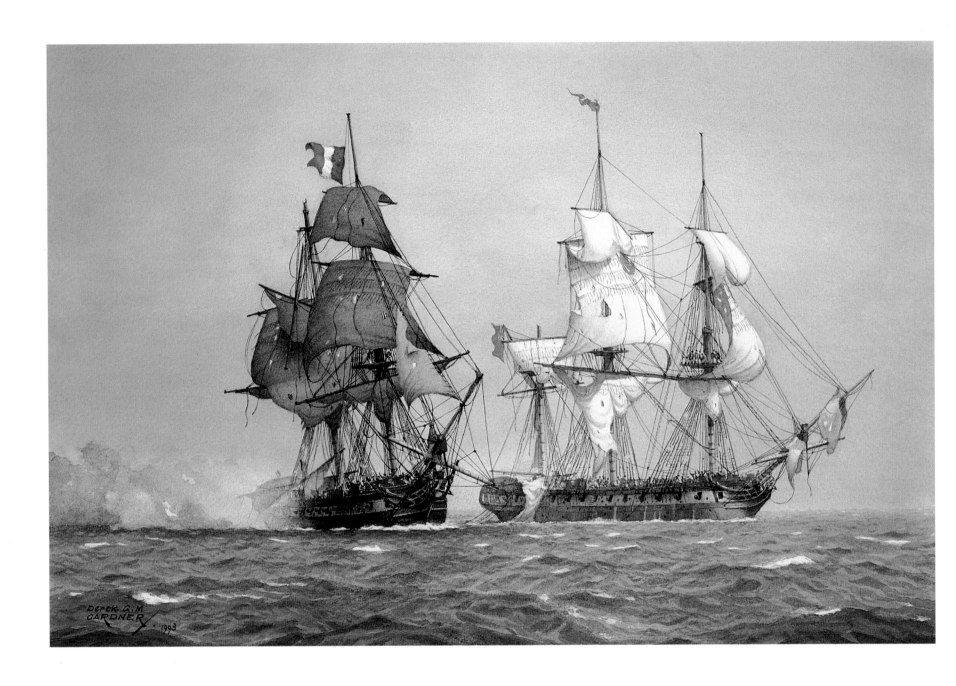

Opposite page:

The Capture of the *Immortalité*, 1798.

Watercolour, 10in x 15in.

In the winter of 1796 the French sent a major expedition to the west of Ireland to aid rebellion by landing 17,000 troops. The venture was a complete failure as a consequence of severe gales, many of their ships being wrecked or later captured.

A smaller expedition with the same objective sailed from Brest in September 1798 but was quickly sighted by two frigates which raised the alarm. From the direction in which the French ships were heading, there was little doubt as to their destination and a powerful squadron was dispatched from Plymouth to the west of Ireland. The expedition was finally brought to action off the Donegal coast on 12 October. Commodore Bompart's flagship, the 74-gun *Hoche*, surrendered after a gallant defence, while his eight supporting frigates were either forced to surrender or made sail as best they could to escape. One of those was the 36-gun *Immortalité* which, on the morning of 20 October, was intercepted by the *Fisgard*, 38, Captain

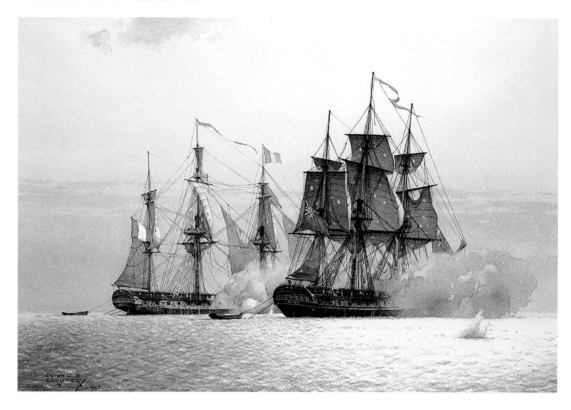

Thomas Byam Martin, when but a few hours' sailing to the west of Brest. A furious fight followed in which both ships suffered much damage and many casualties, but after two hours the French frigate struck, having lost both her brave captain and his first lieutenant. The prize was a fine ship which was taken into the Royal Navy under her French name and served until 1806.

Above is another of the many frigate actions fought during the French wars. This took place on 21 August 1800 in the Mona Passage off Dominica when the British 38-gun frigate *Seine*, Captain David Milne, captured the 38-gun *Vengeance* after a fierce three-hour battle, both ships being much damaged. The prize was taken to Jamaica, but due to the high cost of repairing her she became a prison hulk. The *Seine*, as the name suggests, was originally French and had been captured in the Channel by the frigates *Jason* and *Pique* in 1798.

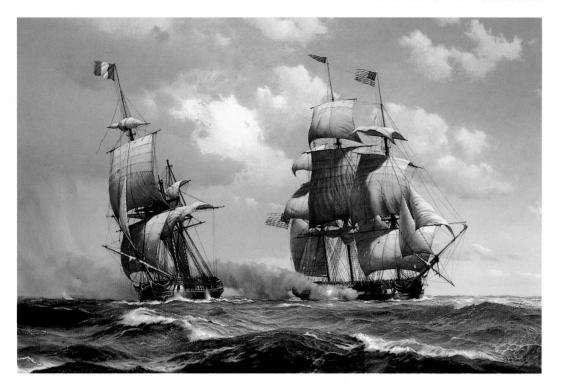

crossed her bows and raked her. With Captain Lambert mortally wounded, heavy casualties and her hold flooded, the gallant *Java* fought on for a further two hours until she was completely dismasted and a total wreck. Commodore Bain-bridge nobly forebore to fire further into the shat-tered ship even though her ensign was still flying. He took possession but next day had to order his prize crew to blow the ship up.

Left:

First Success: The *Constellation* and the *Insurgente*.

Oil on canvas, 28in x 42in.

This encounter took place on 9 February 1799 off St. Kitts in the West Indies, during the so-called quasi-war between the United States and France. In squally weather the 38-gun frigate *Constellation*, Commodore Thomas Truxtun, engaged and captured the French 36-gun frigate *Insurgente*. The French ship, lacking her main topmast as a consequence of previous weather damage, and outgunned by the *Constellation*, surrendered after a fierce resis-tance. This was the first occasion when a ship of the new United States Navy captured a major enemy warship.

Opposite page:

The *Constitution* and the Java.

Oil on canvas, 30in x 40in.

Three defeats by the Americans of British frigates in the early days of the War of 1812 caused shock and much concern in England where success at sea had for many years been the expected result of naval encounters with the country's enemies.

The first came in August when the powerful 44-gun *Constitu-tion* (24pdrs) captured the 38-gun *Guerrière* (18pdrs). Two months later her sister-ship, the *United States*, defeated the *Mace-donian*, 38, and finally, on 29 December, the *Constitution* took the *Java*, 38, off the coast of Brazil. These fine American ships were at that time the most powerful frigates in the world.

The painting on the right shows the situation soon after 3 p.m. when the *Java*'s foremast came down, crushing the fore-castle and masking a number of guns as the American ship

50

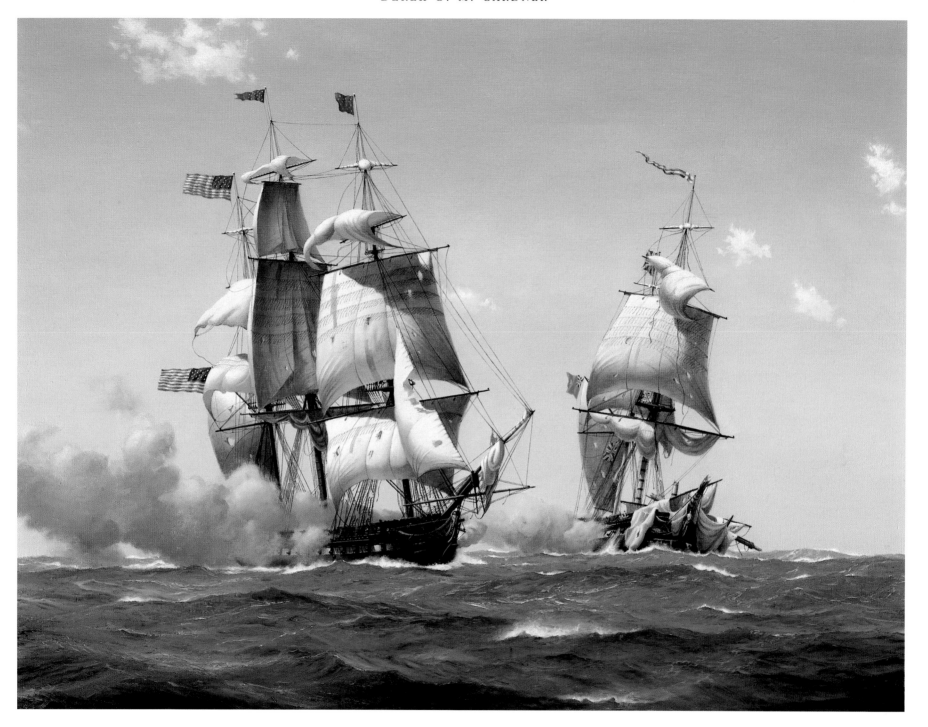

Opposite page:

The 28-gun Frigate *Boreas*, Captain Horatio Nelson, 1787.

Oil on wood panel, 12in x 16in.

Nelson had been a post-captain for five years when in 1784 at the age of 25, he was appointed to the *Boreas* and sent to the Leeward Islands, West Indies, where at Barbados he found himself senior captain and second-in-command to the Commander-in-Chief, Rear-Admiral Sir Richard Hughes.

My painting shows *Boreas* at sea off the island of Nevis where in 1785 he met the young widow Frances Nisbet, who was keeping house for her wealthy widowed uncle. Two years later she and Nelson were married at her uncle's home, Montpelier House. Later that year *Boreas* was ordered home and finally paid off in November 1787. This was the beginning of those eight long years of Nelson's unemployment which went on until war with France broke out in February 1793 and he was appointed to command the 64-gun ship-of-the-line *Agamemnon*.

Below:

The *Agamemnon*.

Watercolour, 13in x 19in.

The *Agamemnon* is seen leaving Spithead (Portsmouth) in June 1793 for the Mediterranean where during the next three years Nelson greatly distinguished himself and brought fame to his ship, his outstanding ability and service resulting in his promotion to Commodore in March 1796. By then the *Agamemnon* was badly in need of a refit and Nelson reluctantly had to leave her, transferring to the 74-gun *Captain*.

In later years the *Agamemnon* went on to take part in the battles of Copenhagen (1801), Trafalgar (1805) and San Domingo (1806). She was with Admiral Gambier's expedition against Copenhagen in 1807, and then in 1808 she was sent to South America with a squadron under Rear-Admiral Sir Sydney Smith, but the following year she grounded on a shoal in the River Plate and became a total loss. What remains of this famous ship has recently been found and is being investigated.

Like the *Indefatigable* (page 40), the *Agamemnon* was built by Adams on the Beaulieu River in Hampshire and was launched in 1781. That year she took part in the Battle of Ushant and in 1782 she was one of Admiral Rodney's victorious fleet at the Battle of the Saintes in the West Indies.

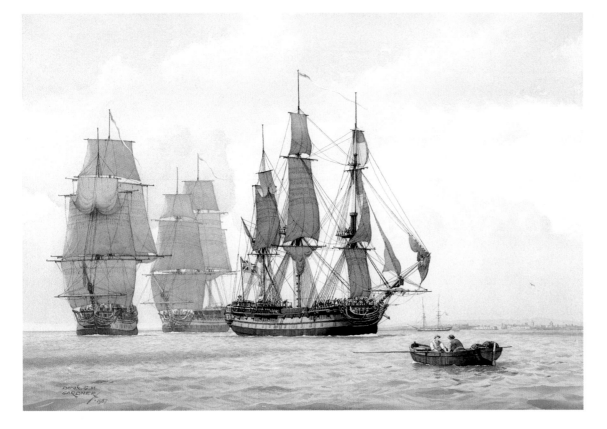

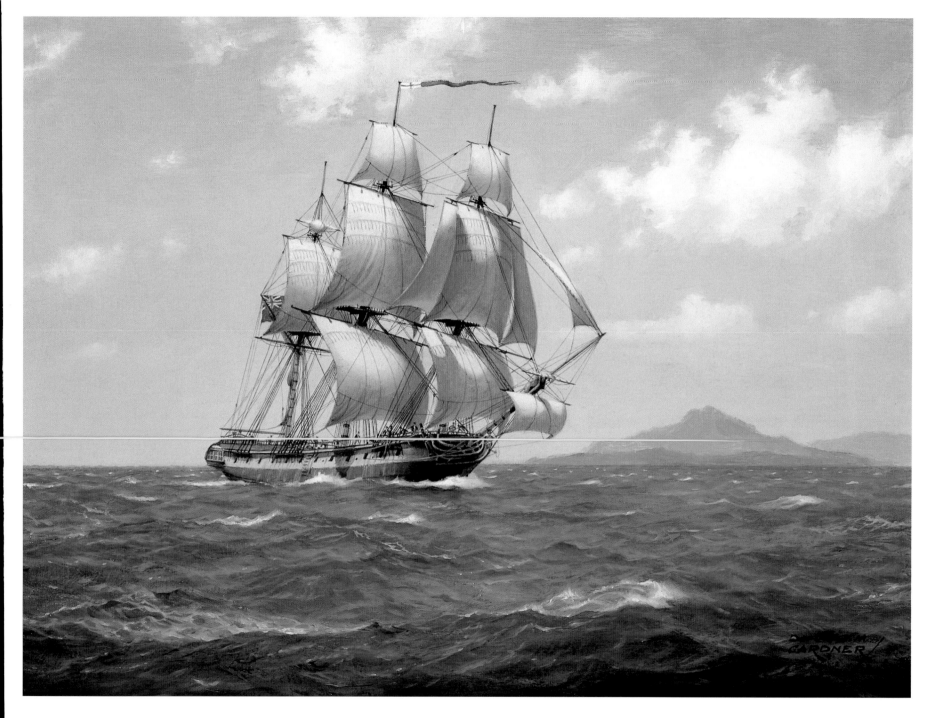

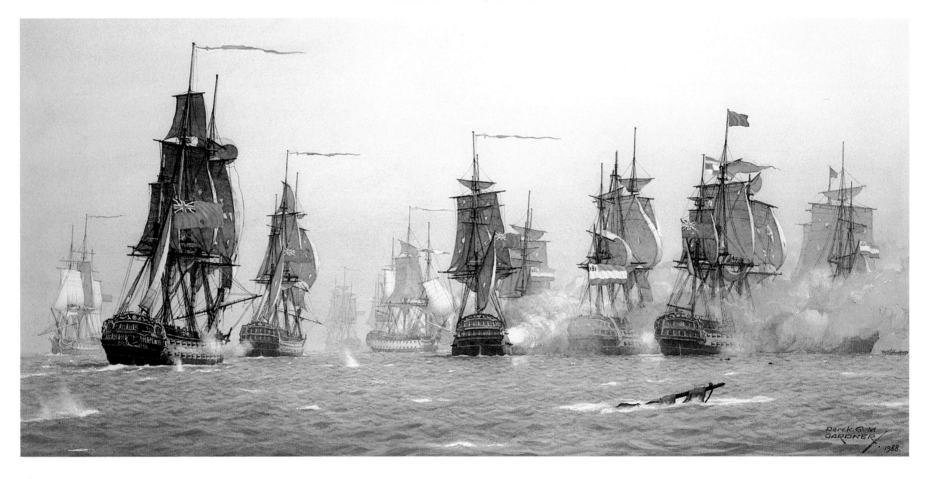

Above:

The Battle of Camperdown.

Watercolour, 10in x 21in.

Holland, drawn into the orbit of Revolutionary France as the Batavian Republic, came into the war against Great Britain in 1795. For the next two years, despite great difficulties the Dutch fleet was blockaded in the Texel by Admiral Duncan's North Sea fleet, but in October 1797 Vice-Admiral de Winter's ships broke out. On hearing the report, Duncan immediately set sail and on the morning of 11 October sighted the enemy five miles off the village of Camperdown. With his blue Admiral's flag in the *Venerable*, 74, his fleet bore down to attack in two divisions, his own and that of Vice-Admiral Onslow, his second-in-command. The battle was one of the hardest-fought during the long years of the war at sea with heavy casualties on both sides. The outcome was an overwhelming victory for Duncan's ships, no fewer than eleven of the Dutch fleet being taken.

The battle is seen soon after 2 p.m., with the *Venerable* and de Winter's *Vrijheid* in close action at right centre. The British ships fought under the blue and red ensigns, those in Duncan's division wearing blue and Onslow's red.

Below right:

The *Victory* at the Close of the Battle of St. Vincent.

Watercolour, 10in x 17½in.

The famous *Victory*, which in 1805 was to be Nelson's flagship at Trafalgar, wore the blue flag of Admiral Sir John Jervis at the battle fought off Cape St. Vincent against the Spanish fleet on 14 February 1797. Despite being outnumbered twenty-seven to fifteen, Jervis' ships captured four without loss and so foiled the Franco–Spanish plan to unite their fleets for the invasion of England. It was this battle which brought fame to Nelson. On his own initiative and with great daring he took the *Captain*, 74, out of the line and stood across the main body of the Spanish fleet to prevent them joining up with a powerful group of their ships to leeward. In recognition of his outstanding courage Commodore Nelson was made a Knight of the Bath and Sir John became an earl, the king himself proposing the title of St. Vincent.

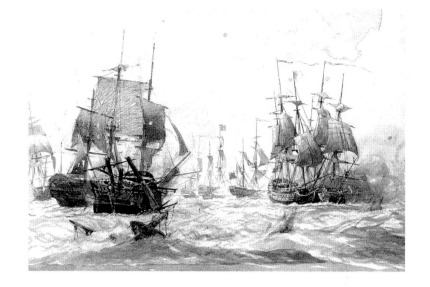

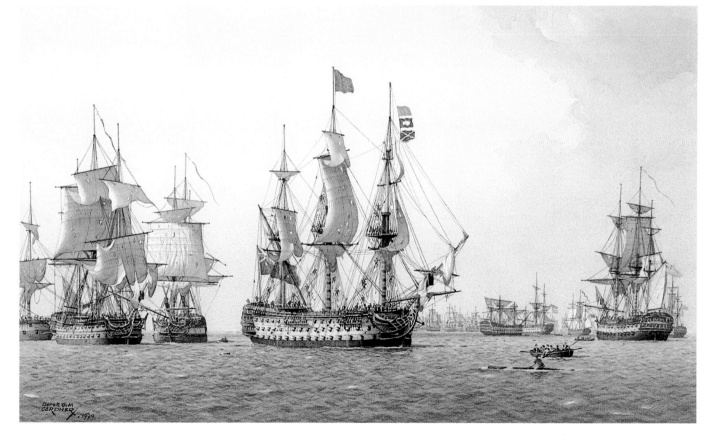

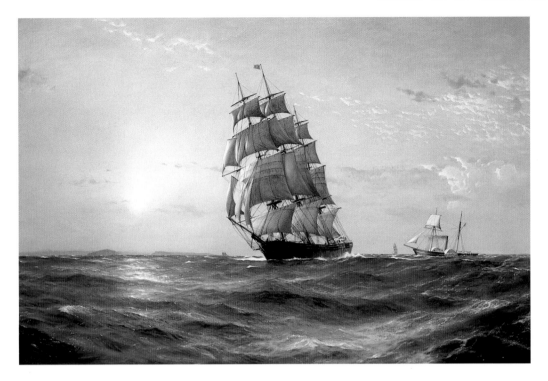

High Seas.

Oil on canvas, 14in x 18in.

This is the celebrated tea-clipper *Leander*, built on the Clyde and launched in 1867.

The China tea trade under sail lasted only a quarter of a century, roughly from 1850 to 1875, yet the names of many of the ships are still remembered today. The most famous of them is undoubtedly the *Cutty Sark*, preserved in a dry dock at Greenwich, the only survivor of the many ships that year by year, raced home to London, their holds packed tight with chests of tea.

These small ships and especially those of extreme build and fine lines like the *Leander*, required very careful handling when running in the kind of weather I have shown in this painting, the man or sometimes men at the wheel carrying great responsibility in seeing that the ship held her course. In such conditions the captain would seldom leave the poop, snatching such sleep as was possible in a deck-chair lashed to the mizen rigging with a canvas weather cloth to give some protection.

Above:

Winter Sunrise: the Young America.

Oil on canvas, 26in x 39in.

This splendid clipper was built by William Webb at New York and launched in 1853. In the course of her long career of more than thirty years, ports all over the world saw her at one time or another, and in this painting I have shown her at sunrise in the Irish Sea off the Pembrokeshire coast, inward-bound from Callao to Liverpool where she docked on 2 February 1861.

Still remembered as one of the outstanding American clippers of her time, the greater part of her life was spent as a Cape Horner in the trade between New York and California, and she was said to have rounded the Horn more than fifty times. In 1858, however, she had to her credit a fast 71-day passage from Liverpool to Melbourne. She finally passed to Austrian interests in the 'eighties and, as the *Miroslav*, foundered in the Atlantic with all hands in 1888.

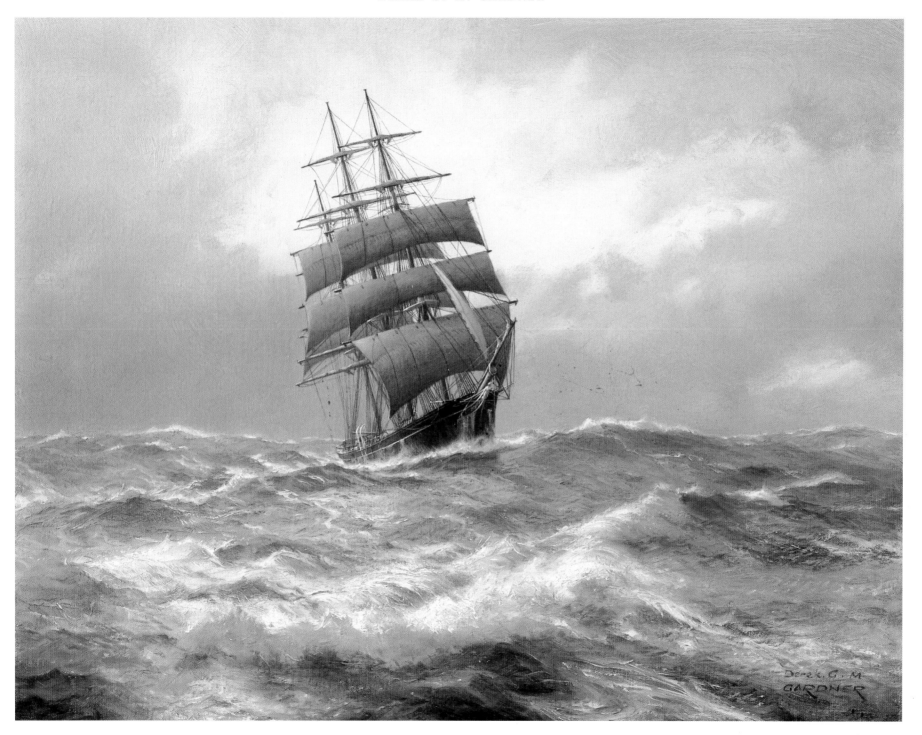

Right:

Sunshine and Squalls: The Tea-Clipper *Ariel*.

Oil on canvas, 24in x 36in.

This famous and yacht-like little ship was built by Robert Steele and launched on the Clyde at Greenock in 1865. That renowned old seaman Andrew Shewan, who commanded the tea-clipper *Norman Court*, named the *Ariel* as the most outstanding in performance of all the British tea-clippers. In what has been remembered as the Great Tea Race of 1866, it was *Ariel* which reached the Downs first with the new season's teas after a final 14-knot duel with the *Taeping* as they raced up-Channel.

My painting shows this lovely little ship at sea, shortening in some of her canvas as a heavy squall builds up astern.

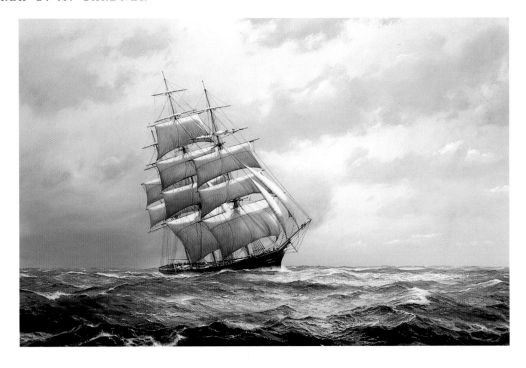

Opposite page:

The Record Breaker.

Oil on canvas, 30in x 40in.

This is the famous *Sovereign Of The Seas* which in the summer of 1853 set up a record crossing of the Atlantic from New York to Liverpool, completing the passage for the first time in less than fourteen days.

She was designed and built by Donald McKay and launched at Boston in 1852. The painting shows her off the south-east coast of Ireland on the evening of 1 July, towards the end of her record-breaking run. She docked at Liverpool the next day and so established McKay as the world's leading designer and builder of fast ships. She was quickly chartered by the Liverpool ship owner James Baines who took her over as a passenger clipper for the Australian trade, but she made only one voyage under his Black Ball line houseflag before passing to Hamburg owners.

There is no doubt that this handsome and powerful ship ranks as one of the finest clippers of her day. Why Baines kept her for only one voyage it is hard to say, but it may have been that, despite her size, her accommodation was not altogether suitable for the large numbers of emigrants anxious at that time to start a new life in Australia.

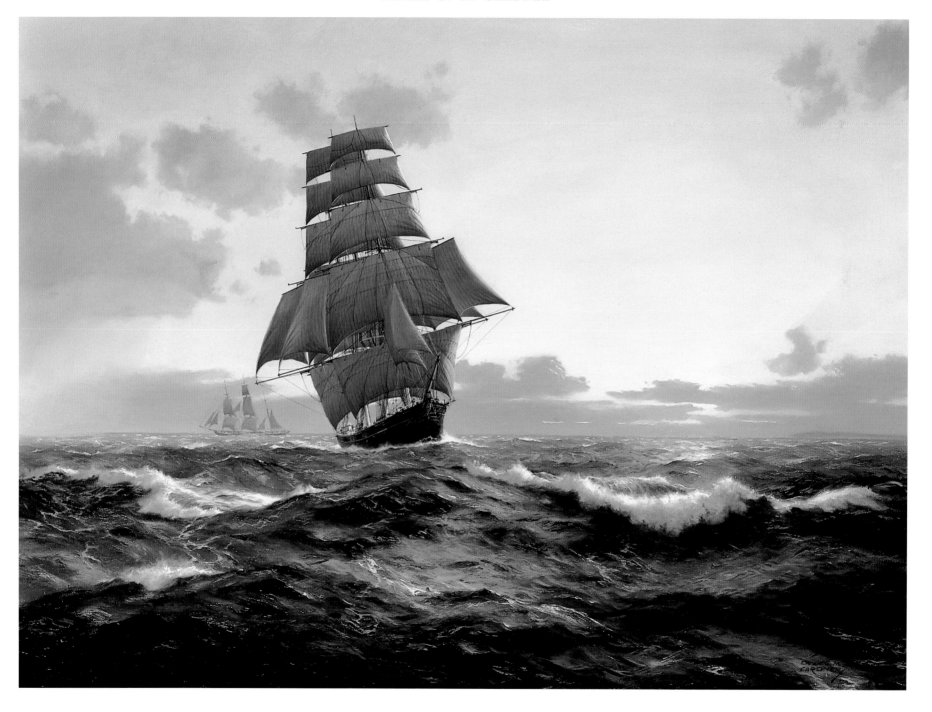

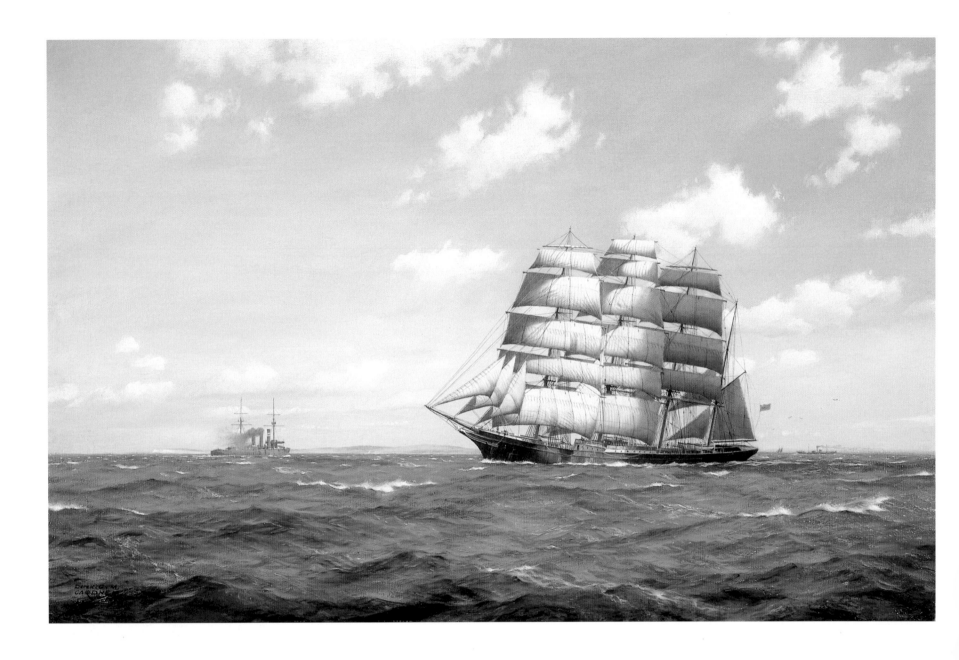

Opposite page:

A Salute For A King's Ship.

Oil on canvas, 24in x 36in.

The lowering of the national flag as a mark of courtesy shown by merchant ships to warships is a consequence of a much older ceremony whereby all such vessels were required by law to strike and lower one or other of their sails when passing or in proximity to a King's ship. Such an ordinance was enacted as long ago as 1201 by King John, and for centuries was rigorously enforced in the Narrow Seas which extended as far south as Cape Finisterre. King's Regulations stated:

'When any of His Majesty's ships shall meet with any Ship or Ships belonging to any foreign Prince or State, within His Majesty's Seas, it is expected that the said foreign ships do strike their Topsail, and take in their Flag, in Acknowledgement of His Majesty's Sovereignty in those Seas ... and if they shall refuse ... to compel them thereto ...'

This requirement applied also to any of His Majesty's Subjects – in other words to English merchant vessels.

After Trafalgar when British naval power was supreme, it was felt that no loss of prestige could arise if the requirement insisted on for so many centuries was quietly dropped. The old courtesy lived on, however, and even today merchant ships both British and foreign lower their ensigns to Her Majesty's Ships which then return the salute by lowering theirs.

Here a four-masted barque lowers her flag to a cruiser heading up towards Portsmouth off the Isle of Wight in the early years of the twentieth century.

Above right:

Better Weather Ahead.

Oil on wood panel, 7½in x 10in.

This is the *Waimea*, built at Hamburg in 1868 as the *Dorette*. She was bought by the New Zealand Shipping Co. in 1874 for their

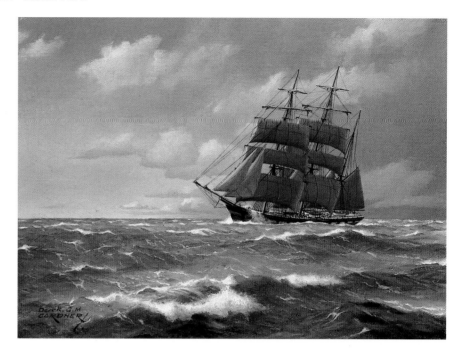

trade between London and New Zealand. She was originally a full-rigged ship, but, no doubt for economic reasons, her mizen yards were later removed and it is as a barque that I have shown her in this small painting. She was the smallest ship ever owned by the company and made more than twenty voyages to New Zealand before being sold to Norwegian interests in 1895.

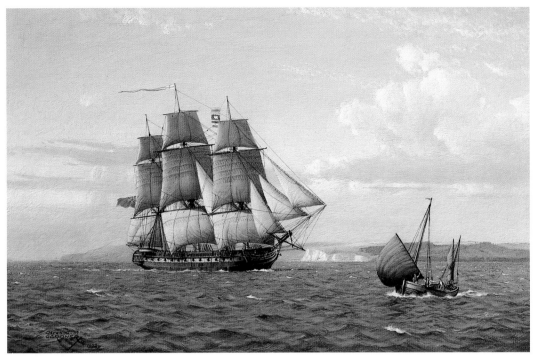

Left:

The *Active*, 38-gun Frigate, 1799.

Oil on wood panel, 11½in x 18in.

The heavy 38-gun frigate *Active* was launched at the Royal Dockyard at Chatham in December 1799. Armed with twenty-eight 18pdr guns as her main upper-deck battery, with 9pdr guns and 32pdr carronades on the quarterdeck and forecastle, she was one of the most powerful frigates in the Royal Navy of her day. I have shown her as a new ship approaching Portsmouth off the eastern end of the Isle of Wight. She spent the greater part of her war career in the Mediterranean and Adriatic, an outstanding action being with Captain Hoste's squadron off Lissa in 1811 when four British frigates defeated a far stronger Franco–Venetian force of six frigates and several smaller war vessels.

Opposite page:

The *Ville de Paris*, 110 Guns, in Tor Bay, 1805.

Watercolour, 13¾in x 20½in.

At the time of her launch in July 1795, this magnificent three-decker was the largest ship in the Royal Navy. A First Rate of 110 guns, her keel was laid at the Royal Dockyard at Chatham in 1789. It has long been the custom in naval affairs to name new ships from time to time after those of former enemies captured in battle, and the naming of this ship commemorated the surrender to Admiral Rodney of the French flagship at the Battle of the Saintes in 1782. Although the *Ville de Paris* was not present at any of the great sea battles of the French wars, she was the flagship of Admiral Lord St. Vincent in the Mediterranean and later of Admiral Cornwallis from 1803 to 1805 when he was Commander-in-Chief of the Channel Fleet blockading Brest. The ship is seen here in the fleet anchorage in Tor Bay with Cornwallis's white Admiral's flag at the main masthead in March 1805.

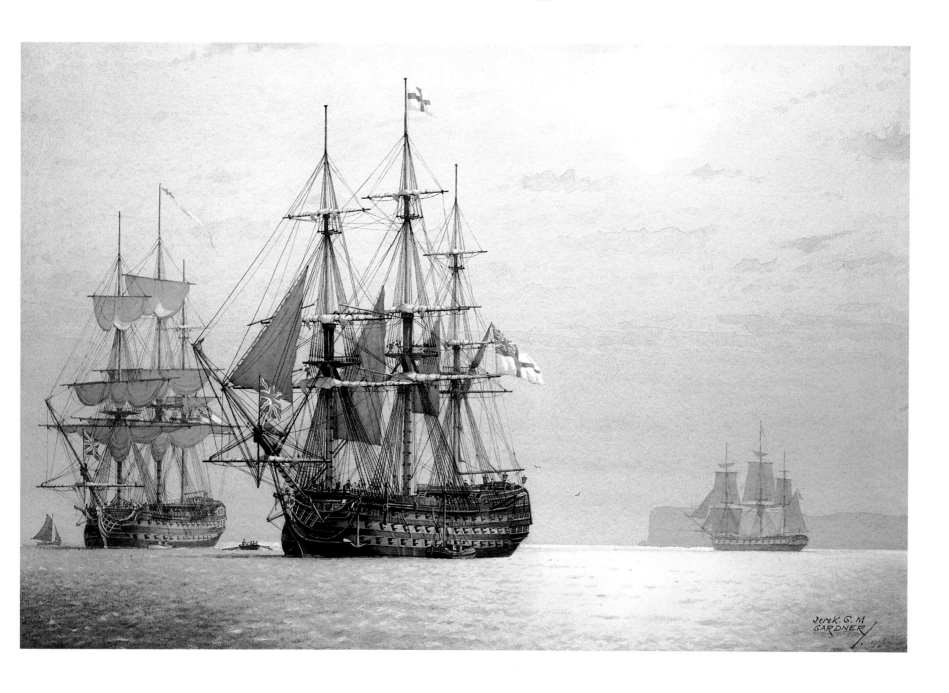

JOHN MICHAEL GROVES
RSMA

Some people have been kind enough to call me a fine artist. I have always called myself an illustrator. The difference (if there is one) does not concern me. All I know is that whatever type of work I do, I try to give it my very best. Art has been and always will be my life.

Being involved with historical subject matter and with recreating the past, I am dealing with something that I have not seen or experienced, only read or researched. This is where the imagination comes in. *Imagination* is the prime ingredient; research and knowledge of history gathers the building-blocks, then the creative process begins. I have to imagine myself *there* in whatever situation is being portrayed, transcending the disadvantages of not having been present at Trafalgar with Nelson, or rounded the Cape with Vasco da Gama, or fought alongside the Saxons at Hastings.

Much emphasis is placed on authenticity (when considering historical subjects) which is fine, but my first considerations are mood, spirit and good strong design. The artist whom I admire for combining these so superbly, is the fine historical painter Fortunino Matania; his wealth of period detail combined with beautiful drawing and colour and composition, and in his early and best work that wonderful evocation of another time, another place, leaves me with my feet very firmly on the ground when looking at my own work. There are many others who serve as guide and stimulus. The artists of the golden age of illustration, the great marine painters of the past and not so distant past who actually worked in sail, all furnish good references as to how sailing ships behaved at sea.

I have from time to time crewed traditional craft, from ketch to schooner, two- and three-masted topsail rig, and square rig brigantine, for periods of one week to four. This does give one a feel of what it is like to sail these vessels in good and bad weather. I felt that I needed this experience in order to have the understanding of what I wished to paint, even though I suffer from seasickness – an ailment that is not considered by skippers and their mates sufficient to stop one from carrying out one's various duties while on board.

Most of my work is commissioned. I like the challenge, and of course one knows that there is definite money at the end. Sometimes one is asked to repeat a certain painting. The challenge is to capture the essence without repeating the composition, and keep the client happy. Then again one will get a request for a subject that one has not painted before, which may involve fresh research that very often opens other doors to new subjects.

If the subject is complicated, or something I have not tackled before, or it is a very large oil painting, I work on sketches in pencil or charcoal and then occasionally a colour rough. Some clients like to have an idea of what one intends to do, particularly if they are paying a tidy sum. I also like to see what I have in mind before putting brush to canvas; otherwise I work straight on the finished picture with the pleasure and excitement of seeing it develop.

Between commissions I work on my own ideas. I might have a bee in my bonnet about a particular subject so I sketch the idea while it's fresh in my mind, maybe for use at some future date, sometimes in colour but mostly black and white, in charcoal, a lovely medium for roughs.

I love to incorporate figures in my pictures, close up, or in the background. They give a sense of life and meaning; sailing vessels of whatever type were never so big that life could not be detected aboard somewhere. My figures are usually straight out of my head. I might draw from the mirror for details of hands, drapery and action. There are times when a figure drawn without a model is more convincing. I do collect from newspapers, magazines, etc., facial expressions and interesting poses, to use, not copy. I have never yet found a photograph of a pose or facial character that I

could use directly, but sometimes I have found a character that I could use, male or female and children from my portfolio of portrait drawings done over the years.

My interest in things military, and period costume and fashion has proved invaluable on many occasions, for example when incorporating figures in my marine painting. In painting the Battle of the Svöld, it was helpful to know the type of weapons that would have been used at that period, the painted designs on the shields, and the important fact that not everyone wore a mail shirt: and although I show only one man armed with a sling, it was widely used because of its simplicity, cheapness, and its deadly effectiveness. Then again, the variety of clothing worn by the different classes in an oil painting of a crowd on the quayside, watching and seeing off friends, relatives, etc., to the New World, in Tudor times. It is not always enough just to go to a museum or look at books; like the business of understanding sailing vessels, it is a long process of acquiring knowledge over a period of years, and there is always more to discover and learn if one covers a wide field of history as I do. Covering a wide field means it is highly unlikely that one will ever be an *expert*, but then I have always had trouble with that word.

Left:

Part of a charcoal sketch showing a Second Rate of the early nineteenth century, taking in stores.

Right:

Lure of the Sea.

Pastel, 11in x 8in. (Private collection}

The ports of bygone days must have attracted like a magnet many young men and boys of an adventurous spirit, with their sights and sounds, and ships that were leaving for or arriving from far-away places.

To sum up; the last twenty years have been great fun and I have met a lot of very interesting and nice people. Long may it continue, until that final moment when I pitch over the side of my easel like a mast shot through at the base, and ascend to that great studio in the sky.

I should like to thank all those customers who lent their paintings and a very busy photographer, Bob Cotton; for their patience, enthusiasm and help in enabling me to put together my section of this book.

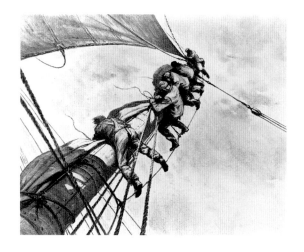

HEAVY WEATHER

Above:
Charcoal drawing of men taking in sail on the yard of a steel ship of the 1920s.

Left:
Hoisting the Upper T'Gallant, 1900s.
Pastel, 13½in x 23in. (Studio collection)
Much of the very heavy work of 'pulley-haul' aboard a ship of this period might be alleviated by taking a halyard, sheet, or brace to one of the capstans fitted on the main deck.

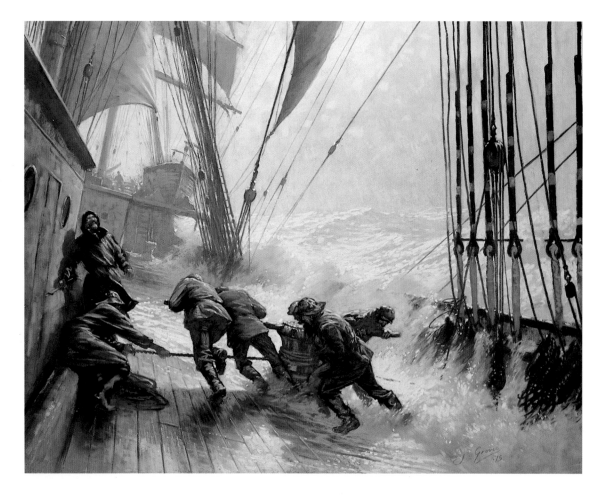

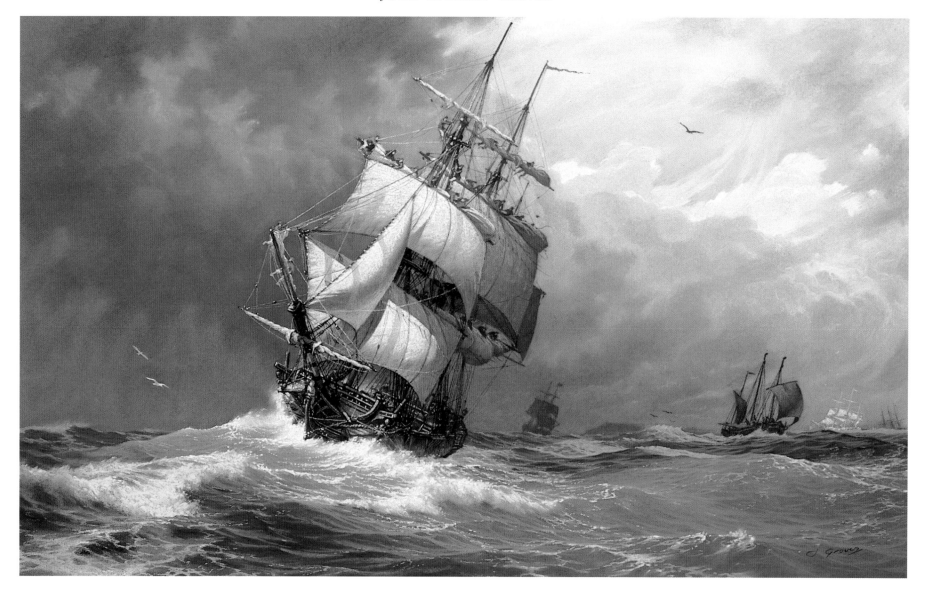

Above:

Gale Coming On.

Pastel, 20in x 30in. (Private collection)

In an advancing gale a merchant ship of the late eighteenth century shortens her sails. The sails were shortened with the aid of reef-points: lengths of rope spliced each side of the sail through stitched holes in reinforced bands of two or three strips across the sail, to enable the sail to be rolled or folded and made fast to the yard so as to expose a smaller area to the wind.

Right:

Launching the Lifeboat, 1890.

Oil on canvas, 12in x 20in. (Private collection)
Until the advent of tractors, which could take lifeboats into the sea, horses' or men's muscle helped to launch many lifeboats, but by 1937 the last horse-drawn lifeboat had been withdrawn from service.

Below:

Dawn: Wind Easing.

Pastel, 13½in x 23in. (Studio collection)
Three men of the watch in an 1880s square-rigger grab the lifeline, or make for higher ground as a sea breaks over the rail. A man could easily be lifted bodily off the deck and swept over the side like a piece of flotsam.

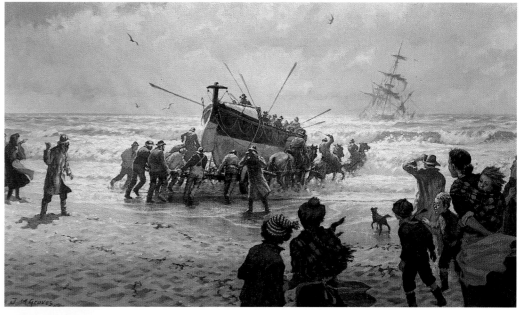

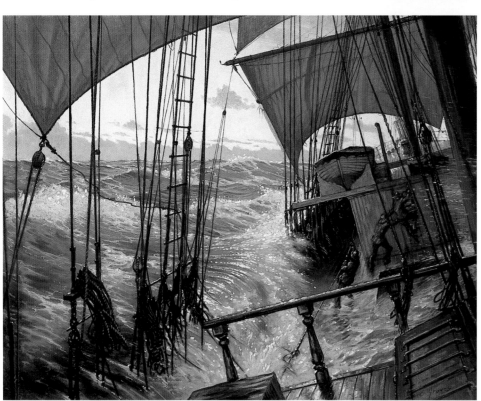

THE SAVAGE SEA

Right:

South West Coast.

Pastel, 20in x 30in. (Private collection)
After several weeks of overcast and stormy weather, making for the English Channel, unable to fix her position and relying on dead reckoning, pushed sideways by currents or the general scend of the sea, this ship came off course and, like so many others, one dark and stormy night found herself embayed on the coast of Cornwall, with every possibility of no survivors among the crew.

Quite a number of people are uncomfortable with this picture. I guess it is because it shows a side of the sea they do not wish to be reminded of.

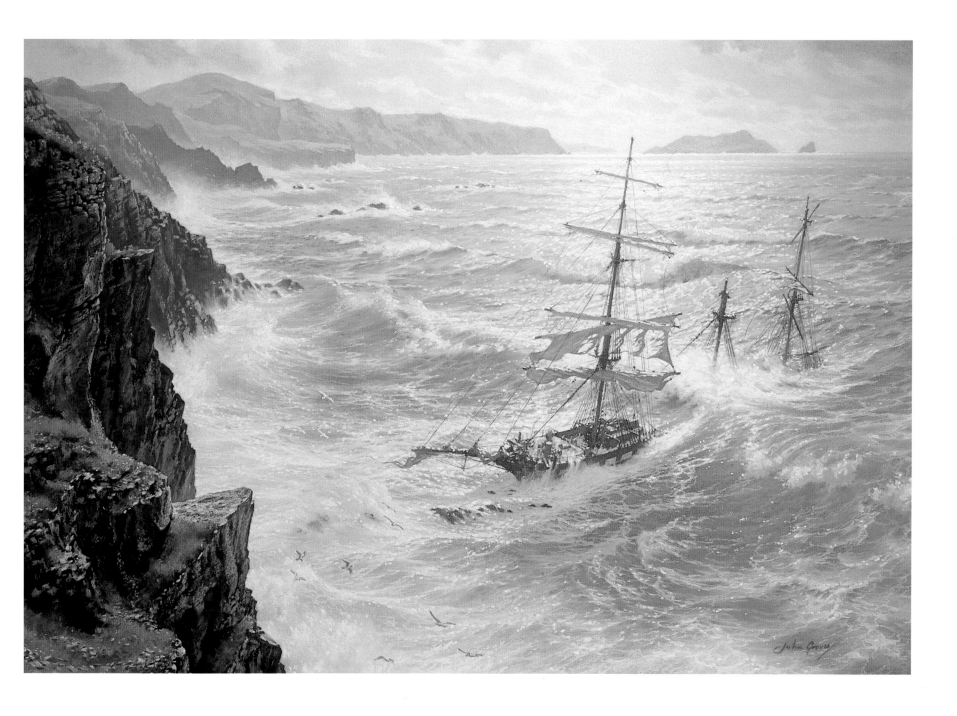

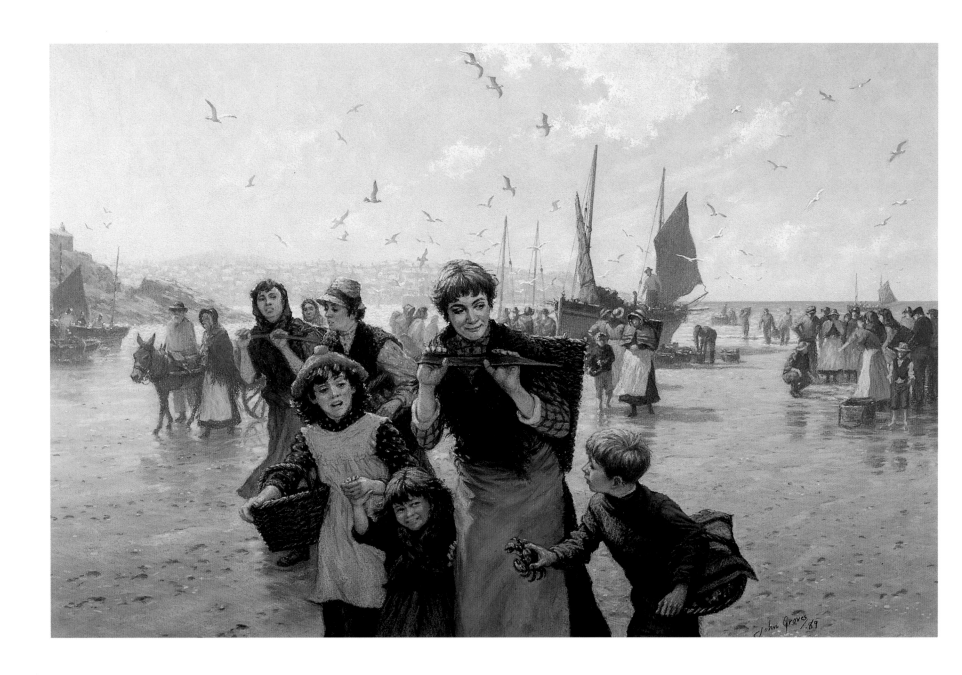

ON THE FORESHORE

Opposite page:

A Good Catch.

Pastel, 15in x 23in. (Private collection)

Some fish was sold locally by retailers who worked direct from the foreshore where the fish was landed. This St. Ives woman with her family is a fish 'jouster' or seller. She carries a wicker basket called a cowal supported by a band. Like others, she would roam the streets and hawk her wares with the aid of leathern lungs.

She would knit while waiting for the fishing boats to come in, a continual occupation between other tasks for the women of the fishing communities.

Right: Pencil and red chalk drawings of characters from my portfolios, that I can sometimes use in my pictures.

Below: Charcoal sketch of fishing luggers lying on the beach at Brighton.

Below:

Hastings, 1850s.

Pastel, 15½in x 25in. (Private collection)

In the nineteenth century not only small fishing boats were beached. Where there was no harbour to speak of, merchantmen with all kinds of cargoes came ashore at the top of spring tides, discharged their cargoes on one tide and hauled off on the next. The great danger of beaching was a strong on-shore wind which could mean disaster, unless the vessels were small enough to be hauled up on to the beach. It was just this sort of situation which ended the practice of beaching at Hastings in 1879 – and earlier at other places.

The painting shows a 'brig' discharging coal into horse-drawn carts belonging to the local coal merchant. A team of horses stands by to assist each cart up the sloping shingle beach.

Opposite page:

Scarborough: The Herring Season.

Pastel, 18in x 30in. (Private collection)

The great fleet of herring drifters has arrived with their catch at Scarborough. The quaysides bustle with activity: on the boats the baskets are filled from the holds then hauled up on to the quay, where the men empty their contents into large rectangular wooden tubs or troughs set up on the quays. Women would gut and salt down the fish and pack them into barrels. Working on piece rates in teams of three in all weathers, they could deal with about 3,000 fish in an hour.

The women, or 'fisher girls' as they were called regardless of age, were Scottish; they worked their way round the coast in the wake of the herring fleets. Tough, and often good looking, they added a colourful element to the scene.

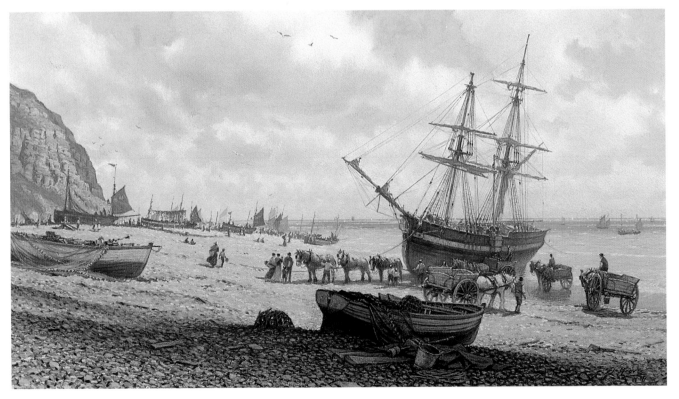

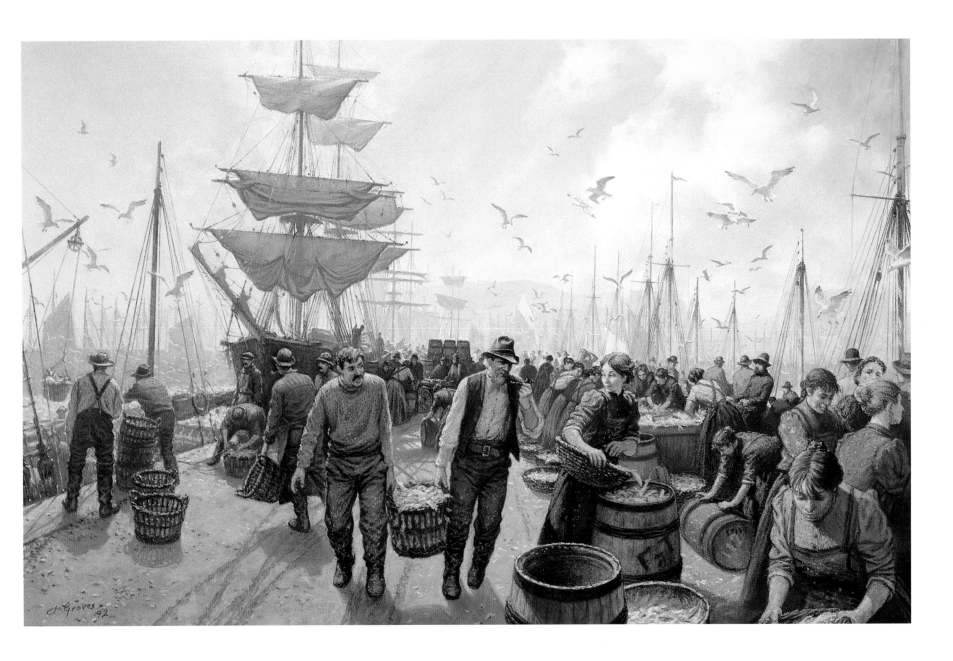

DAYS OF ADVENTURE

Below:

The Sheba Queen.

Pastel, 20in x 30in. (Private collection)

John Rackham, known as Calico Jack for his costumes of colourful cotton, together with the female pirates Anne Bonny and Mary Read, who sailed with him in the 40-gun *Sheba Queen*, came up against two Spanish men-of-war sent to capture or sink them, because of their persistent attacks on Spanish merchant shipping. The action was close and destructive, the Spanish receiving the worst of it. During the action Bonny, being of a fierce and courageous nature, leaped into the main shrouds, exposing herself to the fire from the enemy ships, to cheer on the upper deck gun crews.

Opposite page:

The Taking of the French Guinea-Man, 1717.

Pastel, 20in x 31in. (Private collection)

Edward Teach, better known as Blackbeard, was cruising in the West Indies when a fine large French merchant ship of 40 guns was sighted. Blackbeard made for her although his ship was the smaller in size and fire power. The ships exchanged broadsides, until the pirate ship putting her wheel hard over brought her bow into contact with the Frenchman's fore chains, tangling the rig of the two ships together. Then with a roar which struck terror into the French crew, the buccaneers swarmed up and over with boarding pike and cutlass on to the deck of the Frenchman who quickly surrendered. Blackbeard took this ship for himself and renamed her *Queen Anne's Revenge*.

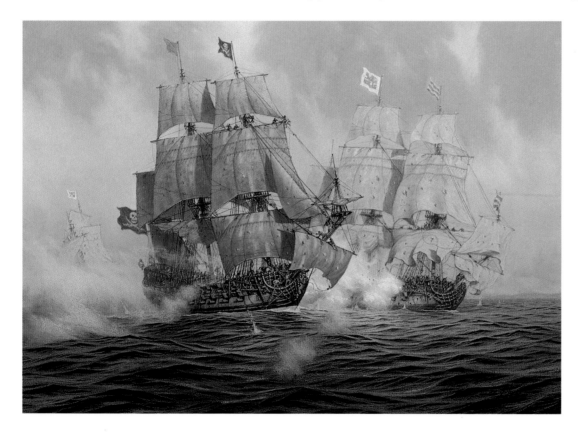

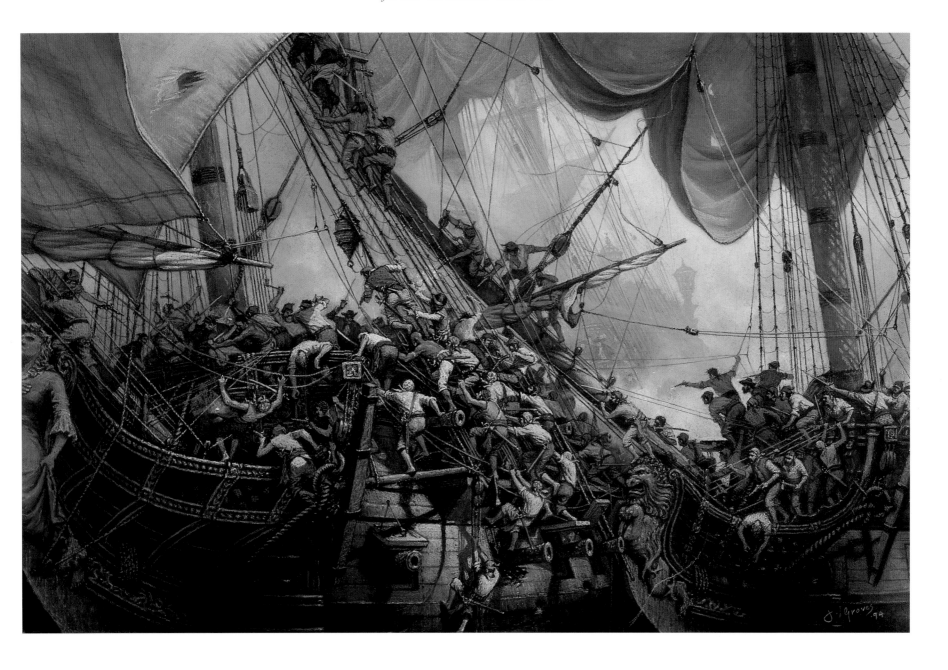

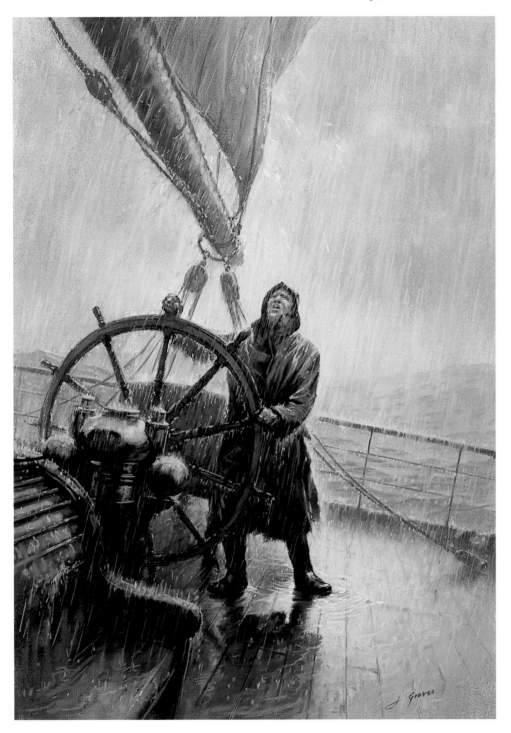

THE HELMSMAN

Left:

No Wind.

Pastel rough, 13½in x 23in. (Studio collection)

Those of us who have done some cruise sailing have been here before in whatever type of sailing craft. Heavy rain knocking the breath out of the wind, a heavy swell, the deck canting, the boom swinging to and fro over one's head, the gear banging and clattering, and the sound of swearing from the galley.

Below:

Easy Sailing.

Pastel, 16in x 22in. (Private collection)

A bright breezy day, no great pressure on the rudder, the helmsman can relax, though still keeping an eye on the course and making sure the sails are drawing well.

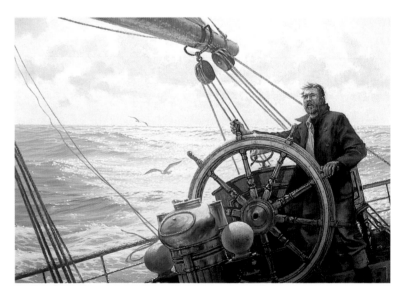

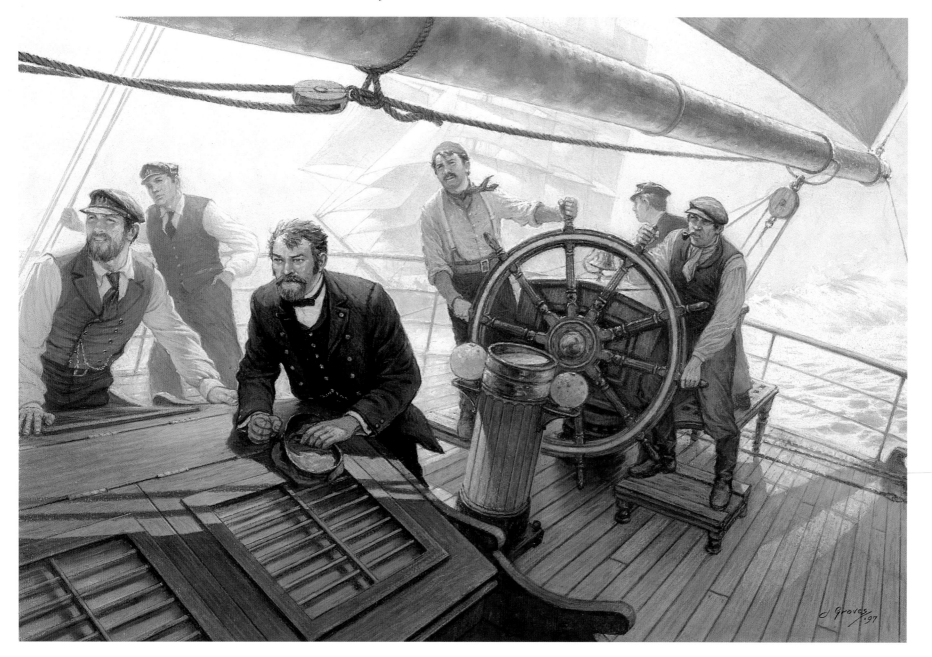

Sail.

Pastel, 20in x 30in. (Private collection)

The owners of these magnificent ships drove their captains who in turn drove their ships and crew hard. Speed was of the essence, whether the cargo was perishable or not. It was a case of first home, bigger profit for all, except perhaps the deck hands.

BOUND FOR THE BLUE WATER

Below:

On Tow.

Pastel, 8½in x 12in. (Private collection)

A barquentine is being towed out of port on a misty, windless early morning, in the hope that she may catch some light airs farther out to sea.

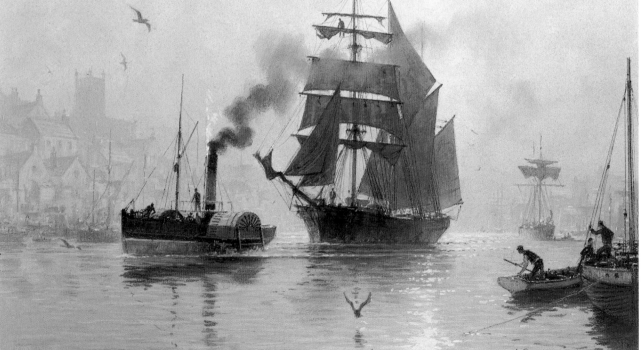

Above:

Charcoal sketch for an oil painting of the traditional massed manpower needed at the capstan to haul the vessel up to her anchor then break it out and bring it to the waterline, whence it was raised to her forecastle head by a tackle or an anchor crane. Very often the work was accompanied by an appropriate shanty. 1880s.

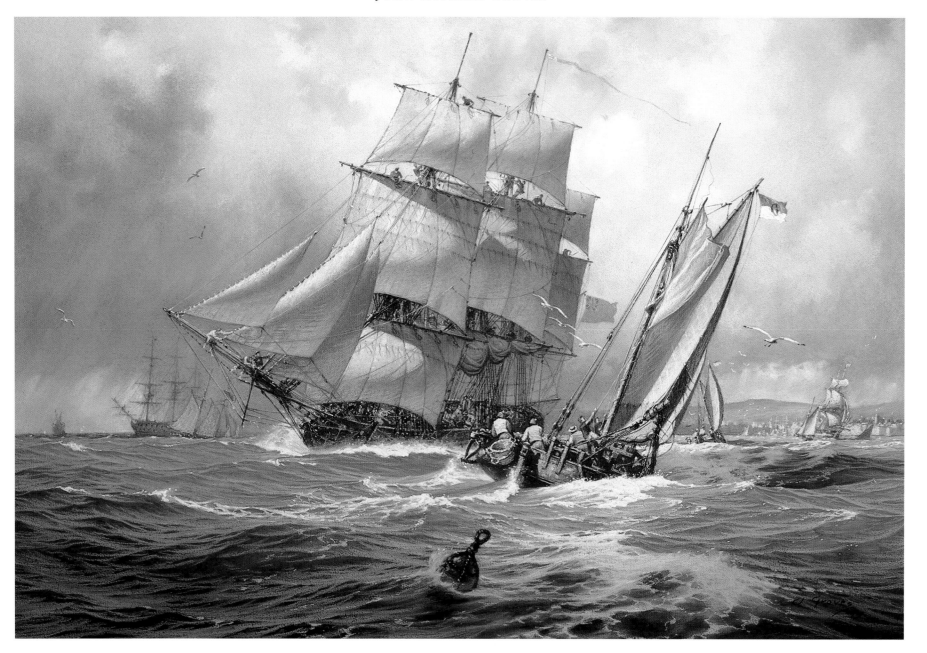

A King's Ship.
Pastel, 20in x 30in. (Private collection)
A corvette, nearly all plain sail set, beats out of the Solent against a background of a passing squall over Portsmouth, during the wars with France. She is a flush decked vessel of war with one tier of guns, small and fast, and designated as a naval escort.

THE DUTCH

Below:

Battle of Terschelling, 1666.

Pastel rough, 13½in x 23in.

This was one of three colour roughs for a 36in x 60in oil painting on canvas commissioned by Shell, for the new Shell building in The Hague; showing English fireships and longboats with sailors, grenadiers and troopers of The Duke of York and Albany's Maritime Regiment of Foot, (the ancestors of the modern Marines), destroying a fleet of Dutch merchant ships. This successful raid was in part responsible for the Dutch attack on the Thames the following year.

Opposite page:

Dutch East Indiamen Making Sail.

Pastel, 20in x 30in. (Private collection)

A small fleet of ships of the Netherlands East India Company preparing for sea. They are bound for their trading stations in South East Asia, and are being seen off by relatives, friends and trading partners.

The first stop will be Cape Town, where some of the passengers will join the growing settlement, and supplies of fresh vegetables and fruit will be taken aboard for the next stage of the voyage across the Indian Ocean to the Malay peninsula and the Spice Islands; and maybe on to the China Sea and Japan.

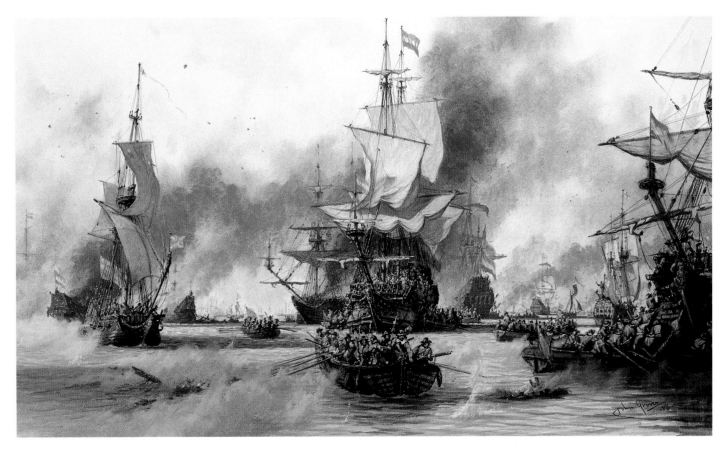

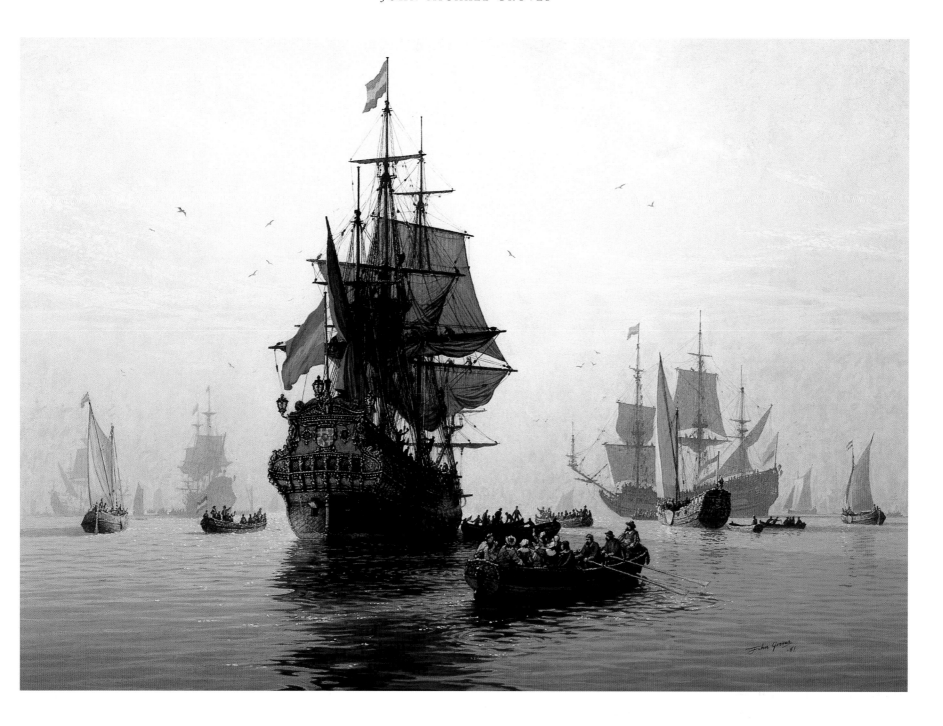

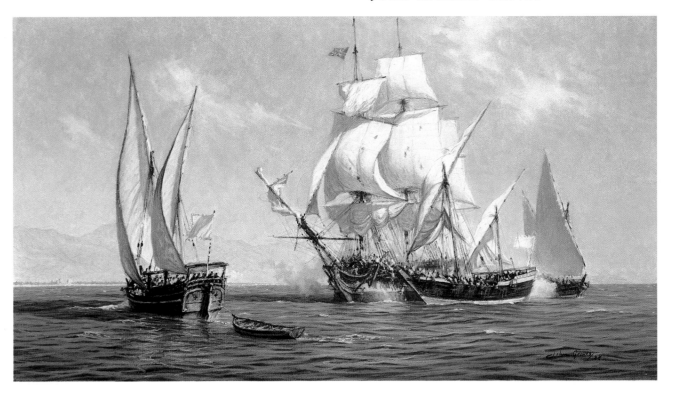

Opposite page:

Muscat, 1900.

Pastel rough, 13½in x 23in.

(Private collection)

This was for a 36in x 60in oil on canvas, commissioned by Shell for the King of Oman, depicting the old port of Muscat as it appeared at the turn of this century. The two forts at each end of the crescent-shaped bay were originally built by the Portuguese late in the sixteenth century. The buildings along the edge of the bay were the beautiful European embassies with the original King's palace at the northern end. The nearest building, left of the sand

DHOWS: SAUDI ARABIA

Above

The Straits of Hormuz.

Pastel rough, 13½in x 23in. (Private collection)

This was one of three colour roughs for a 36in x 60in oil on canvas, commissioned by Shell for the King of Ras al Khaimah, of the United Arab Emirates.

The east Indiamen which traded in the Persian Gulf were frequent targets for the fleets of pirate dhows that gathered around these coasts, one of their main centres being Ras al Khaimah.

Right

Study of Boom Dhow.

Coloured pencils on tinted paper, 12in x 20in.

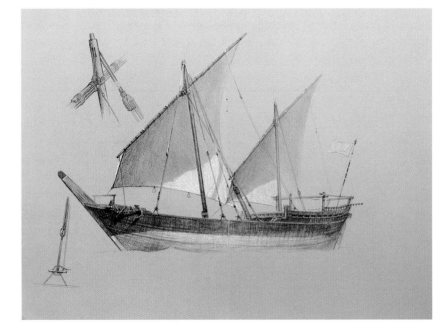

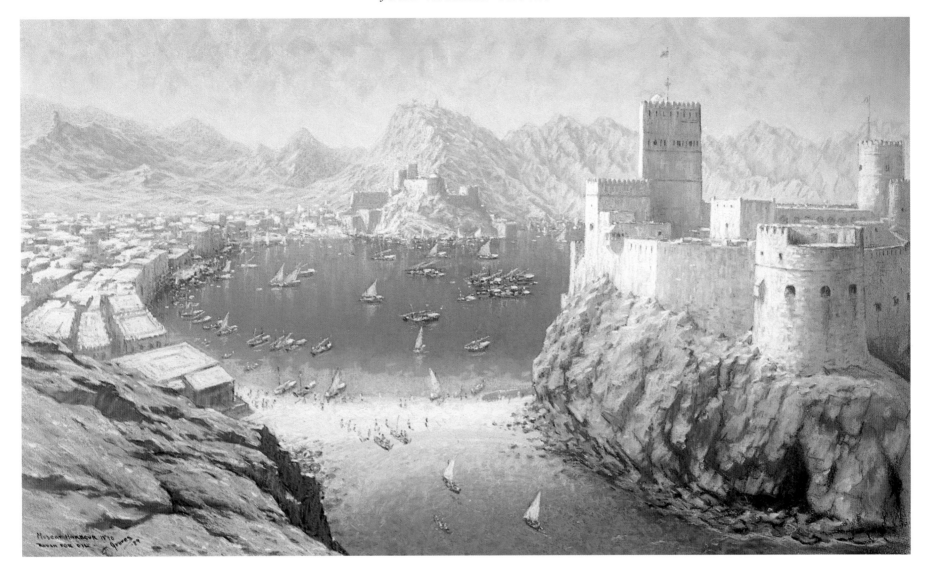

spit, was the British embassy. I was not to put in any of the European flags that would have been visible at that time.

As is very typical of this kind of commission, I could not go there for various reasons, so my main references were a sharp, detailed aerial photograph, 10in x 6in, taken from the opposite side they wished me to paint, and a small colour slide which gave me the colour of the rock out there. My knowledge of fortress architecture was of help.

THE VIKINGS

Opposite page:

The Battle of the Svöld, AD 1000.

Pastel, 15½in x 25in. (Private collection)

The Christian King of Norway, Olav Tryggvesson, with a great fleet, led an expedition to regain his wife's lands from the Wendish King Burislav. He was waylaid off the island of Svöld, near Rugen by the combined Swedish and Danish fleets. The battle ended in the annihilation of the Norwegians. Olav fought to the last in his great vessel the 'Long Snake' (see in the centre background) the mightiest ship in the North, and finally leapt overboard and drowned.

Below is the left-hand part of a charcoal sketch depicting the ambush of a Viking raiding party on the beach near the present Portsmouth. King Alfred had a fleet of ships built to repress the ravages on our coasts by the Danish hordes. On this occasion he landed a small fleet unobserved a little way up the coast, and caught the returning Danes who were laden with booty.

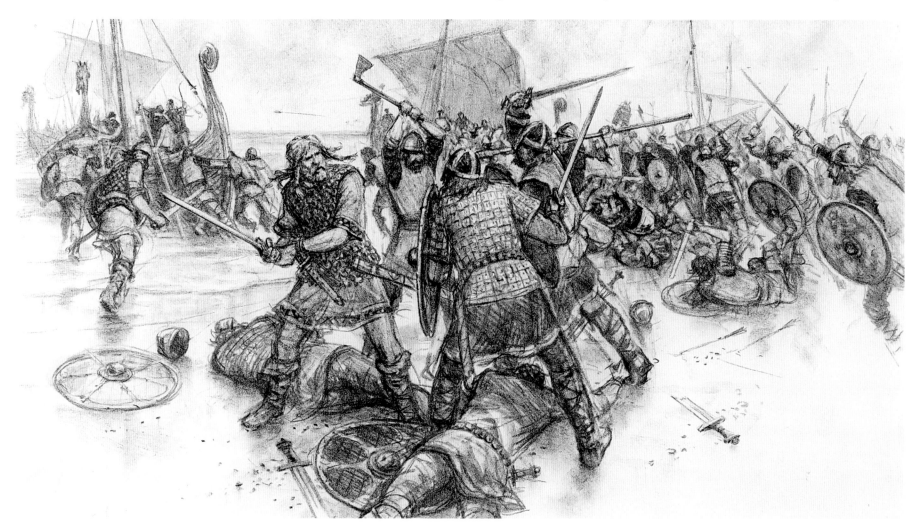

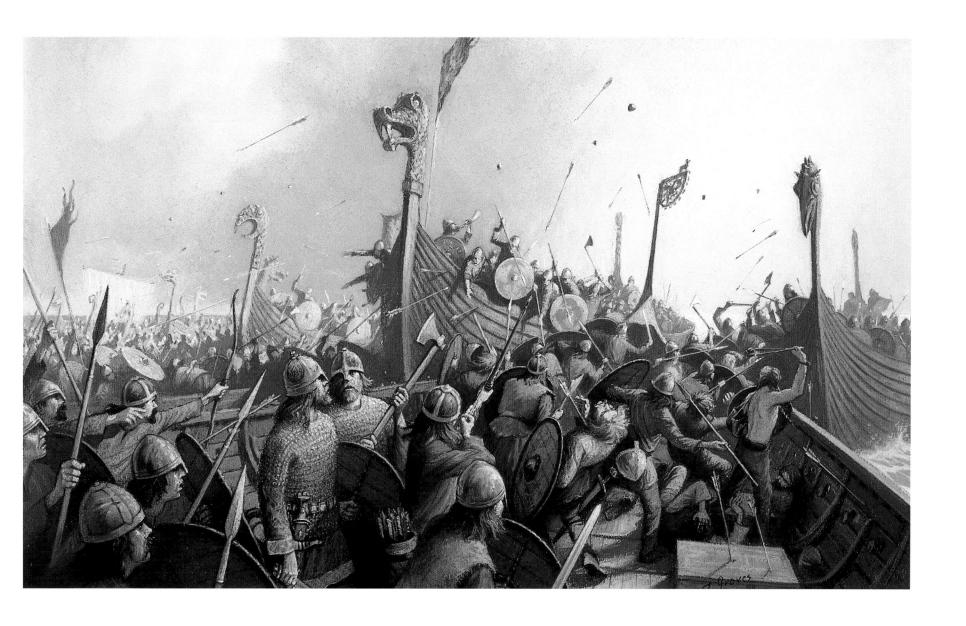

BEAT TO QUARTERS

Below:
A King's Ship: a Sighting.
Pastel, 15½in x 25in. (Private collection)
A ship-sloop of war while on patrol in the English Channel has just come about after sighting a strange sail on the horizon. She closes to investigate.

Opposite page:
Crescent and Réunion, 1793.
Pastel, 20in x 30in. (Private collection)
The 36-gun frigate *Crescent* in action with the French frigate *Réunion*. The English ship lost her fore topmast early in the action, but shot away the Frenchman's fore yard and mizen topmast. After two hours of close-quarters fighting *Réunion* struck her colours with heavy casualties; astonishingly, *Crescent*

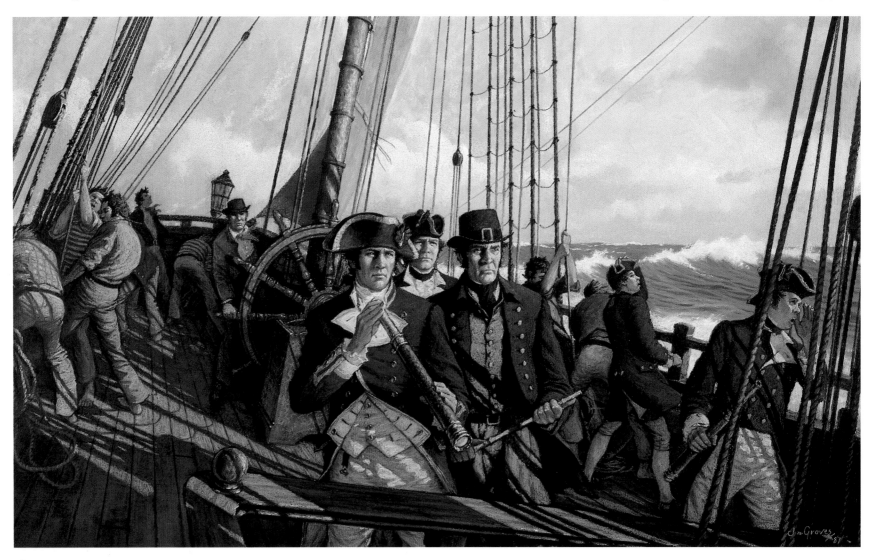

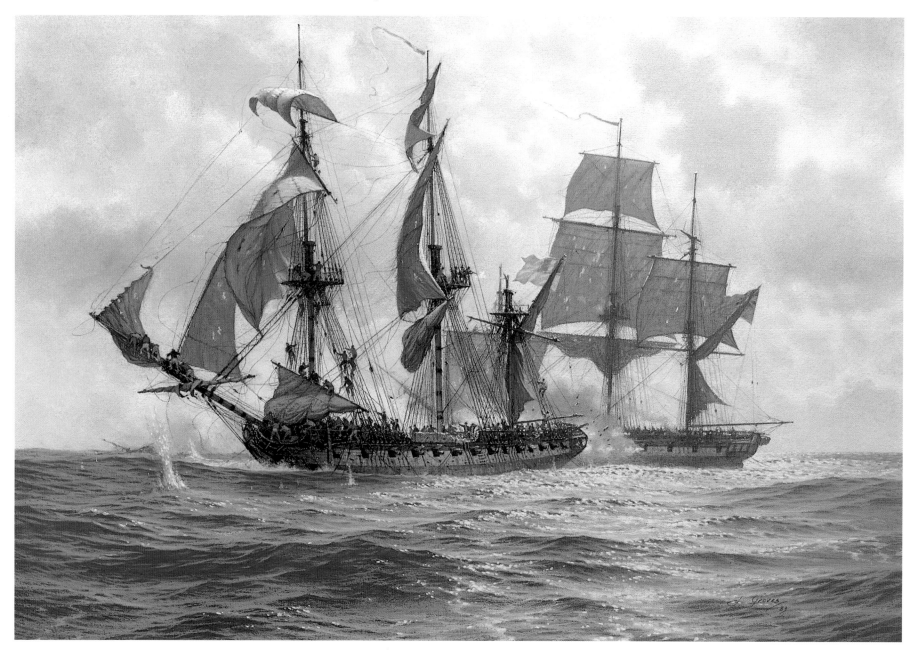

had only one man injured. The English Captain James Saumarez was knighted following the ship's return to Portsmouth with her prize. The French frigate's ensign is the design which preceded the present tricolor.

Below:
This is a close-up of a long charcoal drawing of the Battle of Cape St. Vincent in 1797 and was drawn in the early 1970s. Parts of it are not accurate, but I have included it to show the lengths to which I am prepared to go when painting a large canvas of a fleet action.

Opposite page:
Trafalgar, 1805.
Oil on canvas, 36in x 60in. (Private collection)
Of all the big important battles under sail, I suppose Trafalgar with Nelson's *Victory* breaking the line must be the most painted, and one would think by now that every possible viewpoint of that dramatic scene had been covered. So on receiving this commission from Shell, I was, as with a smaller Trafalgar painted in the early 1980s, determined to make it mine; all part of the challenge.

After five days of sketching and brushing away visions of those wonderful scenes painted by W. L. Wyllie and many other favourites, I was on the verge of giving up any idea of originality when something clicked; here at last was the germ of an idea which, as I worked at it, developed into, as far as I can tell, an accurate and telling original representation.

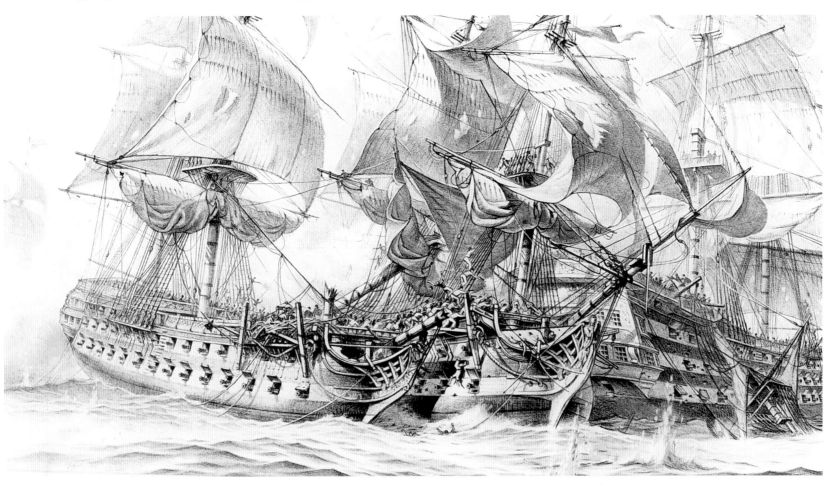

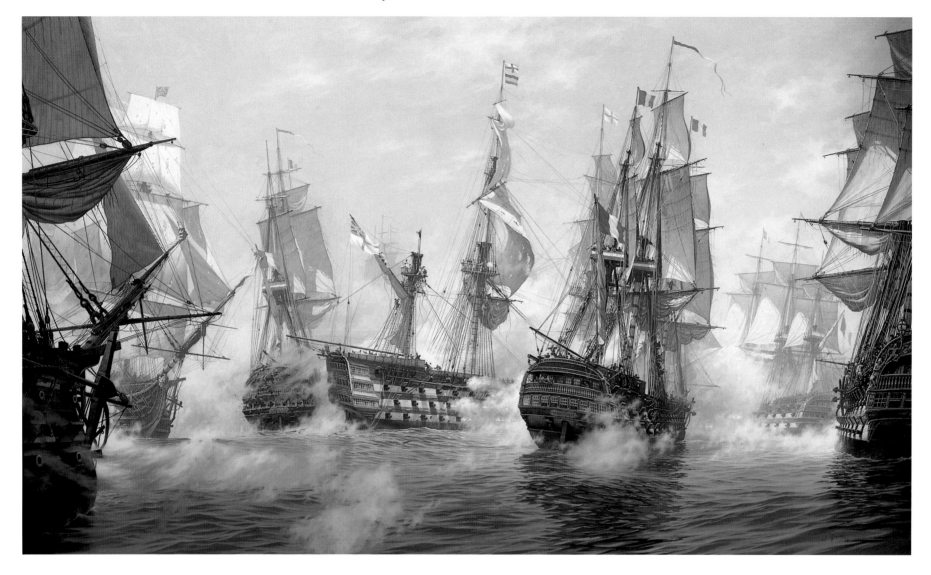

The disposition of the ships I have taken from the bird's-eye view of 'Trafalgar: Breaking the Line', painted by Nicholas Pocock (1740–1821), the most accurate of all the representations.

My painting shows the action at 12.55 p.m. Starting from the left: the Spanish *San Leandro*: just showing; *Temeraire* beginning to fire into the stern of Admiral Villeneuve's flagship *Bucentaure* that has just received the devastating broadsides of the *Victory*, which has lost her mizen topmast; flying the flag of Vice-Admiral Lord Nelson at the fore, and the signal for close action at the main, *Victory* is engaging the *Redoutable* whose crew are the best trained in cutlass and musketry in the entire enemy fleet – one of them killing Nelson with a shot from the mizen top; then *Neptune* firing her one and only broadside into the bow of *Victory*; finally the Spanish *San Justo*.

GEOFF HUNT
RSMA

I don't know where my fascination with ships originated, a fascination which I appear to share with a fair proportion of the population, although I do know that it has been with me since earliest childhood, and that I have drawn and painted these remarkable creations for as long as I can remember. As a marine artist, one is often expected to have some sort of family history demonstrating a maritime heritage. I think that the second mate of the clipper *Maju* (lost with all hands on her maiden voyage in October 1874) was probably a distant relative of mine, but that is a tenuous enough connection and no more than many other people could claim, very few of whom have become marine artists. This effort to trace some mystical link with a maritime ancestry may be misplaced. Probably the fascination with ships and the ability to paint them is no more than the product of the genetic scrabble which creates everything else about us. The true magic, the incandescence when something far off in time or space seems suddenly real, is to be found in the subject itself.

For nothing can quite match the electrifying instant when historical research jumps into life – such as when, while reading the manuscript log-book of a certain warship for 1801, I realised that another hand had just taken over the quill pen, a much more forceful and decided hand than the previous writer's. It belonged to her newly-appointed captain – none other than Captain William Bligh, *the* Captain Bligh, late of the *Bounty*, and clearly in characteristically assertive mood. Such moments bring the buzz, the electricity, the vivid flash of images before the mind's eye. Or take the story from James's *Naval History,* which I stumbled on purely by chance, in which the frigate *Terpsichore* took on the battleship *Santisima Trinidad*. After reading a few words of this account, the finished painting jumped into my mind virtually complete. Such moments of revelation keep me going. They continue to make these subjects so fresh in inspiration, and so compelling to paint.

To the art establishment, marine painting is an unfashionable genre – so unfashionable that it has dropped completely below the horizon of critics' awareness. Yet for all that it continues to fascinate its practitioners and there seems to be no shortage of appreciative buyers for this art. There is often the notion that it is wholly derivative, wholly a pastiche. But although we are representational artists we do not generally approach our work in the spirit of former ages. We see through twentieth-century eyes. We have at our disposal the visual language of photography and the cinema; we are aware of other art; and consciously or unconsciously our work reflects these new influences. Furthermore, in any age the marine painter, the ship portraitist, unlike the portrait-painter or the still-life painter, has very rarely worked from the subject. Ships are large moving objects in a difficult environment; the marine painter therefore has always had to work at a distance from his subject, merging his personal experience of the sea with reference sources of the ships he wishes to depict. These factors are worth further comment. As far as experience of the sea is concerned, the marine painter is dealing with ever-present realities – with wind, weather, light and the changing sea. To those who sail, many of the concerns of the mariner of any other century are instantly comprehensible. The sailor's world, the rough and wet interface between the atmos-

phere and the ocean, is still elemental. Sailing ships of whatever size or century, from Hanseatic cogs to Whitbread racers, have always rolled, pitched and heeled, and their builders and crews have always tried to make the damn things go better upwind, or faster downwind, or ride the sea more easily. The universality of this experience makes much of the artist's involvement with past subjects as legitimate as with contemporary subjects.

And because the marine artist must work at a distance, dependent upon his reference sources regardless of what he paints, an historical source can be as valid as a modern one. Engravings can convey as much information as photographs (or even more, if your engraver is someone like Cooke or Baugean); a log-book is as good as a documentary; and plans are reasonably dependable in any age.

I have been involved for much of my painting career with publishing, both as a book illustrator and as a book designer and typographer. I worked for some years as a freelance designer for Conway Maritime Press, a fascinating period which brought me into close contact with the academic side of the marine world. The high point of this was perhaps the wonderful experience of designing John Harland's *Seamanship under Sail*, an encyclopaedic work illustrated with hundreds of drawings by Mark Myers. My copy of this book, like so many others from the same publisher, I have used as reference so intensely and incessantly that it can only be described as distressed. Indeed the output of marine specialist publishers over the last twenty years has been a revelation, and I am indebted – we are all indebted – to the constellation of talented researchers who have done so much to illumine the world of the square-rigged sailing ship. I mention particularly Jean Boudriot, Howard Chapelle, Robert Gardiner, John Harland, Brian Lavery, James Lees, David Lyon and David MacGregor, and beg the forgiveness of those I have not named.

Right:
Mediterranean deployment: USS *Ontario* leading Decatur's squadron, 1815.
Oil on canvas, 18in x 27in.
(Private collection)
In 1815 Commodore Decatur went out to the Mediterranean with the new *Guerrière* (44), the *Constellation, Macedonian*, and some smaller vessels, to suppress Barbary piracy. *Ontario*, a ship-sloop carrying twenty 32pdr carronades, under a handsome spread of studding-sails, leads the squadron.

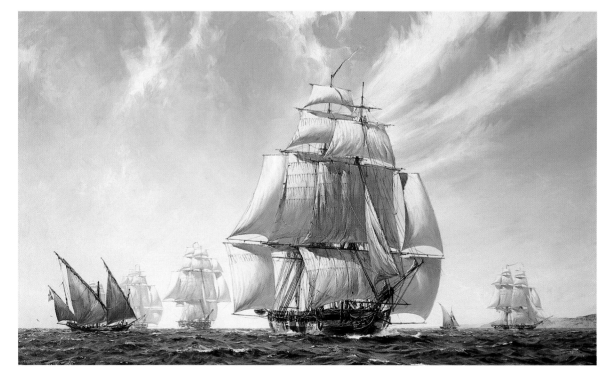

Nor could I possibly fail to thank the writer Patrick O'Brian, who possesses in a high degree the magic that I mentioned earlier, the ability to hot-wire the past directly to present life, and whose book-jackets I have had the great privilege of illustrating. My gratitude also goes to my wife, and to my sons, who continue to tolerate the marine monomaniac in their midst remarkably well. Lastly I would like to pay tribute to another marine artist, Chris Mayger, whose lucid paintings demonstrated how the most unpromising subjects could be transformed into works of delight; and who would still be leading the way had he lived.

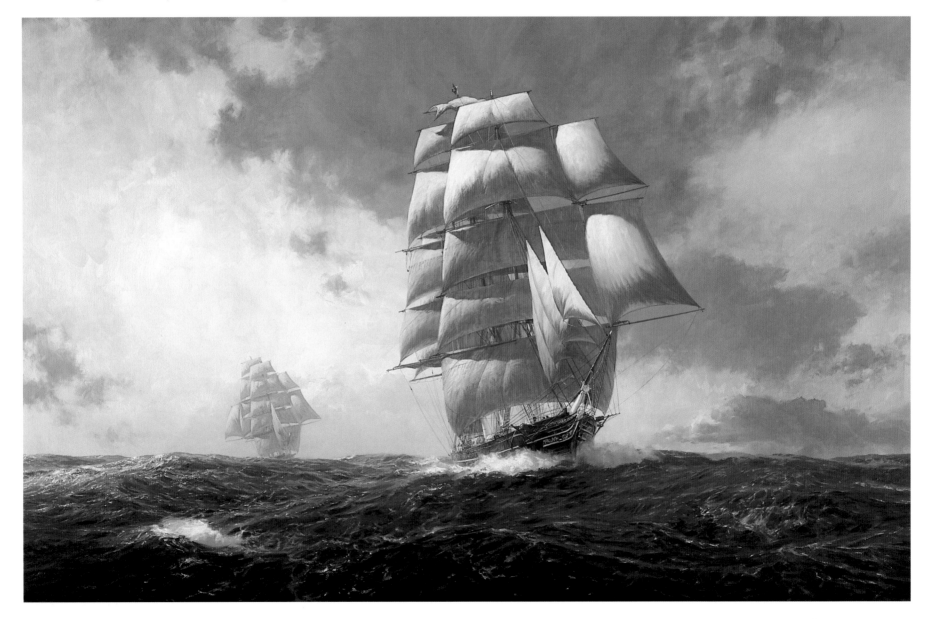

Opposite page:

Cutty Sark and Thermopylae.

Oil on canvas, 40in x 60in. (Private collection)

This painting presented me with a challenge, being the largest picture I had painted to that date. The shift of scale from 30 or 36 inches to 60 inches is a considerable one, but I enjoyed the change in thinking required, and the chance to sweep about with some big brushes. The incident depicted is the well-known duel between *Cutty Sark* and the ship she had been purposely built to beat, *Thermopylae*. Both ships loaded with tea at Shanghai and got out to sea together before noon on 18 June 1872. After racing together through the China Sea they emerged into the Indian Ocean and as they picked up the strong trade winds *Cutty Sark* drew ahead (the setting for the painting). It was not to be a straightforward race, however. On 15 August *Cutty Sark*, now 150 miles east of Port Elizabeth, was struck by heavy seas and lost her rudder. In a fine demonstration of seamanship and grit Captain Moodie had a jury rudder made on board, together with its iron fittings and stern-post, fixed the whole contraption in place and was under sail again inside five days. Even with this handicap, the clipper docked at Gravesend on 18 October, only seven days behind *Thermopylae*.

Below:

Lymington Quay, circa 1790.

Oil on canvas, 18in x 24in. (Private collection)

At the other end of the merchant shipping scale from *Cutty Sark* is this earlier and far humbler scene, based on a Rowlandson engraving. Standing on Lymington town quay today it is quite easy to visualise this scene, though the water is jammed with yachts rather than trading vessels, overlooked by visitors and their cars rather than by countrymen and their cattle.

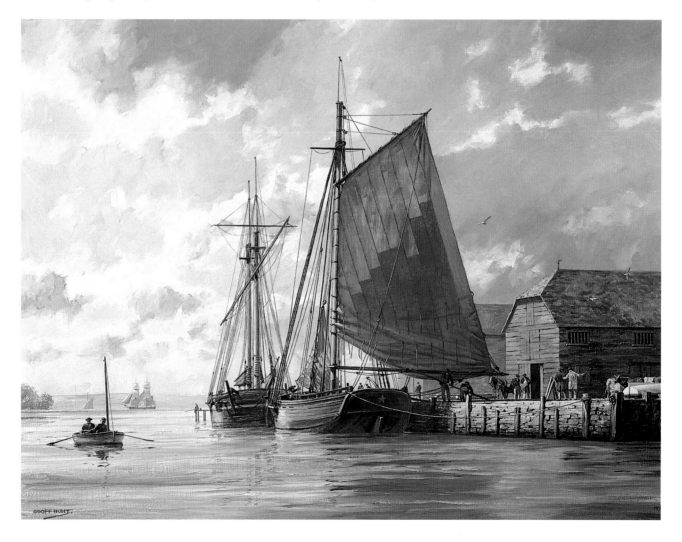

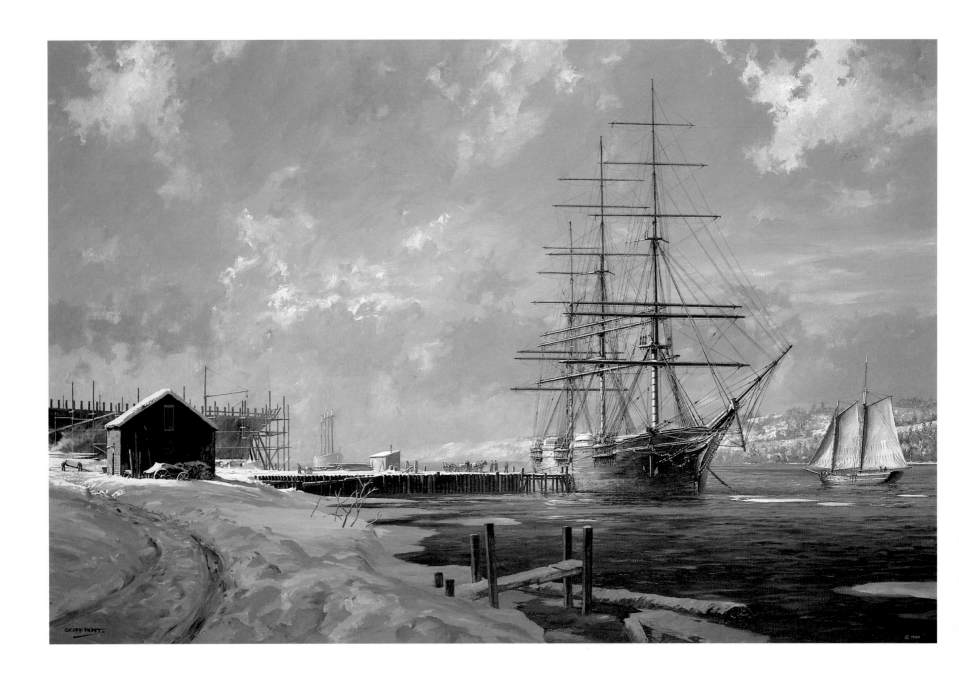

Opposite page:

Shipbuilding along the Kennebec River, Maine; the *Henry B. Hyde* alongside.

Oil on canvas, 24in x 36in. (Private collection)

The *Henry B. Hyde* was one of the celebrated 'Down Easters' (so-called because they were all built along the American north-eastern coast, in the New England states). These ships were the successors of the tea-clippers, inheriting the traditions of speed and hard driving, yet they were bigger ships, required to carry substantial loads in a tough trade – the Cape Horn route to California. The *Henry B. Hyde* was built at Bath, Maine, in 1884, and made a reputation as a fast ship, but from the crew's viewpoint a hard one. The ship's origin suggested this winter scene; snow is wonderful stuff, and the opportunity to paint it does not often occur in marine art.

Below:

Nina and _Pinta_ racing home, February 1493.

Oil on canvas, 20in x 27in.

Another winter scene in a northern latitude, some four hundred years earlier. Attention is always concentrated on Columbus's arrival in the West Indies, and the story of the return voyage is not so well known. Yet without the courage and seamanship aboard these two tiny ships, packed with survivors from the lost *Santa Maria*, flying before the winter storms across the north Atlantic, there would have been no story to tell. These 'ships' were so small – no more than seventy feet long – that the only valid size comparison today is with a yacht. And they were caravels, lighter and lower than the more burdensome *Santa Maria*. Within their structural limitations they would have been fast downwind like present-day yachts, if their crews were strong and determined enough. They are known to have touched 11 knots on the way back, which gives a terrific impression of speed in a small vessel; it must have been a wild ride.

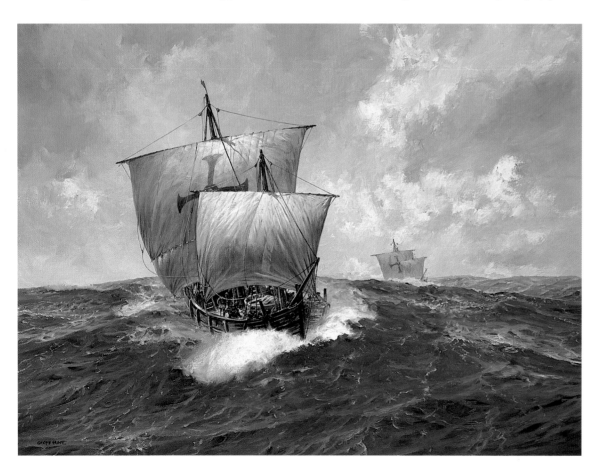

In 1740 Commodore Anson's squadron of six ships set out from England to harry Spanish possessions and trade in the Pacific (his ultimate objective in fact was to capture the fabulously rich Manila Galleon). The full account of this extraordinary story provided Patrick O'Brian with the material for two books, and myself with two paintings.

Below:

Centurion closing with Nuestra Señora de Cobadonga.

Oil on panel, 16½in x 25in. (Private collection)

The climactic moment of Anson's voyage, as his sole remaining ship closes with the Manila Galleon, which was to yield thirty-two wagon-loads of gold and silver treasure. Patrick O'Brian's *The Golden Ocean* deals with the story from the viewpoint of Anson's flagship, *Centurion*.

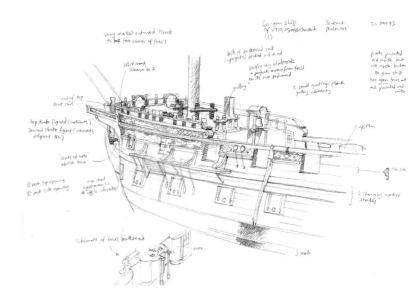

Centurion was almost identical with a 60-gun ship of the 1719 establishment, as seen in this drawing.

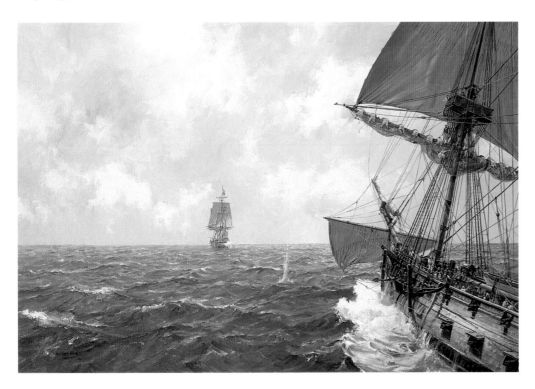

Opposite page:

Wager in the Great Southern Ocean, 1741.

Oil on panel, 19½in x 28in. (Private collection)

One of Anson's ships was the *Wager*, a former East Indiaman converted to naval use as a store ship, but rated as a sixth-rate post-ship carrying 22 guns. Among the load she bore was Anson's siege-train, the heavy guns required to batter Spanish fortifications on land.

But *Wager* was not destined to deliver this cargo. She lost touch with the other ships during eight weeks of terrible struggle, off Cape Horn, in the great seas of the Southern Ocean. With a hundred and twenty of her crew sick with scurvy, and only twenty fit to go aloft, she was wrecked on the desolate and uninhabited coast of what is now Chile, at the Gulf of Penas, on 14 May 1741. Mutiny and death followed before different groups of survivors straggled home – the captain did not reach

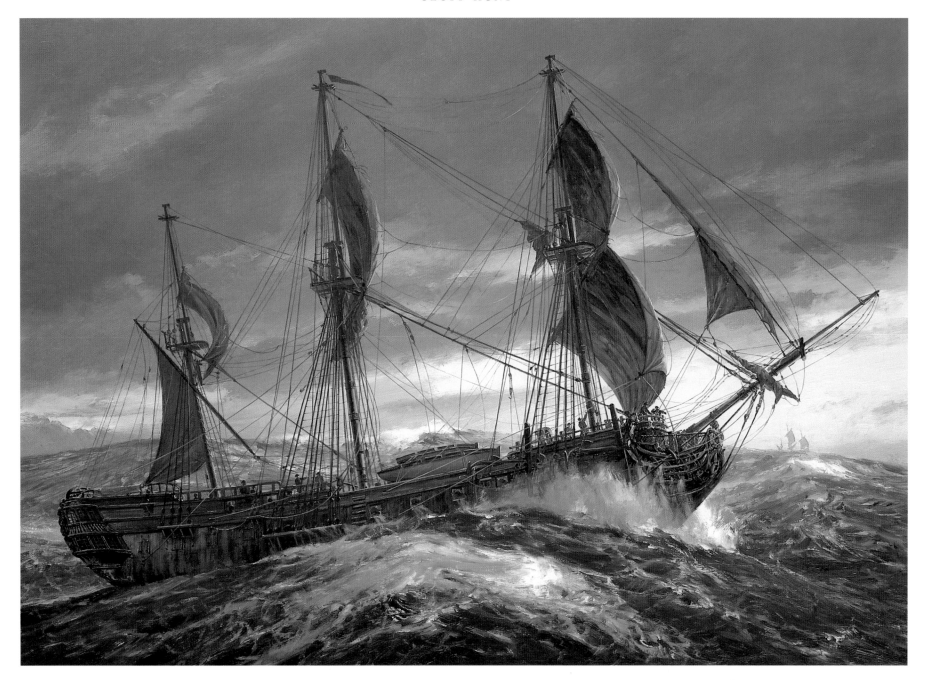

England until early 1746. I depict her in the fight to round Cape Horn, temporarily forced to scud eastward again, with another store ship, the *Anna*, in the distance. This painting appeared on the jacket of Patrick O'Brian's *The Unknown Shore*.

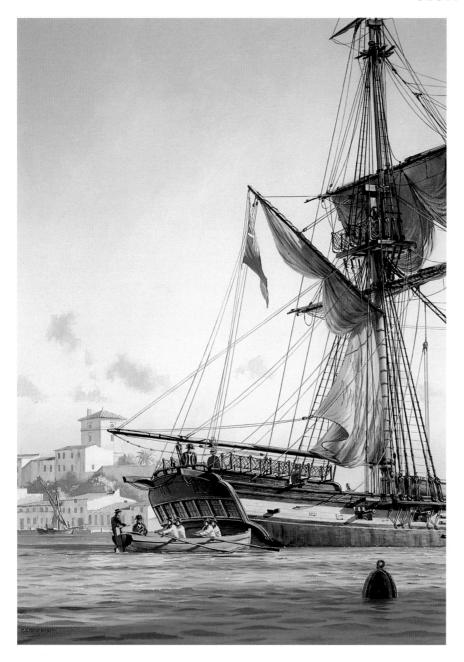

Left:
HM Brig *Sophie* in Port Mahon.
(Cover painting for *Master and Commander.*)
Oil on panel, 19in x 13in (Collection of Royal Naval Museum, Portsmouth)
The tiny brig *Speedy* achieved spectacular successes out of all proportion to her size, while under the command of Lord Cochrane, in the Mediterranean during 1801. Patrick O'Brian used *Speedy* and her exploits directly as the model for *Sophie*, in the very first of his superlative Aubrey/Maturin novels. This is more a portrait of *Sophie*; the real *Speedy* did not have anything as grand as these stern windows.

Opposite page:
Nelson's *Agamemnon*: Mediterranean, 1796.
Oil on panel, 21in x 22¾in. (Private collection)
At the beginning of 1793 Nelson, having been on the beach for five years, was given command of the 64-gun battleship *Agamemnon*. He was to remain in command of this ship, which he referred to as his favourite, for the next three and a half years. Towards the very end of the commission, in March 1796, he was given a Commodore's pennant and so *Agamemnon* was also his first flagship, just before, in June of that year, he transferred to the 74-gun *Captain*. In April, Nelson was operating in the Gulf of Genoa with a small squadron under his command, which provides the setting for this painting. *Agamemnon* leads, followed by *Meleager* (32), *Blanche* (32), *Diadem* (64) and the little 16-gun brig-sloop *Speedy* (see left).

This painting appeared as the jacket for Anthony Deane's interesting *Nelson's Favourite*, the story of HMS *Agamemnon*. Just as he was putting the finishing touches to this book, news came that divers had located the wreck of the *Agamemnon*, in Maldonado Bay in Uruguay – where the author spends his summers, in a house overlooking the bay.

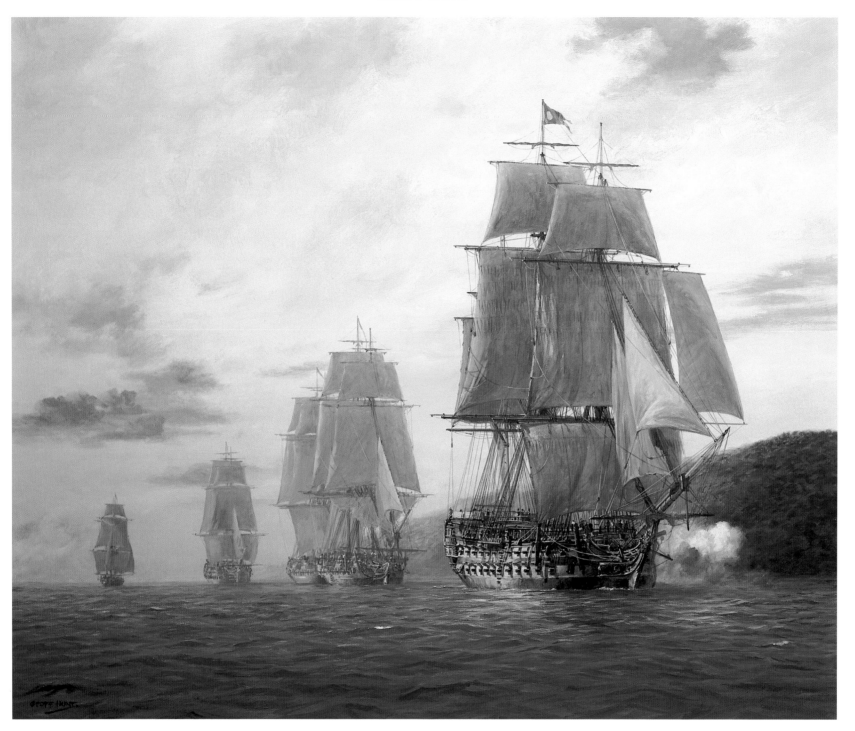

Opposite page:

The Battle of St. Vincent, 14 February 1797, at about 1.50 p.m. Leading British ships in action with Spanish main group, HMS *Captain* in the distance.
Oil on panel, 24in x 28in.

Although not a large painting, this proved to be a very complicated subject and took a long time to research, compose and paint. Briefly, the scene hinges on the actions of Nelson, then a commodore (having no fewer than four admirals superior to him actually present on the day). In a characteristic combination of eagerness, daring and independence that bordered on insubordination, he ordered his ship, the *Captain*, 74 guns, to 'cut the corner' on a rather slow fleet manoeuvre and so got into action with the Spanish flagship, the 130-gun *Santisima Trinidad*, and at least two other first-rate battleships before the rest of the fleet caught up with him. I finally chose to paint the moment when the

leading British ship, *Culloden* (centre, partly masked by the foreground *Blenheim*) is about to reach the battered *Captain* (farthest right) before passing on to the Spanish flagship (right centre). In the confused fighting that followed, Nelson was to perform his well-known feat of capturing an 80-gun ship, the *San Nicholas*, and using her as a bridge to capture another even larger, the 112-gun *San Josef.* The ship at the extreme left is the 98-gun *Prince George*, which was to play a major role in knocking out the *San Josef.*

It is difficult to analyse the timings and individual ships' actions in such a big and complex engagement, even with access to the ships' log-books (some of which sometimes appear to have been written with hindsight and other motives than factual narration in mind), and I made small (and very basic!) models of about twenty-five of the ships to help in plotting the action; even so there were moments when I felt none the wiser.

Left: Original thumbnail sketch for composition.

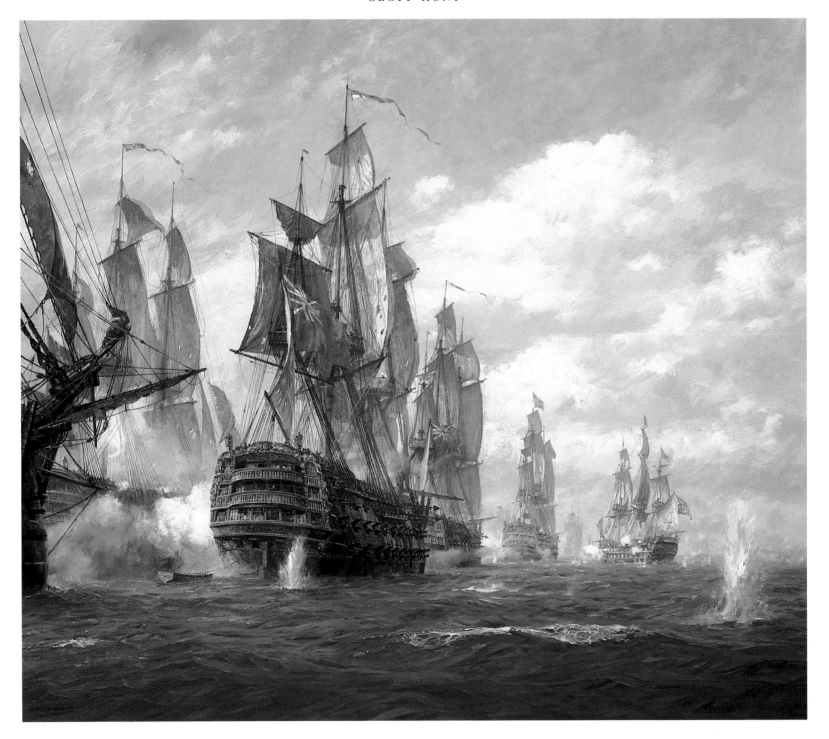

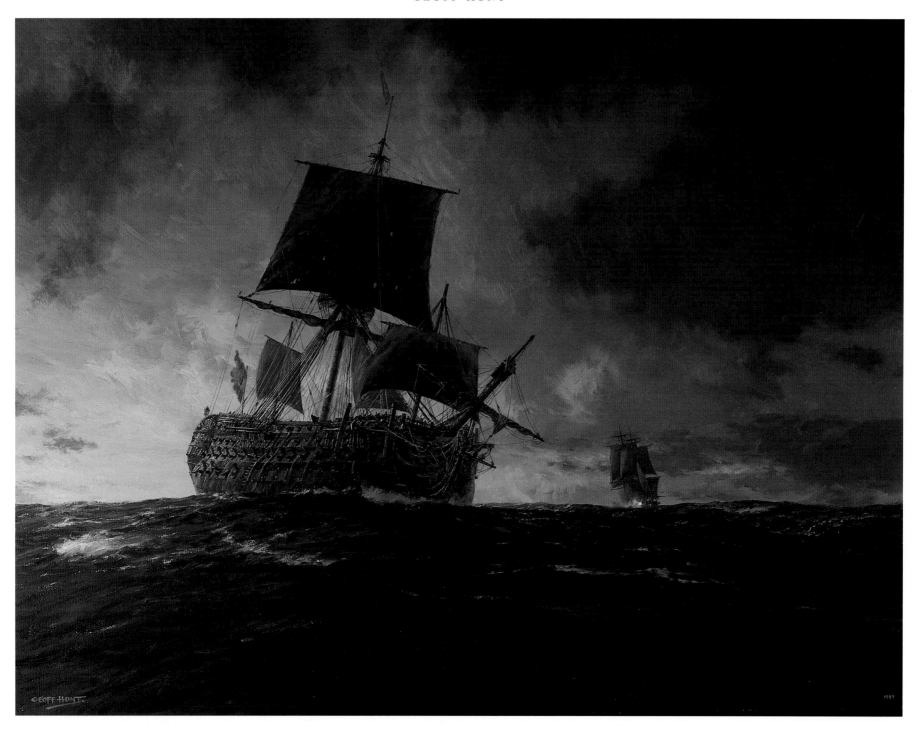

Opposite page:

Tormented Giant – the *Santisima Trinidad* harried by *Terpsichore*.

Oil on panel, 21in x 25in

A real incident, but one so unlikely that it seems to come from the world of fiction. Some days after the battle of St. Vincent in February 1797, the British frigate *Terpsichore* came across a damaged Spanish battleship west of Gibraltar. She proved to be the *Santisima Trinidad*, then considered to be the world's most powerful battleship, carrying about 130 guns on four complete gun decks, which had taken a terrible pounding in the recent battle and was now, partly dismasted, heading for a friendly port. Captain Bowen of the *Terpsichore* decided to tackle this overwhelming monster (four times the size of his ship, with six times

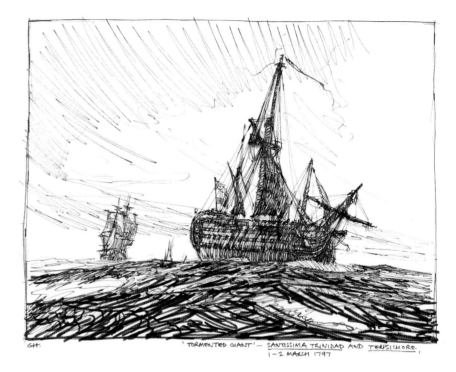

'TORMENTED GIANT' – SANTISIMA TRINIDAD AND TERPSICHORE, 1–2 MARCH 1797

the firepower). Having made contact in the morning, he followed at a prudent distance until dark when he moved in to open fire, shifting from side to side of his adversary, until after midnight. Throughout the next day *Terpsichore* hung on, until that evening brought no fewer than twelve more Spanish warships, at which Bowen finally took his leave.

The basic idea for this picture sprang to mind instantaneously – the ships heading eastward with the sunset behind them, the dismasted *Santisima Trinidad* rolling heavily in the light wind – and the first sketch (above) was done in minutes. Second thoughts about the position of the two ships, and a careful reading of *Terpsichore*'s log-books, led to the changes made in the finished painting, which nevertheless retains the spirit of the sketch.

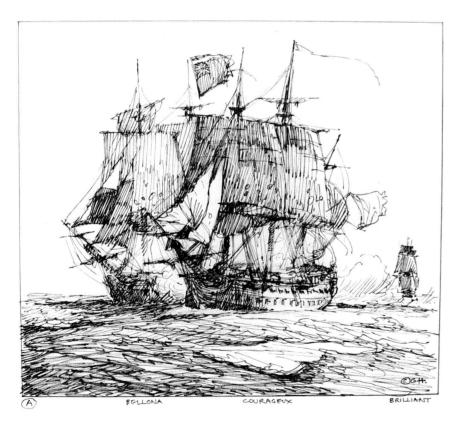

BELLONA COURAGEUX BRILLIANT

Left: *Bellona* and *Courageux* in action, sketch idea.

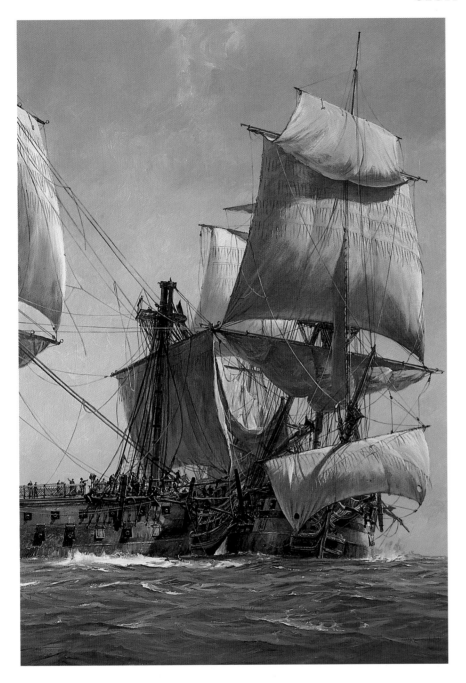

Left:
**A slight error of judgement:
French 74-gun ships in collision.**

Oil on panel, 20½in x 14in. (Private collection)

A moment from naval fiction, illustrating a scene in Dudley Pope's *Ramage and the Saracens*, an irresistible opportunity to paint a couple of ships not, for once, locked in battle, but in the middle of a glorious self-induced chaos after crashing into each other. Even at the modest speeds attainable under sail, the momentum of a battleship massing about two thousand tons was enough to cause the kind of shock damage, such as dismasting, suggested in the novel and in my painting. Warships' hulls by this time were painted (rather than varnished) in a variety of decorative schemes, all using black together with a range of yellow to red earth colours, or – much less commonly – white.

Opposite page:
***Bellona* and *Courageux* coming home,
Spithead 1761.**

Oil on canvas, 27in x 30in. (Private collection)

HMS *Bellona* (left) was one of the first of the new British standard 74-gun ships – a long-lived ship, completed in 1760, still active in 1813. On 15 August 1761 she ran into the powerful French *Courageux* 74 off the coast of Portugal. A famous, hard-fought action ensued, in which *Courageux* was finally captured. She proved to be an excellent ship and influenced British battleship design for decades. After refitting at Lisbon the two ships came home in company with the frigate *Brilliant* and the East Indiaman *Lord Anson* (extreme right). As a captured ship *Courageux* is shown with British colours flying over the French ensign – at that time simply the plain Bourbon white. The boat nosing into the scene, left, is meant to be an Admiral's barge. These narrow boats were rowed single-banked (the oarsmen sat to one side and pulled the oar belonging to the other side).

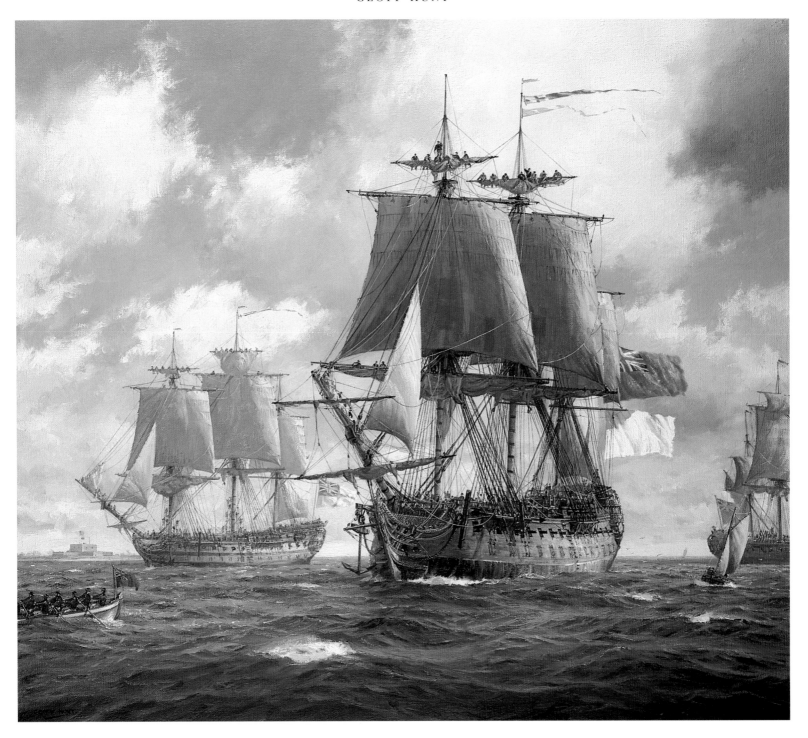

From the opening words of his first Aubrey/Maturin novel, Patrick O'Brian was recognised as the supreme master of naval fiction. I already knew and admired his work when, in 1988, I was asked to paint jacket illustrations for these books; a wonderful, priceless opportunity to honour both the novels and the naval period they portray. The next six paintings either belong to or are connected with this series. When I began to illustrate Patrick O'Brian's books I had to consider twelve simultaneously, which gave them a unity of thought and appearance. Many of my first thoughts, in the form of thumbnail sketches like those on the opposite page, proved capable of almost direct translation to the finished paintings.

Right:

HMS *Worcester.*

Oil on panel, 19in x 13in. (Royal Naval Museum, Portsmouth) A 74-gun ship of the late war period. The fictitious *Worcester* belongs to a real class of forty ships hurriedly built in wartime, not very satisfactory either as to their design or their build quality, which earned themselves the nickname of the 'Forty Thieves'. This painting provided the jacket art for *The Ionian Mission.*

Opposite page:

HMS *Bellona* on blockade duty off Brest.

Oil on panel, 22in x 27in. (Private collection) As a change from dramatic episodes, I wanted to depict a moment in the monotonous and largely uneventful blockade duty which formed the greater part of a British battleship's life during the Napoleonic Wars. Patrick O'Brian's *The Yellow Admiral* provided the perfect excuse for this painting. The ship is hove-to (the sails so arranged as to, in effect, put the brakes on) while her cutter visits another ship. This moment of relative stillness, with the ship riding over the Atlantic swell, gave me the opportunity to use a slightly unusual viewpoint. *Bellona* is one of those ships that has had a dual career, once in real life with the Royal Navy, and again

in fiction with Captain Jack Aubrey. This scene is represented as taking place quite late in the wars, and the real *Bellona*, which by this time had been refitted many times – she had been completed originally in 1760 – would probably not still have had the handsome stern gallery shown here.

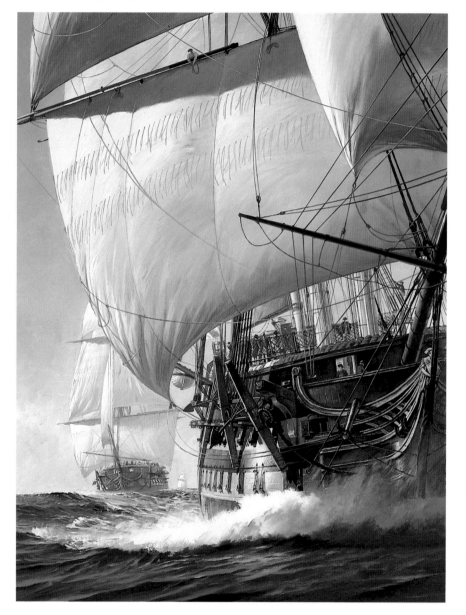

coming aboard small vessel at anchor
(Master e Commander?)
—late sunlight

Leopard (Desolation Island)

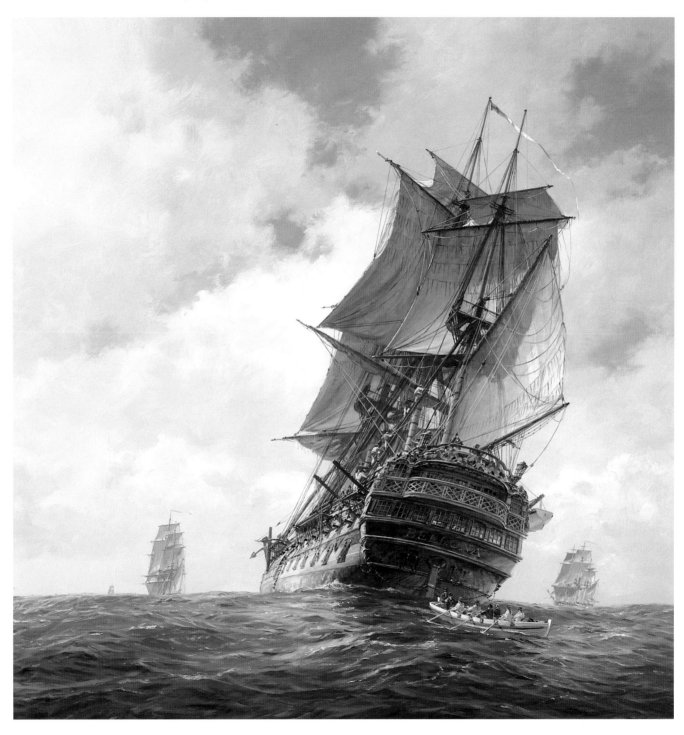

Opposite page:

The Wine-Dark Sea.

Oil on panel, 17in x 26in. (Private collection)

In a memorable passage Patrick O'Brian conjures up from the depths of the Pacific a new volcanic island, which the frigate *Surprise* encounters at night. The lurid dawn that follows provided the dramatic scene for my book-jacket illustration.

Surprise has had a bad time of it during the night, but repair work is already in hand. With a considerable work-force of skilled craftsmen aboard – the carpenter, boatswain, sailmaker, armourer and all their crews, not to mention the able seamen – and ample supplies of timber, tackle and rope, a ship of that time could be remarkably self-sufficient, equipped not merely to sail round the world, but to repair damage such as this en route. Even topmasts could be replaced, since spare topmasts were always carried, stowed between the boats; only damage to the lower masts was likely to cause serious problems.

Right:

Treason's Harbour.

Oil on panel, 19½in x 13in. (The Royal Naval Museum, Portsmouth)

Moonlight over Grand Harbour, Malta. Once again the ship is HMS *Surprise*, this time securely moored, a marine sentry stationed over the bowsprit ready to shoot any potential deserter trying to swim away from the ship (or so the guide aboard HMS *Victory* always used to say). In the distance a Genoese barque, for which I am indebted to the French engraver Baugean, is being towed through the flat calm by her longboat.

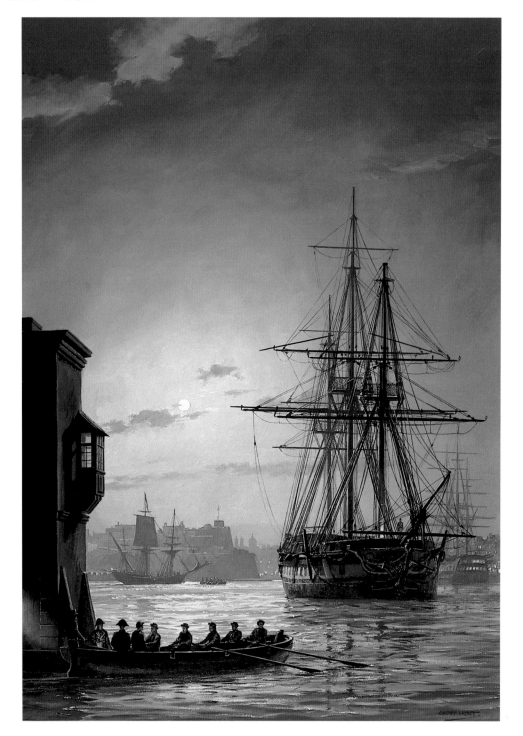

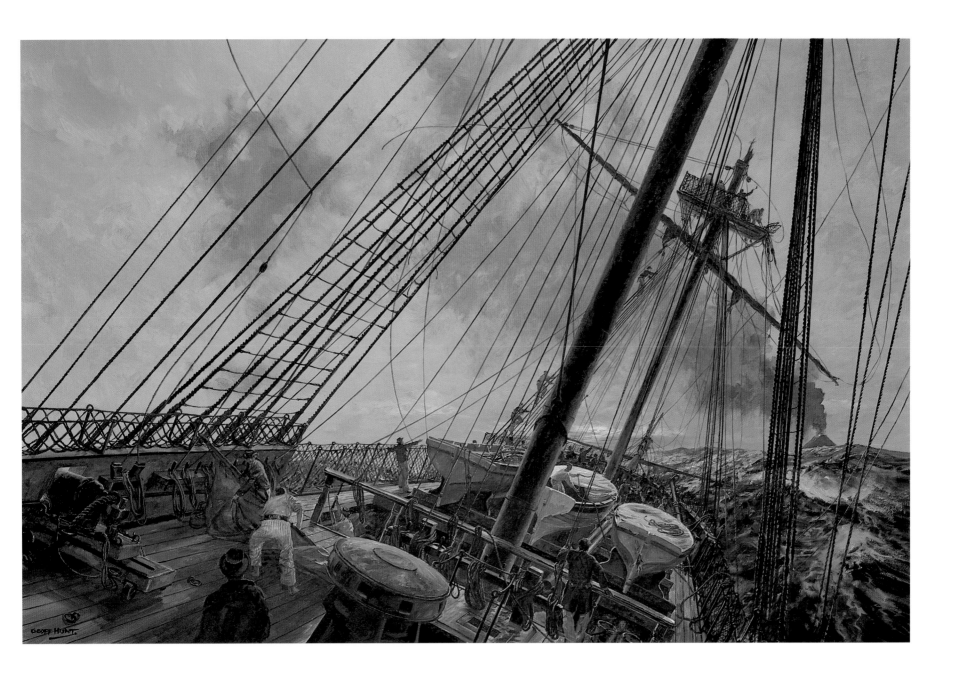

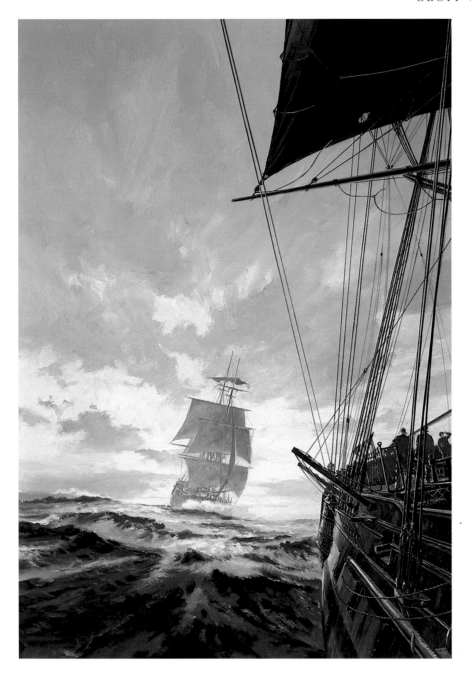

HMS *Leopard*, 50 guns, pursued by the *Waakzambeid*, 74 guns.

Oil on panel, approx. 19in x 13in.

(Royal Naval Museum, Portsmouth)

The jacket illustration for *Desolation Island*, which contains an extraordinarily vivid and intense account of this desperate pursuit across huge seas, the bigger ship steadily gaining on the smaller, each continually firing on the other despite ever worsening sea conditions.

Opposite page:

HMS *Inconstant* and *l'Unité*.

Oil on panel, 48cm x 60cm.

On 20 April 1796 the frigate *Inconstant*, Captain Fremantle, reconnoitred what is now the Bay of Tunis. There she found a French warship lying at anchor and, in circumstances which the *Inconstant*'s log-books do not make at all clear, captured her without a shot being fired. She proved to be *l'Unité* of 34 guns, a size of vessel that was just dropping out of the category of frigate – in the French Navy such ships were now called corvettes. The interesting thing about this particular corvette is that she was bought into the Royal Navy, renamed HMS *Surprise*, and had a busy and distinguished career (she was Captain Hamilton's command in the recapture of the *Hermione*), before going on to have an even busier and far more celebrated career in fiction as Captain Jack Aubrey's ship, in so many of Patrick O'Brian's novels.

Here we see the two ships on the morning following the capture. *Inconstant* is making sail to investigate a strange vessel to the northward, but all turns out well; she proves to be the British frigate *La Sybille*, and they join company before noon.

L'Unité even as built had rather an English look about her and there is not much to mark her as a French-built ship to outward appearance, though the spidery object dangling from the driver boom is a characteristically French lifebuoy.

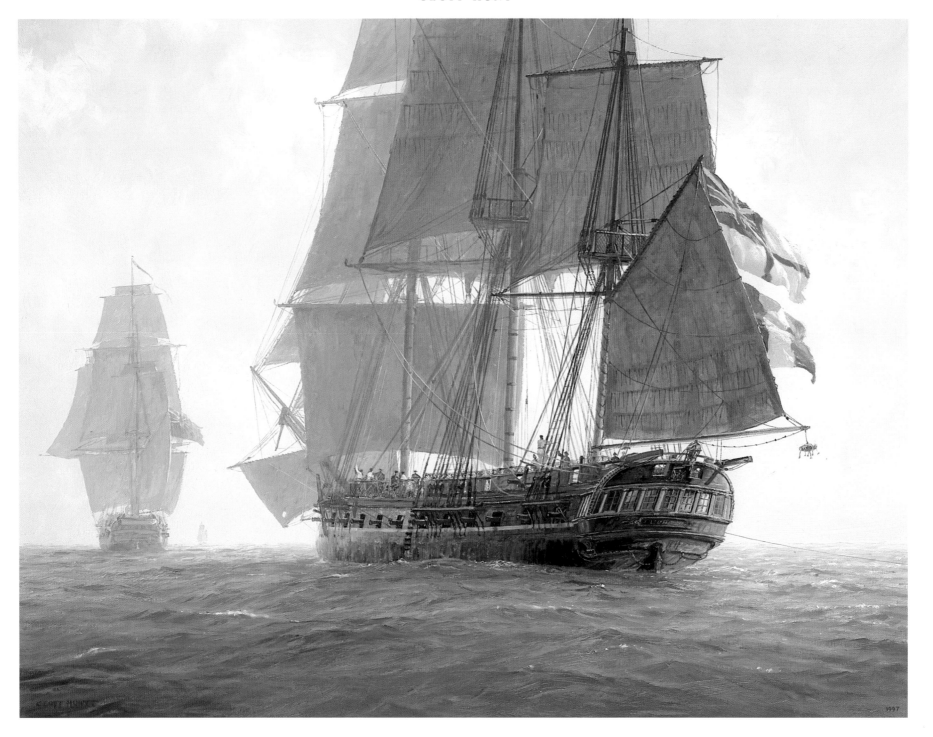

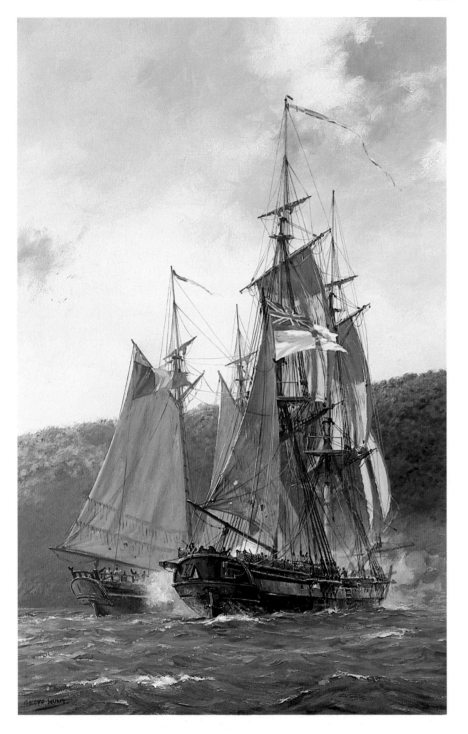

Left:

HM Brig *Triton* in action with privateer.

Oil on panel, 20in x 12½in.

The West Indies is the setting for this little action, now back in the world of fiction, which is to be found in Dudley Pope's *Ramage and the Freebooters*. The Navy's ubiquitous 10-gun brigs, so notoriously cramped and unseaworthy as to be called 'coffin-brigs', were much the same size as many privateers and pirate vessels, and so were employed against these tough customers. In order to pack a heavy enough punch the 10-gun brigs were armed almost exclusively with carronades, which in turn meant that they had to fight at very close ranges. *Triton* has the better of this particular engagement, but naval vessels sometimes came off worse.

Opposite page:

HMS *Trusty* in English Harbour, Antigua.

Oil on panel, 21½in x 27in.

The 50-gun ship *Trusty* takes on stores, while to the right a sloop is careened (heeled over to get at the underwater hull) for attention. Fifty-gun ships were too small to be battleships and too slow and unweatherly for anything else, but they did have two gun decks and 24pdr cannon, and so usefully filled a niche as overseas and flotilla flagships. Some were built as late as 1814.

Today the West Indies are a wonderful holiday destination for us, and it is difficult to adjust to the eighteenth-century viewpoint, which saw them as a death-trap, a desirable posting for junior officers solely because rampant disease was likely to remove their superiors (not to mention many of their shipmates) resulting in their promotion – if they survived. This harbour has changed in appearance remarkably little since Nelson was last here.

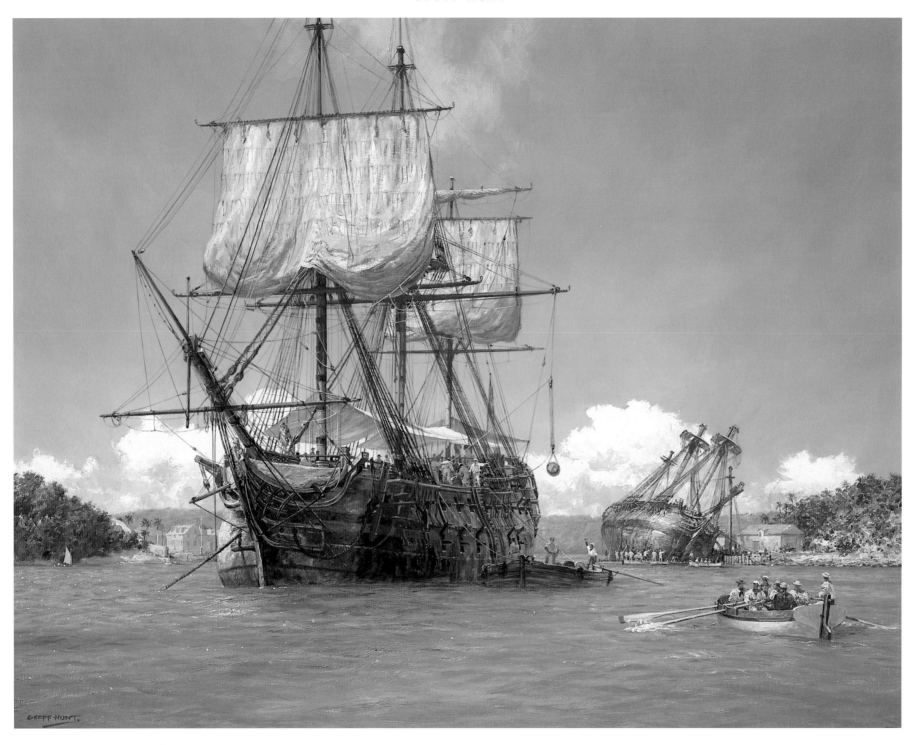

Opposite page:

Star Clipper off Martinique, West Indies.

Oil on canvas, 27in x 36in.

A pleasant reminder that not all tall ships belong to history. _Star Clipper_ and her identical sister-ship _Star Flyer_ are purpose-built cruise ships, designed to carry about 150 passengers in great luxury, but they are also true sailing ships, four-masted barquentines. They are not usually operated at anything like their performance potential, since an angle of heel greater than 6° would spill the drinks, but on trials _Star Clipper_ made nearly 20 knots under sail, quite as good as any of the great clippers. Both of them regularly cross the Atlantic, and _Star Flyer_ has crossed the Indian Ocean. In 1995 I had the very great pleasure of sailing aboard _Star Clipper_ at the invitation of the company, and this resultant painting has appeared as a limited-edition print. In the distance is the staysail schooner _Gloria_; beyond her lies the isolated Diamond Rock, a tooth of rock rising sheer six hundred feet out of the sea, which in 1804 was occupied, fortified and commissioned as a warship – HMS _Diamond Rock_ – by the Royal Navy. The land beyond is Martinique, then as now a French possession.

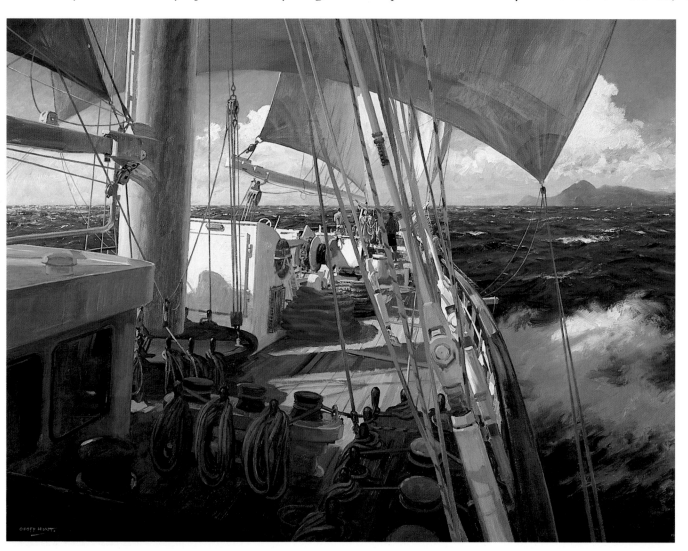

Left:

Martinique landfall.

Oil on panel, 21in x 28in.

Star Clipper from the paying guest's more usual viewpoint, on board. Some of the gear necessary for handling the immense sails is visible, though most of the muscle, including setting and furling all the square sails, is provided by power operation. It is not normally necessary for anyone to go aloft.

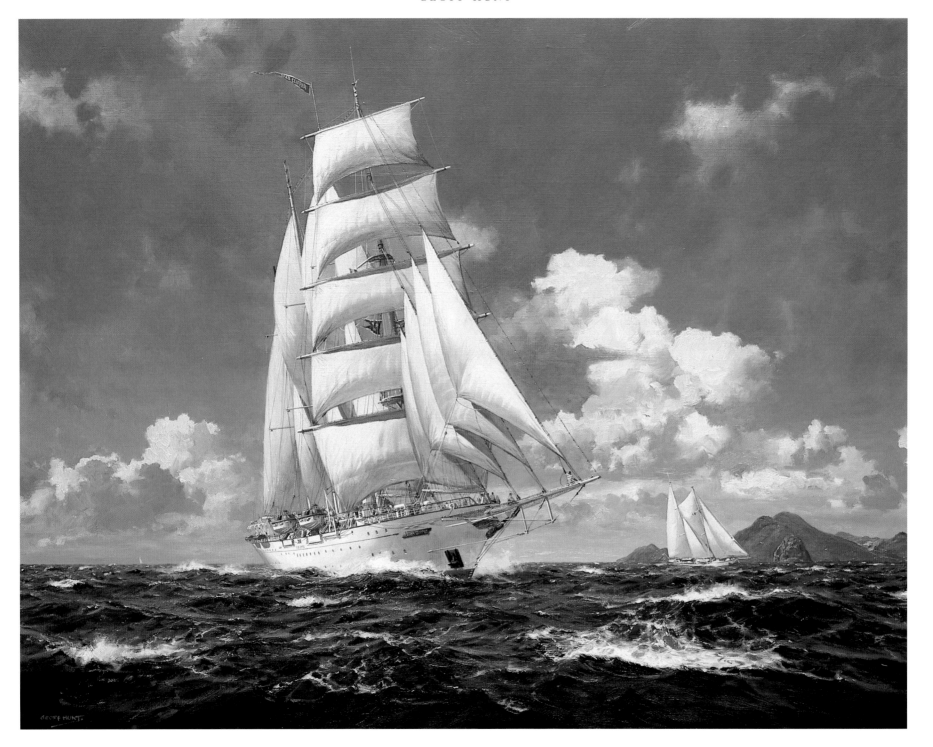

MARK R. MYERS
PRSMA, F/ASMA

San Francisco Bay was a maritime happy hunting ground when I was growing up there in the 1950s and 1960s. There was plenty to inspire a seaminded boy out in the Bay and at the piers and wharves. And what a place to sail! The South Bay sloughs were mine as 'Master under God' of an 8ft plywood sailing dinghy. Later there was the great Bay itself to explore, from the Golden Gate to the mighty Sacramento River.

One of the greatest sights was the big Cape Horner *Balclutha*, newly restored, towering over the Embarcadero. She attracted me like a magnet, and by benevolent fate I began to haunt the offices and library of her owners, the San Francisco Maritime Museum. To my surprise they took my interest seriously. With their encouragement I immersed myself in sea-lore and started to set down what little I knew with brush and pen, getting expert nautical criticism from the patient staff and the regulars – largely seamen and historians – who frequented the place.

I knew no local marine artists to pester as my interest in this branch of painting grew. Later on, I met a few back East, but up until that time I used persistence as my tutor and made all the amateur's mistakes. There was no notion that marine art might one day provide a living – if so, I should probably have put some thought into learning how to paint. For me the ships were the thing rather than the technique of painting, which more or less looked after itself and even modestly improved in spite of this neglect.

The next step was to get to sea in sailing ships somehow, and here I was supremely lucky. Through a letter sent more in hope than expectation of a reply, I got to know just the man who could perform such miracles, Captain Alan Villiers. We corresponded over the years and when I was 19, reading history at university, he got me to sea in a couple of small wooden square-riggers doing film work in Hawaii. Jobs in such interesting craft weren't plentiful, so I kept up my studies or worked on my painting ashore until the next berth came along. Other craft followed until in 1968, BA in my pocket, I came to England to serve aboard the *Nonsuch* ketch, then fitting out in Appledore.

Sea time made a difference to my view of ships and to how they might be painted. It knocked the romance out, bringing in its place some old-fashioned practical seamanship, a bit of weather knowledge, and familiarity with the way of a ship in the sea. It showed me the colour, the feel, the movement of the open ocean. I found it difficult to sketch at sea, however, and seldom tried to paint unless the

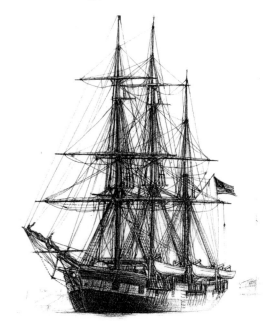

Right:
The Barque *Wandia* Alongside at Honolulu.
Pencil drawing, 1965.

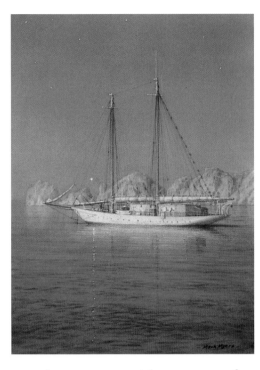

Left:
Te Vega at Anchor, Cabo San Lucas, 1966.
Watercolour, 15in x 11in, 1996 (Collection of Mrs Ruth Pizani)

When I sit down to tackle a new work the inspiration has to come from somewhere, ideally something as fresh and sharp as that first long look aloft from the _Balclutha_'s deck. Something in the subject should spur one to one's best. This can come from reading or travel, fine art or music or any watch at sea. This isn't to say that one can sit about to wait for it to happen – not if one has a family to support – but even the most hackneyed subject demanded by a client has its inspiring points if one can feel them out.

Preparation invokes all the research skills learned through the museum and honed at university. The more one knows about the subject, the more valid one's interpretation will become and the wider one's options will be in deciding how to paint it. Not every picture calls for exhaustive research of course; some flow from pure experience, others are at their best in expressing basic mood or motion. But if the brief is to portray a certain ship in harbour, say, one needs to dig, sift and weigh the information needed for the job.

Then comes imagination – making the subject come to life. A fusion of inspiration, experience and research, it plays a key role in the work of any good historical painter. It works like this for me: I have a subject which I want to show as real, let's say a ship at sea. So I think: 'what would the crew be doing?; what sort of sea

vessel were at rest. A lame excuse for a marine artist to make, but I was getting paid for working the ship and that came first.

A year after I had left the _Nonsuch_ I had enough contacts and clients on both sides of the Atlantic to gladly return to North Devon, settle down with the girl of my heart and set to again with the brushes. The old question arose one last time when the _Golden Hinde_, on which I'd been working as a rigger, was ready to sail for San Francisco. I had a good chance of a berth in her, so was I going to be a seaman who was good at painting or an artist who used to go to sea? Decision made, my wife and I waved the ship off from Plymouth's Millbay Docks.

If there's a point to this story, I suppose it shows that even the most wayward path can lead to a living in art. Being self-taught has its limitations, so it was fortunate that along that path I came across the skills I'd need to make a go of it. These most essential tools were forged in youth: inspiration, preparation, imagination and application.

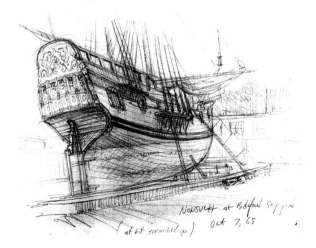

Right:
The _Nonsuch_ Hauled Out at Bideford Shipyard.
Pencil drawing, 1968.

is running?; what light, what time of day is right?' With luck, the images will come.

And finally, application. By this I mean hard work, which is still required to get the paint and paper to do what I would like. Mistakes and struggles with materials don't all disappear with practice – for every difficult effect one learns to master, there'll be a new one to try out tomorrow – so perseverance counts.

None of this will tell you how to paint, but I'm sure that my distinguished co-authors will have better advice than any I could give. The pictures that follow, painted over many years, will show what I've been learning as I went along. I hope that you enjoy them.

Opposite page:

Onnonnistoy.

The visit of Onnonnistoy and other chiefs to Captain George Vancouver aboard the *Discovery* at Port Stewart, Alaska, 1 September 1793.
Watercolour, 22in x 30in, 1994.
(Collection of Captain and Mrs John M. Baldry)
This sounded like a great job from the minute I picked up the phone. It was an old shipmate calling from Alaska, where he's now a very busy ship's pilot. The Alaska State Museum was planning a big exhibition to mark the 200th anniversary of Vancouver's visit to their waters, he said, so could I paint a picture showing the explorer somewhere in South-east Alaska which could serve as a focus for the show and help relate the artefacts and documents on display to a use and place modern Alaskans would recognise?

The result was this painting, a record of the elaborate ceremonial visit of the Tlingit chief Guna'ne'sté ('Onnonnistoy' to Vancouver) to the English ships at anchor near present-day Ketchikan. I picked this from all the incidents during Vancouver's two-year survey of the area because it seemed to symbolise best the meeting of cultures which is still part of everyday Alaskan life. The research was extensive and absorbing, involving fresh work

reconstructing the *Discovery* and *Chatham* and examining the voyage logs and journals at the PRO to work out anchorages, weather, activities on board and so forth. Understanding the Tlingit and Haida customs, dress and canoes involved a grounding in pre-contact native cultures and the intricacies of historic North-west Coast formline art, but here I got sound guidance from the experts in the field who helped me build on what I'd learned from published sources. I had never visited Port Stewart, so while I was poring over pilot books and new and ancient charts at home, my pilot friend John took boat and camera to photograph it from all angles. After this the artwork went along smoothly.

There's a postscript to this story: I finally got to visit the State Museum in Juneau two years later, and there I learned that their posters of Onnonnistoy had nearly sold out – they had become *de rigueur* in every Native American home, so the staff told me.

Below: The *Discovery*'s sail and rigging plan, reconstructed from Admiralty draughts, period rigging tables, and Vancouver's noted alterations.

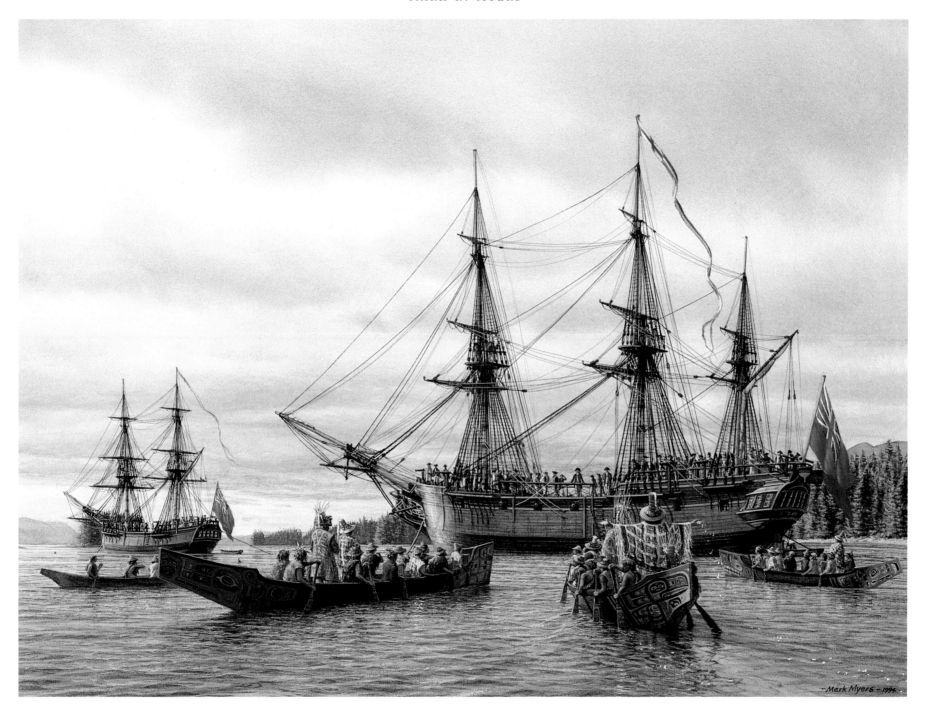

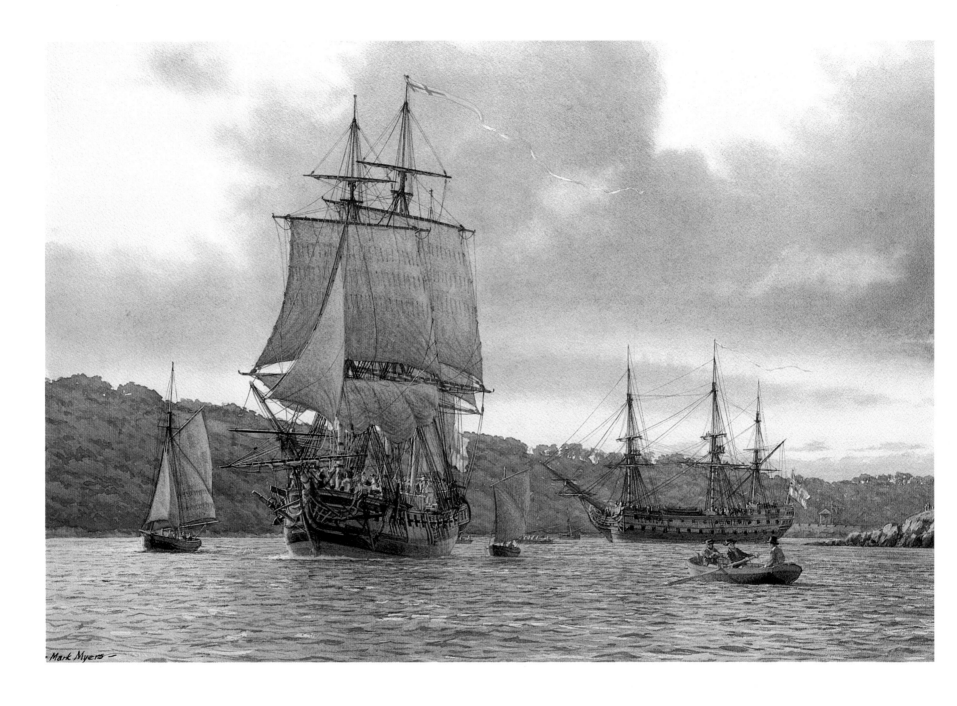

when the gales roar outside. Every time we're in Barnpool I think of the ships that have anchored here before; every time we pass a state-of-the-art frigate or an RFA in the entrance it brings on a similar sensation. One afternoon when the rain was clearing and the light was full of magic, a penny dropped and the sketch for this was made.

Below:

Cap Fréhel.

Watercolour, 15in x 22in, 1995.

(Collection of Jan Peterson, Esq.)

Another picture which just about painted itself, thanks to *Minard*. We found we were being set down on Cap Fréhel by a strong wind and tide one day, on passage to St-Malo. Weather it we did, but close enough to get a good shaking up in the seas off the point and an unforgettable view of the cliffs above. St-Malo of course was a great home for the *Terre-neuviers*, those hardy, pungent schooners and barquentines which made yearly trips across the Atlantic in search of cod. I find these vessels fascinating, so put one down in our place off the Cap as a reminder of that day.

Opposite page:

Frigate off Barnpool.

Watercolour, 15in x 22in, 1997.

(Collection of Commander and Mrs A. Crews)

If there's one thing that beats having a boat, I always say, it's having a good friend with one. As I have a dinghy fit for not much more than Bude Canal, I thank benign providence for putting a dear old friend and shipmate into the owner's bunk of a sea-kindly little cruising sloop and allowing me to stick to my freeloader's principles. Through Ni Glassborow and *Minard* I've been able to keep up an acquaintance with the Channel, sailing West Country, Breton and Irish waters over the years. The ideas for the pictures on these two pages were born in the boat, whose fecundity in this respect seems just as limitless as the owner's cheerful hospitality

Barnpool lies where the Hamoaze meets Plymouth Sound, a snug, deep cove, perfect for riding out a tide or for holing up

Right:: A page from the sketch-book 'log' of a trip in *Minard*. The scribble on the right is the first idea for 'Cap Fréhel'. Pencil, 1994

Opposite page:
The *Eclipse* off Anjer, 25 April 1832.
Oil on canvas, 24in x 36in, 1995.
(Collection of Mr and Mrs T. T. Gore)
Marine historical artists are often called in, like forensic scientists, to recreate the image of a subject long deceased. The *Eclipse* is a good case in point. A patron in the States who had collected a few early American ships' passes for their signatures of famous Presidents and Secretaries of State asked me if it would be possible to paint a portrait of any of these ships. I doubted it at first; to paint a portrait one needs to know a lot about one's subject, enough at any rate to show not only a likeness but something of her character as well. Most of the vessels on Ted's list were obscure, leaving only a token record of their existence, but I hit paydirt with the *Eclipse.*

I found that she was one of the celebrated Salem East Indiamen, a regular in the Sumatran pepper trade. The staff at Salem's wonderful Peabody Museum directed me towards a wealth of information about the *Eclipse* and to top it all, produced log-books and journals from several of her voyages. Through these I learned that she had been famously plundered by Sumatran pirates in 1838, her crew driven overboard and her captain and a ship's boy murdered. To put flesh on the bones of these facts, the museum also came up with a black-and-white photograph of an exquisite French portrait of the ship, now sadly lost.

After four years of off-and-on research and a visit to Salem I felt ready to tackle the picture of the *Eclipse.* I did two paintings, in fact, a watercolour of the piratical attack and the oil reproduced here which was inspired by the journal entries from her maiden voyage. The

setting off Anjer called for more research into that once-famous Javanese town and its topography plus detail on the native craft then common in the harbour. As for the atmosphere, I spent a childhood Christmas in those parts and still remember the heat, the humidity and the smells!

Below:
Sweepstakes – 93 Days From New York.
Watercolour, 22in x 30in, 1988.
(Collection of L Montfort Myers, Esq.)
Another handsome American ship, the extreme clipper *Sweepstakes*, arriving in the anchorage at San Francisco in May 1856 after an excellent run out around the Horn – 93 days and 23 hours land to land from New York, the eighth fastest passage on record.

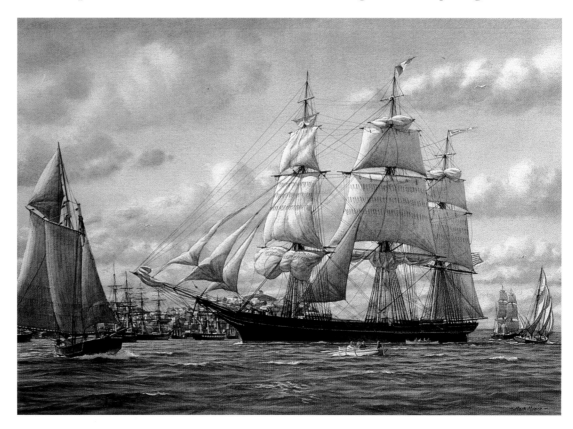

Below:

A Capsize in the Baie de Roscanvel.

Watercolour, 11in x 15in, 1991. (Private collection)
An imaginary accident in Brest Roads, painted for pleasure and in homage to the Ozanne brothers, whose stamping-grounds these were.

Opposite page:

There Came To Us A Canoe.

First contact: Juan Perez and the Haida People, 19 July 1774.

Watercolour, 22in x 30in, 1991.
(Collection of Mr. & Mrs. Mark Hough)
Much of my work in recent years has been involved with the early history of the North-West Coast of America, as the old explorers had it. A fascinating place and time; each voyage there was dangerous, each contact between cultures potentially explosive. Many of these paintings grow from the words of witnesses to the adventures or events portrayed. For me, nothing compares with their vividness and immediacy when trying to conjure up the past, and often these descriptions are pictures in themselves. To give a taste of this process, the inspiration for 'There Came To Us A Canoe' is given below.

To set the scene, you should know that Juan Perez's little frigate *Santiago* had been ordered to sail north from Spain's infant Californian outposts to locate the unknown coasts above and claim them for his Catholic Majesty in advance of any Russian penetration. The ship had been haunted by fogs and thwarted by headwinds for more than a month before land was finally sighted in the vicinity of the Queen Charlotte Islands.

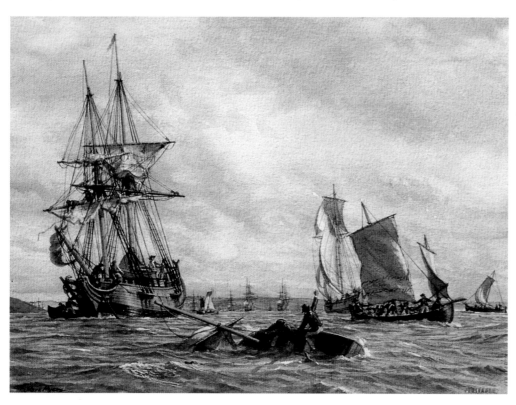

'About three in the afternoon we were near the land which had appeared to consist of islands, although this could not be confirmed because the fog so limited the view ... At that hour we saw bonfires on the land, and presently there came to us a canoe with nine men in it. This canoe drew nearer to the vessel, the pagans in it singing.' (From the journal of Fray Tomás de la Peña, Second Chaplain on board the *Santiago*.)

'There were eight men and a boy. Seven of them were paddling, the other, who was advanced in years, was upright and making dancing movements. Throwing several feathers into the sea they made a turn about the ship. From the stern gallery of the ship we called out to them that they should draw near, and ... after showing them some handkerchiefs, beads and biscuit they came near to the stern of the ship and took all that was thrown to them.'

From the journal of Fray Juan Crespi, Senior Chaplain on board the *Santiago*.

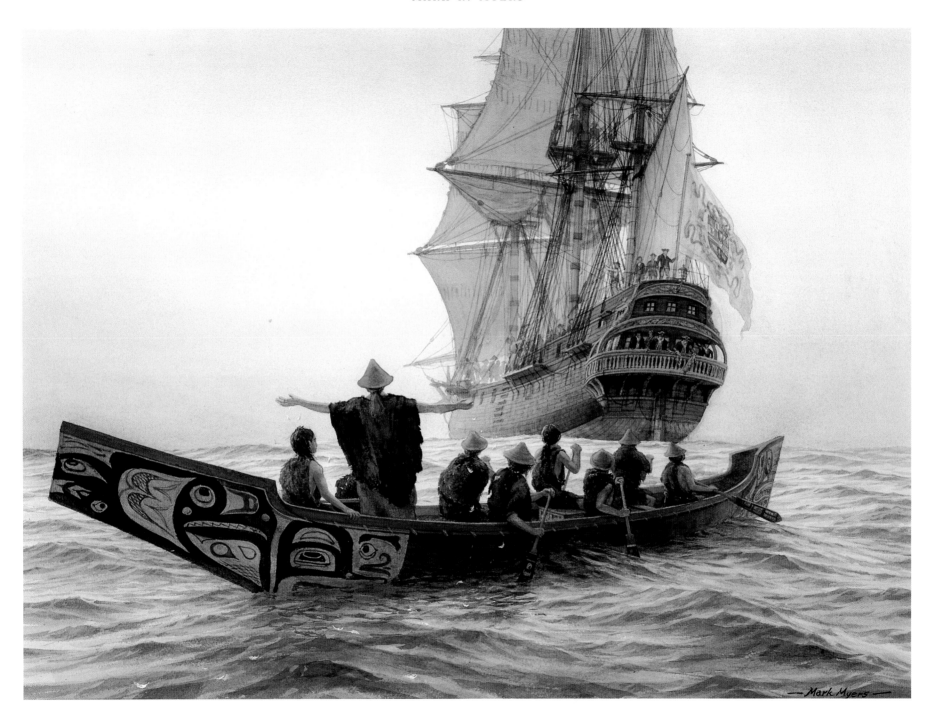

Below:

The Burning Mountain.
The *King George* and *Queen Charlotte* in Cook Inlet, Alaska, 27 July 1786.
Watercolour, 9in x 22in, 1995.
(Collection of Mr and Mrs Bill Holm)

The Iliamna Volcano dominates the western sky in this view seen during Portlock and Dixon's 1785 fur trading voyage for the King George's Sound Company. As Master's Mate and Armourer on Captain Cook's third voyage, the two captains had seen it before and recognised it easily: 'At noon on the 27th, the Burning Mountain bore South-West by West. A considerable smoke issued from its summit, which is very lofty, but we saw no firy eruption,' wrote William Beresford, Assistant Trader in Dixon's 200-ton snow *Queen Charlotte*.

Opposite page:

Pulled With Uncommon Strength.
The *Neva* Crosses Sitka Sound, 28 September 1804.
Watercolour, 30in x 22in, 1994.
(Collection of Mr and Mrs R. M. Alexander

'... on the 28th towards noon, we moved out of Cross Bay. The weather was so calm, that our ships were obliged to be towed till ten in the evening, when we anchored for the night, at a short distance from the old settlement of the Sitcans. The *Neva* could not have reached this situation, but for the united assistance of upwards of a hundred bidarkas, which, though small in size, pulled with uncommon strength.'

This passage in Captain Yuri Lisianski's *Voyage Around the World* was simply asking to be painted. A fleet of Russian ships being towed Gulliver-like into battle by a horde of Lilliputian kayaks makes an unusual subject, to say the least.

The incident took place in Sitka Sound, site of a Russian fur 'factory' which had been wiped out by the local Kitsadi tribe two years before. In order to regain their post the Russians had convoyed 800 Kodiak and Aleut hunters in their one-, two- and three-man bidarkas along a thousand miles of the Alaskan coast. While this invasion fleet was gathering in Cross Bay they were unexpectedly joined by Lisianski in the 14-gun corvette *Neva*. The Kitsadi put up a stiff resistance when this Russian might assembled off their fort, repulsing an armed landing force and holding fast for six days while the Russian cannon roared. As the seventh day dawned the fortress was silent. Their ammunition spent, the tribes had melted into the woods overnight, leaving only the bodies of the aged and the infants who could not travel with them. Sitka, built by this site, became the capital of Russian America.

Below: An idea for a picture yet to be painted of a fur trading brig in the rain. I usually do a quick sketch or two like this to sort out my thinking before laying down the basics for a finished painting.

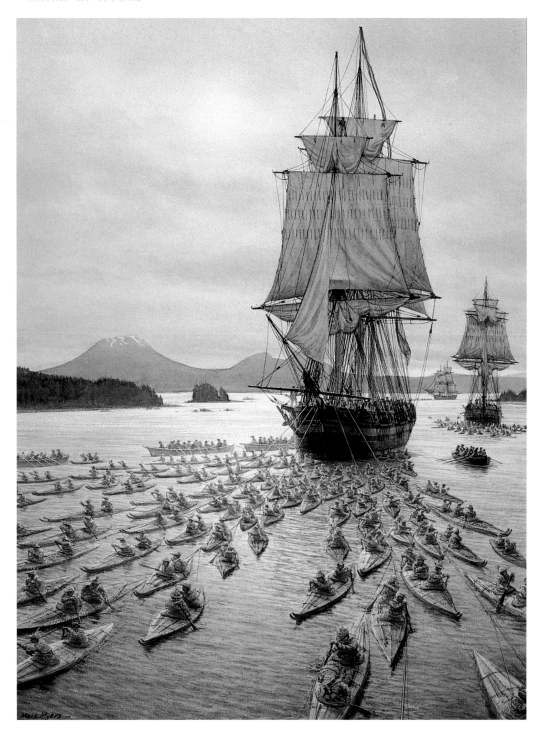

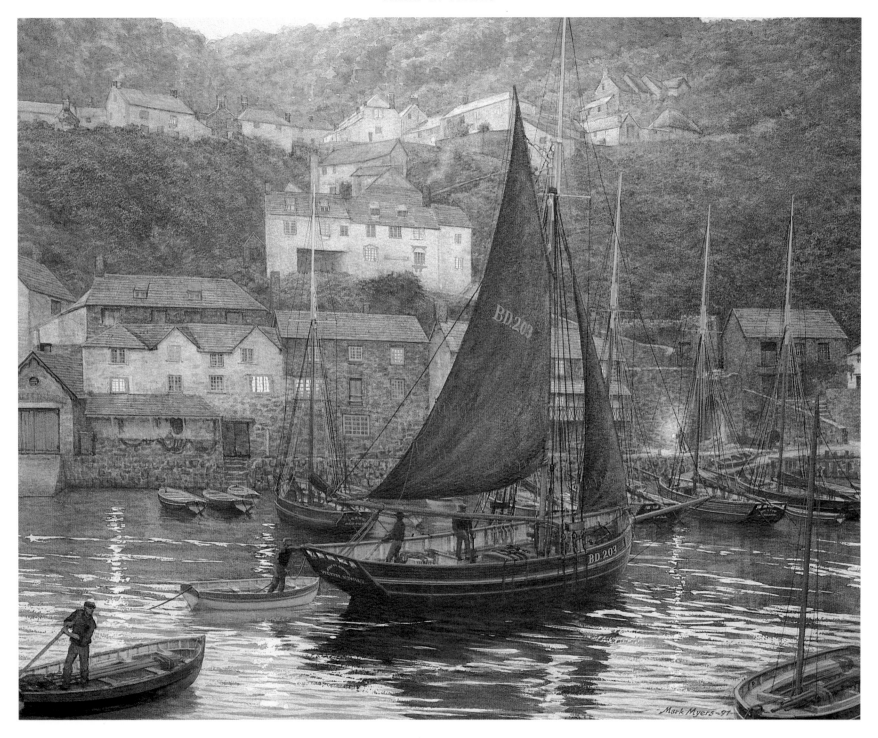

Opposite page:

Clovelly, Evening.

Watercolour, 22in x 27in, 1997.

(Collection of Bernard Payne, Esq.)

My adopted home in the North Devon–North Corn-wall borderlands suits me fine – I like the people, the landscape, the scale and pace of life here in Sir Richard Grenville's country. Painting the rich local maritime history is a joy as well, for one needs no great leap of imagination to picture yesterday's events on a stage so little changed by time.

Twilight is stealing down the hill as the local smack *Victory* slips back into harbour in this scene from the end of the last century. She's been out trading to one of the small ports nearby, perhaps with 30 tons of coal for Lundy or a cargo of Delabole slate for customers up-Channel. Built on the shingle beach at Clovelly in 1838, the *Victory* doubled as a trawler, for fishing was the cornerstone of life before the tourists came. When one stands nowadays on Sir George Carey's sixteenth-century pier and looks back up at the village, the boats are much diminished but the rest is virtually unchanged.

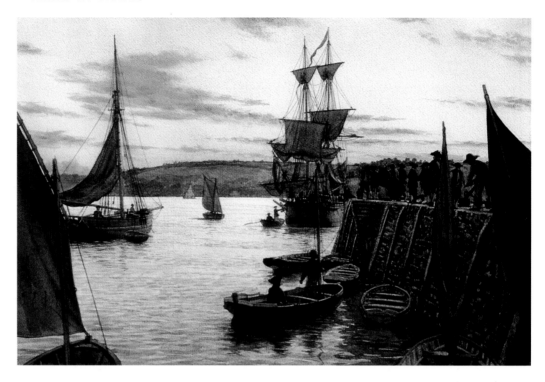

Above:

The Return of the *Nightingale*.

Watercolour, 15in x 22in, 1990. (Private collection)

This is a view from Instow Pier, just across the river from Apple-dore. The year is 1750 and the crowd is gathering to welcome home Thomas Benson's *Nightingale*, just back from the American colonies. Benson was a notoriously corrupt local MP and merchant who used his fleet to smuggle goods at will. His downfall came in 1752 when word got out that the *Nightingale* had been scuttled on his orders (after her cargo had been secretly discharged) for the insurance money. Benson fled to Portugal; the *Nightingale*'s Captain Lancey ended up on the gallows at Execution Dock.

Left: A small ball-point study of Bideford, made for reference in an exercise book on the spot, 1977. The hulk in the foreground is the old Salcombe smack *Marie*, now broken up.

Below:

The *Kaiulani* Off Diamond Head.

Watercolour, 22in x 30in, 1988. (Private collection)

The crack 'sugar packet' *Kaiulani* leans to the fresh trade wind off Honolulu at the beginning of a passage to the mainland, a study in power and grace. She became a very special ship – the last American-built merchant square-rigger afloat of the estimated 17,000 vessels which her country's shipyards had produced. After her time in the Hawaiian trade she sailed as a cannery ship to Alaska. She was taken out of retirement to make one last voyage around the Horn with lumber at the beginning of the Second World War.

On board at the time was a young seaman, Karl Kortum, who later became the dynamo of an international ship preservation movement as Director of the San Francisco Maritime Museum, 'the genius in whose wake we are all proud to steer,' as Frank Carr said. Karl's love for *real* sailing ships was unusual in the museum world at that time, and his energy in seeing that as many of them as possible

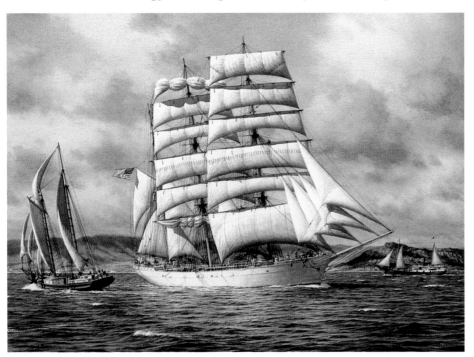

were saved was phenomenal. Unfortunately, the battle to save the *Kaiulani* was one of the few he could not win, and her hulk was cut up at Manila in the 'seventies.

Right: One of Karl Kortum's victories, the three-masted lumber schooner, *C. A. Thayer*, preserved at San Francisco. Pencil drawing from life, 1985.

Opposite page:

The *Dolores* off Salcombe Bar.

Watercolour, 17in x 22in, 1997. (Private collection)

The entrance to Salcombe harbour is wonderfully paintable, with Bolt Head's jagged cliffs beetling over the restless waters of the Bar. Although I've painted it occasionally before, after sailing there last year I thought I'd try again, this time looking in from seaward in bad weather. For a centrepiece I chose a small fruit schooner of the 1840s, the *Dolores*, whose formal owner's portrait I remembered seeing in the Salcombe Maritime Museum. I looked her up and scrutinised the painting, then got out old pilot books and charts to check the marks and dangers in the entrance.

Malcolm Darch, Salcombe's world-class model maker, came up trumps (as always) with details of the buildings in view at the appropriate period. Marine artists and ship modellers have a lot in common, both of them researching and working towards similar ends, albeit in different dimensions. Malcolm once talked a client who had commissioned one of his superb models into having me paint a portrait of the ship. As if that were not enough, he then built her in perfect miniature for me to study, sketch and photograph.

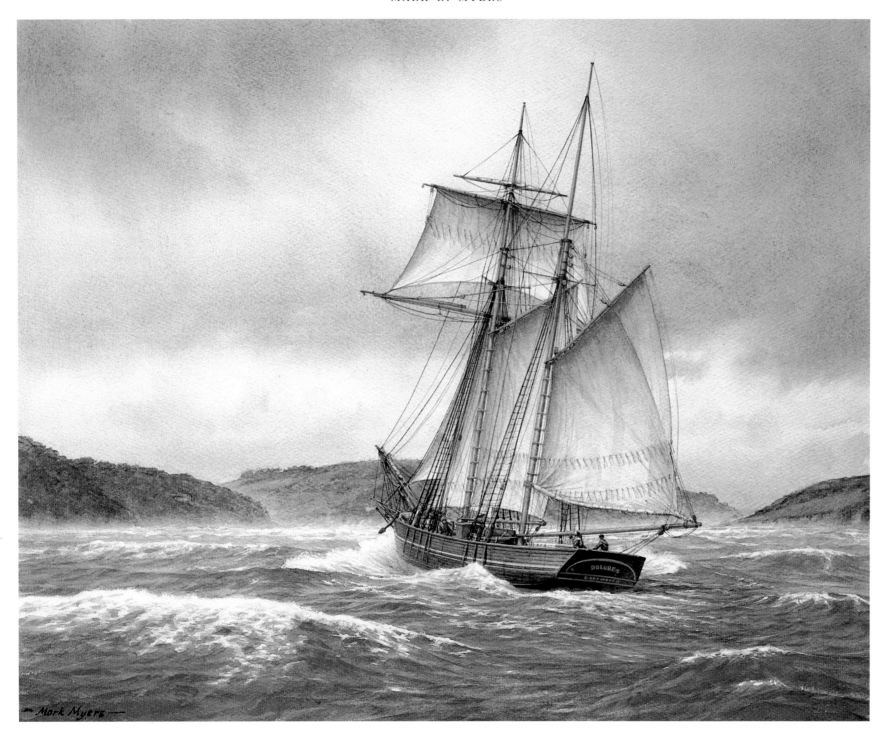

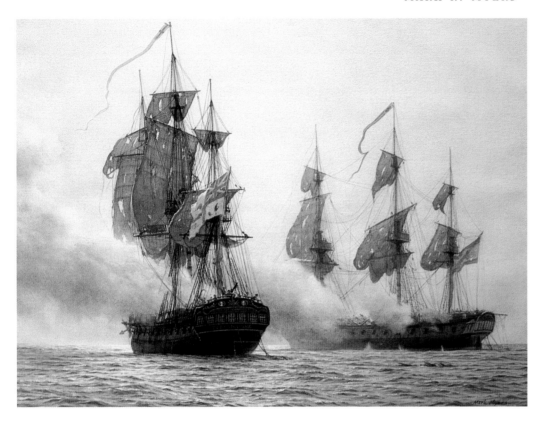

Opposite page:

**At Day Dawn on Friday.
Vancouver's Voyage Begins, Falmouth,
1 April 1791.**

Watercolour, 22in x 30in, 1996.
(Collection of Mr and Mrs. R. M. Alexander)

As there's another picture of the *Chatham* and *Discovery* in this book, I think I had better explain that I don't often paint the same ships over and over again. Some painters do this beautifully, I know, but being a fickle sort I like to ring the changes. New subjects call for new research, and I enjoy each opportunity to widen my horizons.

The *Discovery* is a favourite ship of mine, an ugly duckling shown here at the outset of her epic four-year voyage under Vancouver. Laid down as a merchant ship on the Thames in 1789, she was purchased by the Navy Board while building and completed as a sloop-of-war. Later in her career, after her exploits in the Pacific, she was converted to a bomb vessel, and draughts of her showing both these major alterations survive in the Admiralty Collection at Greenwich.

By any reckoning the ship they show is an ungainly one – blunt, top-heavy-looking with a mean low head and oddly flaring sides. This is confirmed by the surviving drawings from Vancouver's expedition and by the exacting drypoint of her (mis-identified as Captain Cook's *Discovery*) in E. W. Cooke's *Shipping and Craft*. One of the ugliest vessels I know from a time of the greatest elegance in naval architecture. Curious as to why she was so unlike the other vessels of her time of which I'd seen plans, I tried an exercise. I traced out the draught of her first conversion, eliminating all the Admiralty's overdrawn alterations. The result was a revelation – this ugly naval duckling had been designed as a merchant swan.

Above:

Terpsichore and _Mahonesa_, 13 October 1796.

Watercolour, 22in x 30in, 1994. (Artist's collection)

Captain Richard Bowen, third son of a humble North Devon ship-master, shot to fame through a series of brilliant frigate actions. Nelson said of him: 'a more enterprising, able and gallant officer does not grace His Majesty's naval service'.

The painting shows Bowen's 32-gun frigate *Terpsichore* engaging the Spanish 34-gun *Mahonesa* in light winds off Carta-gena on the morning of 13 October 1796. The time is about 11 a.m., an hour and a half since the commencement of the action, and the Spanish gunnery is beginning to slacken. The *Mahonesa* struck her colours ten minutes later, her masts tottering and her waist guns heaped in wreckage from the booms.

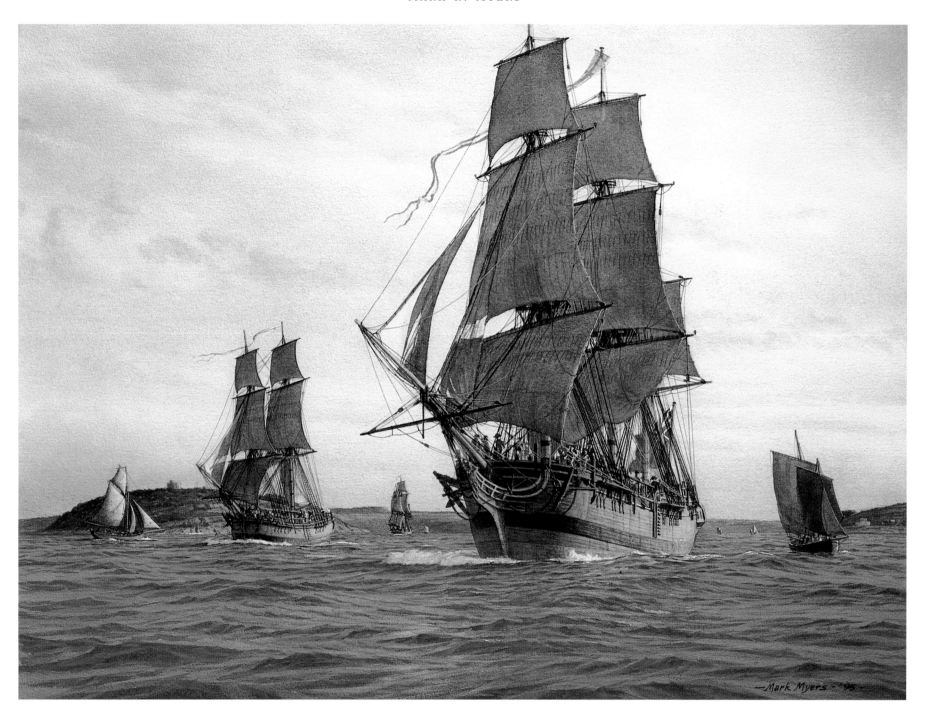

Right:

**This Day They Launched There Schooner.
The *Lady Washington* in Friendly Cove, 19 September 1788.**

Watercolour, 14in x 11in, 1991.

(Collection of Chester Pasternak, Esq.)

'This day they launched there Schooner and named her the North West America. On this occasion the ships saluted and the day among the English was spent in festivity and mirth.'

So wrote Robert Haswell, the 19-year-old Second Mate of the sloop *Lady Washington*, seen beached at Nootka Sound in the foreground, repairing some of the wounds earned on her year-long passage out from Boston. She was the first American vessel to reach the North-west Coast, beating her larger consort the *Columbia* by a week. Three days after her arrival, the Nootkans gathered in wonder at John Meares' British 'factory' along the beach to see him launch his diminutive schooner *North West America* with all the flags, guns and fanfare he could muster '... to give all due honour to such an important scene ... as being the first bottom ever built and launched in this part of the globe'.

Launching of the Golden Hinde - April 5, 1973 MYERS '75

Left:

**The Launching of the *Golden Hinde*,
Alan Hinks' Yard, Appledore, 1973.**

Line drawing, 1975, from a sketch made on the occasion.

Oposite page:

**Towards Evening We Went On Shore.
The *Slava Rosjii* at Three Saints Harbour,
20 June 1790.**

Oil on canvas, 15½in x 24in, 1994.

(Collection of Mr. & Mrs. Glyn Cooper)

I paint principally in watercolours these days, but like to keep my hand in with oils if I can. The painting opposite is a rather sombre oil of the landing of the Billings Expedition at Three Saints Bay, a desolate Russian trading post on Kodiak Island. Founded and

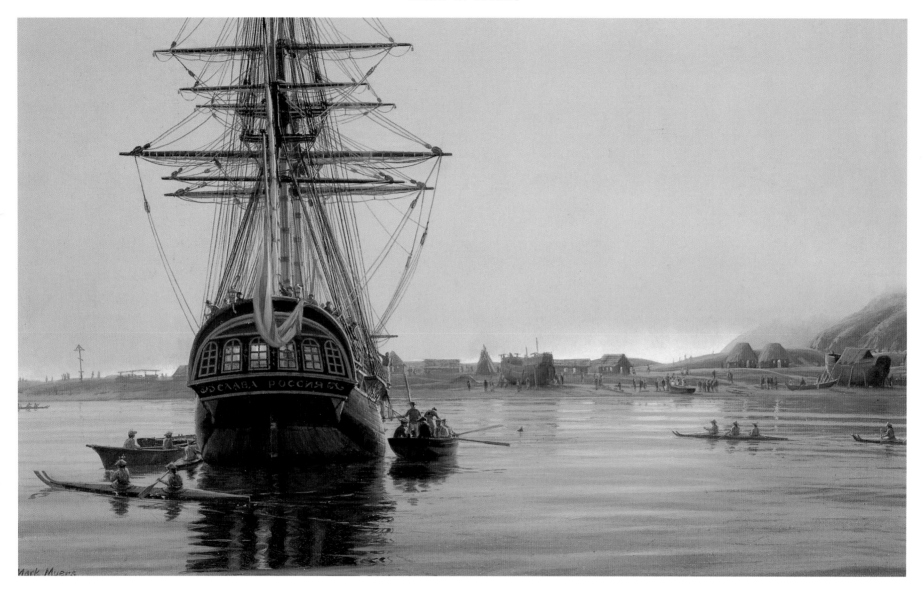

fiercely defended by the merchant Shelikov in 1784, Three Saints had become fairly well established by the time that Billings anchored there, although the inhabitants still hauled small ships ashore to serve as forts at times of native unrest.

Joseph Billings was an Englishman employed by Catherine the Great to explore and chart vast tracts of Siberia and Russian America. His 86ft *Slava Rosjii* had been built at Othotsk to carry the main body of the expedition, and during her stately progress eastward in 1789–90 she called at Petropavlovsk (where she spent the winter), Unalaska, Kodiak Island and Prince William Sound. The painting and its title come from Lieutenant Gavriil Sarychev's account of the voyage.

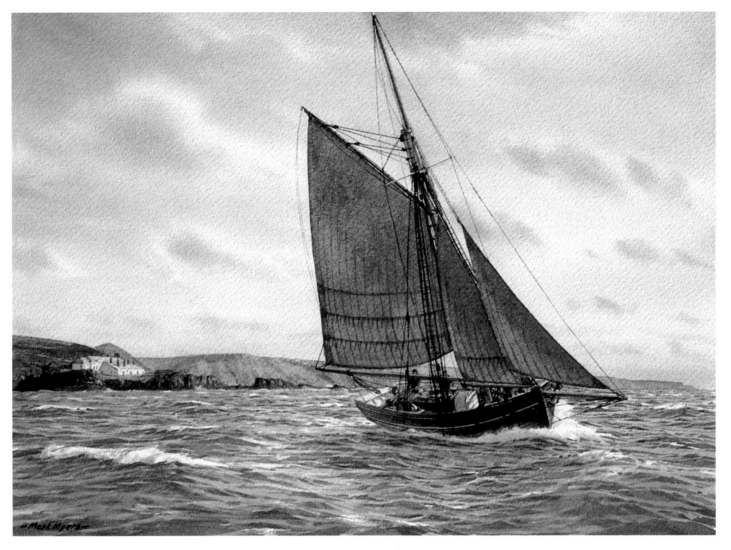

museum – which we did! The painting shows the last of the smacks owned at the Quay, Charles Brimacombe's *Susanna*, reaching out for an offing on a blustery afternoon.

Opposite page:
In Windbox Gorge.
Watercolour, 30in x 22in, 1996.
(Collection of Mr and Mrs R. M. Alexander)
'In Windbox Gorge' was painted at the request of a friend and client who had long been impressed by the Chinese junkmen's courage and ingenuity in surmounting overwhelming obstacles, as

Avove:
The *Susanna* Off Hartland Quay.
Watercolour, 11in x 15in, 1986. (Private collection)
The little pier which made a harbour under Hartland's cliffs had been in ruins for more than a century when my wife and I first settled down nearby. But there is something about the place which goads your curiosity. Over the years a friend and I learned and collected enough about its 300 years of trading to fill a small

in tracking their craft up the hellish gorges and rapids of the Upper Yangtze River. He introduced me to James Hersey's novel, *A Single Pebble*, suggesting that there would be inspiration for a painting or two inside. How right he was! I was absorbed in Hersey's simple story of a passage up the river, and then reading more widely, learned how truthful his work of fiction was.

The painting shown here is not 'marine' in a strict sense, being set a long way from salt water. It shows a place called

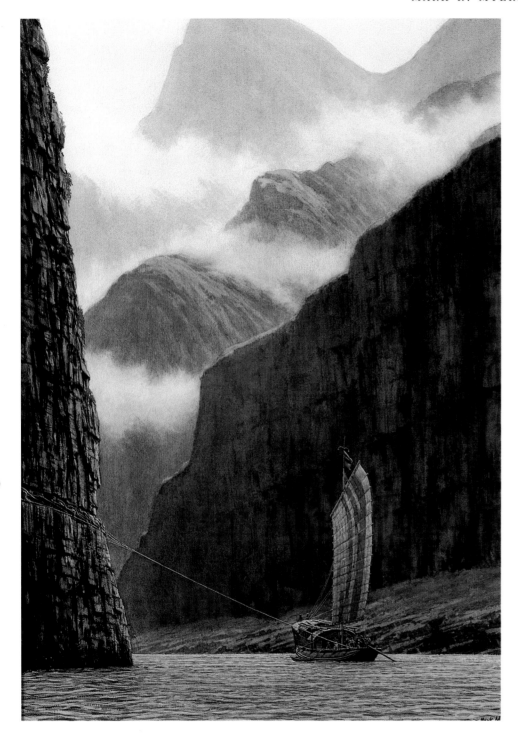

Windbox Gorge (Qutang in modern usage) where the Yangtze boils through walls of rock down to 150 yards apart and up to a thousand feet high. To sail up this chasm is impossible, so the gang of trackers which every junk must have toils along a path cut into the sheer face of the limestone cliffs, wide enough for one man only and low, so that they are stooping almost double as they strain to haul their vessel up the stream.

Below: A view from the bowsprit end of the *Nonsuch*. Ink, drawn on board (but not on the bowsprit!), 1969.

a Bone in her Teeth

5-17

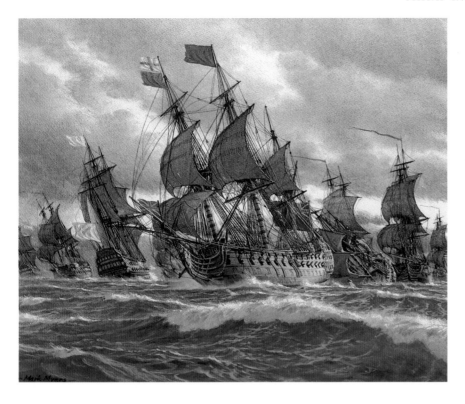

Above:

The Battle of Quiberon Bay.

Watercolour, 15in x 17in, 1993. (Artist's collection)

Sea battles make stirring subjects for painters, none more so than Admiral Hawke's headlong plunge to catch Conflans in the confines of Quiberon Bay. The French and British fleets came in sight of each other at first light on a blustery November day in 1759, and the opening guns were fired in a rising gale off the Cardinals Rocks in the early afternoon. This painting shows the tumultuous action at about 4 p.m. Hawke's *Royal George* is in the centre, with Conflans' flagship, the *Soleil Royal*, standing out just to the left of her and the shattered *Superbe* going down in her wake. Hawke's victory was decisive – twelve of the twenty-one French ships were either taken, sunk, stranded or disabled up the River Vilaine.

I once had the thrill of following Hawke's course into Quiberon Bay, the wind making up to a gale as we rounded the Cardinals and rendering the experience complete. But this was in July, not November, and instead of riding out an anxious night surrounded by a hostile fleet, we ran for the shelter of the yacht harbour at La Trinité-sur-Mer.

Below: The *Nonsuch* yet again, drawn just for fun 'to demonstrate the manner of putting her about'.
Ink on board, *c.*1970.

Opposite page:
As Close To The Shore As We Dared.
The *Sv. Pavel* Off Lisianski Strait, 18 July 1741.
Watercolour, 22in x 30in, 1994. (Collection of Ray Scheetz, Esq.)
Vitus Bering is the man we think of as the curtain-raiser for the European exploration of the North-west Coast, but it was his Russian co-captain Alexei Chirikov who performed the opening act. He was the first to sight the land, two days before and 320 miles SE of Bering's more famous landfall at Mount St. Elias.

As the *Sv. Pavel* closed with the shore of what is now South-east Alaska, Chirikov was cautious. On 18 July he finally took the plunge, his journal reading 'At 3.30 in the afternoon we went as

The 'Nonsuch' Ketch in five successive positions shown to demonstrate the manner of putting her about

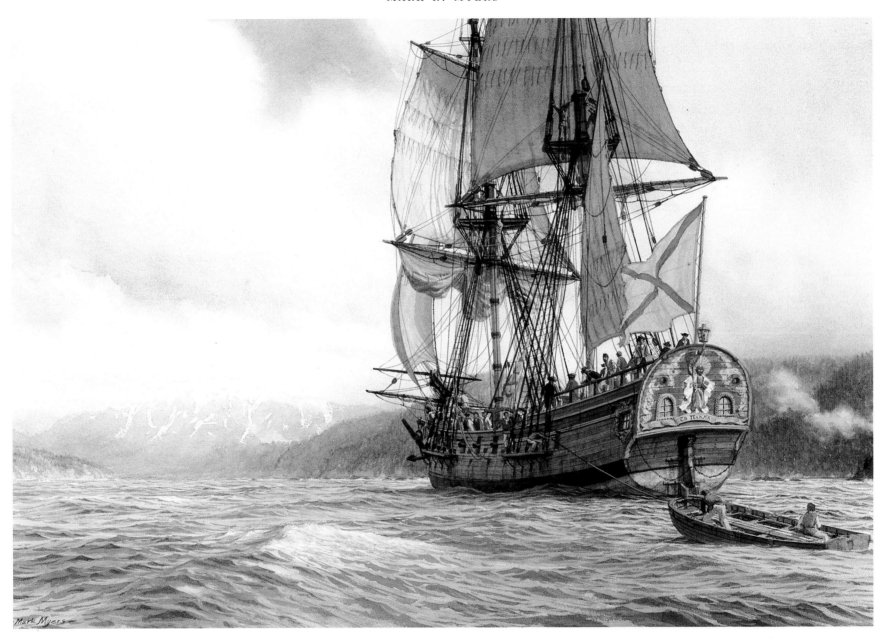

close to the shore as we dared. We sent the boat ashore under Fleet Master Dementiev who had with him ten armed men.' The boat disappeared around a point and was never seen again. Tension mounted on board the *Sv. Pavel* as the crew struggled to regain this spot after a spell of bad weather. The ship's last boat was sent in desperation to search for the missing hands, but this, too, vanished utterly. Unable now to water ship or take vital soundings, Chirikov and his depleted crew sadly sailed for home.

Below:

Entering Brest, 12 July 1992.

Watercolour, 11in x 15in, 1992. (Artist's collection)

This is *Minard* running into the Goulet under easy sail, about to join in the happy pandemonium of the Brest 92 Festival. We'd been overhauled close-to by the *Astrid* a few minutes earlier, and by now were in sight of some of the thousands of weird and wonderful craft, churning up Brest Roads, packing the port and dockyard, which made the event so spectacular.

Opposite page:

Hands To Reef Tops'ls! (Convoy off the Cornish Coast).

Watercolour, 13in x 25in, 1983.

(Collection of Mrs Peternella Myers)

I see this painting every day, which is unusual in our house because there's seldom much of my work on the walls – it has to go out to make a living. But the convoy stays on for a reason. It was painted to decorate the jacket of a book I felt very privileged

Below:

A merchant brig outward bound at daybreak, a study for a painting. Chinese inks on paper, 1984.

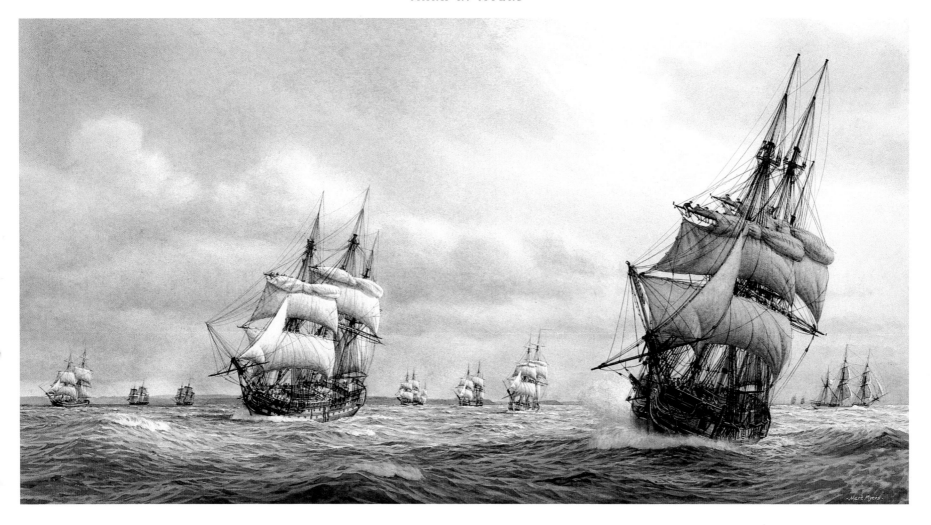

to have been involved with several years ago. When the publishers returned the picture I realised that my wife had rather a soft spot for it so told her that henceforth it would leave only at her command. If I hadn't, the picture would have been gallery-fodder long ago. The good people who maintain 'stables' of artists have a constant call for hay.

The scene the painting shows is typical of 'eighteen hundred and wartime', the long-drawn-out conflict with Napoleon. A convoy sets out into the Atlantic with a rising wind and sea and much to be done in shepherding the flock. One can imagine the thoughts of the man in charge. The Sixth Rate on the right is based on the *Volage* and *Garland*, two 22-gun ships built at Bideford in 1807. North Devon-built ships interest me, and as I'd picked up details of their convoy service from the columns of old *Lloyd's Lists*, I couldn't resist the temptation to include one.

THE ARTISTS

ROY CROSS, RSMA

Born in South London on 23 April 1924, his education was interrupted by the outbreak of war in 1939 when he was evacuated to Reading. Roy's initial contact with the sea and ships came with his first employment early in 1940 as a junior shipping clerk with a Thames-side import/export firm, which entailed carrying bills of lading and other documents around the vast extent of the London Docks. A main

ROY CROSS

interest was aviation, however, which, combined with a growing talent for artwork and the publication of some of his drawings in the technical press, led to employment in the wartime aviation industry as a budding technical illustrator. Post-war, Roy became freelance, specialising in aviation and commercial artwork, journalism and illustration.

Severe curtailment of the British aircraft industry in the 1960s meant less work and caused Roy to seek additional, and perhaps more prestigious, sources of income. A latent interest in things nautical, sailing experience during long Cornish holidays and a growing appreciation of the great twentieth-century marine painters led him to experiment with some sea pieces and begin to build up a large library of marine books and prints, which he studied avidly. Eventually Roy felt confident enough to show his marine paintings around the London West End art galleries and was lucky enough to meet a specialist dealer who recognised a likely talent and encouraged him to participate in a forthcoming exhibition of contemporary

marine work, in which he achieved a modest success. In time the dealer became Roy's agent and friend, and was able to find enough commissions to persuade him to drop his other work and specialise in the field of marine painting. In 1976 Roy was elected a full member of the Royal Society of Marine Artists.

When his dealer decided to transfer business to the USA, Roy chose to accompany him in spirit, while continuing to reside in this country, with the result that he has specialised for the past 20 years or more in paintings of American historical scenes, ships and ports exclusively of the age of sail.

DEREK G. M. GARDNER, VRD, RSMA

Derek Gardner, VRD, RSMA, was born in 1914, the son of Alfred Charles Gardner, FRSE, MICE. He was educated at Monkton Combe and Oundle. After leaving Oundle in 1931 he studied to become a civil engineer. In 1934 he joined the Clyde Division of the Royal Naval Volunteer Reserve as a midshipman. Mobilised in August 1939, he served for more than seven years in the

DEREK GARDNER

Royal Navy, retiring at the end of 1946 as a Commander. He was mentioned in dispatches for distinguished service when the destroyer *Broke* was sunk in the Mediterranean in 1942.

After the war he resumed his career as a chartered civil engineer, eventually becoming a Fellow of the Institution of Civil Engineers. In 1948 he joined the Colonial Service and went to Kenya where he served for fifteen years, becoming senior Regional Engineer in the Ministry of Works. In 1951 he married Mary née Dalton and has a son, Charles, and a daughter, Angela. He retired in 1963 and returned to England with his family to begin a new career as an artist.

His work was first exhibited in London with the Society of Marine Artists in 1958. In 1966 he was elected to membership of the Society and became an RSMA. In 1982 and again in 1984 he was a finalist in the Hunting Group Art Prizes competition organised by the Federation of British Artists. In 1984 his work was chosen for the Schaeffer Award at the International Exhibition of Marine Art at Mystic, Connecticut. Two of his paintings are in the National Maritime Museum at Greenwich and his work can also be seen at the Royal Naval College, Dartmouth and the Bermuda Maritime Museum. Since 1972 he has held seven one-man exhibitions at the Polak Gallery in London, and twelve of his marine paintings and watercolours have been published at various times as signed limited edition prints. In 1988 he was accorded the unusual honour of being elected an Honorary Vice President for life of the Royal Society of Marine Artists.

JOHN MICHAEL GROVES, RSMA

Pastel, oil pen and ink. Born Lewisham 9 March 1937. Camberwell School of Arts and Crafts 1951–7. Graphic designer and illustrator for sixteen years: began painting marine subjects in 1970. Exhibited 'Lee Shore' at RSMA in 1971, and has exhibited there regularly ever since. Full-time painter since August 1977. Two large oils for The Harrison Line shipping company

JOHN GROVES

early 1980s, five large historical oils for Shell in the 1980s/early 1990s for Dutch Oil, The Hague, Saudi Arabia and Shell House, Waterloo. Works mainly to commission.

GEOFF HUNT, RSMA

Geoff Hunt studied graphic design at Kingston and Epsom Schools of Art, and spent two years in advertising as a visualiser and art director before beginning his freelance career. During a long association with Conway Maritime Press he was Art Editor of *Warship* Journal, and designer of many books on marine subjects, including John Harland's *Seamanship under Sail.* In 1979 he and his wife sold up house in order to buy a 26ft sloop, *Kipper,* which they spent

GEOFF HUNT

He has sailed boats of all sizes, and has been seasick on most of them. He presently owns a small dinghy, the perfect yacht (it spends 98 per cent of its time on land, and the remaining 2 per cent in a depth of water where you can usually get out and walk).

Geoff Hunt was born in 1948. He is married, has two sons, and lives in Wimbledon.

MARK R. MYERS, PRSMA, F/ASMA

Mark Richard Myers was born in San Mateo, California in 1945. History and sailing were early interests, widened by childhood years in Hong Kong and working experience on board square-rigged and fore-and-aft-rigged sailing ships

most of a year taking to the Mediterranean and back, traversing France by canal and river. Since returning he has devoted himself to marine painting, a lifelong passion, and has become best known for his work as a book-jacket illustrator, notably for Patrick O'Brian's epic series of naval novels set in the Napoleonic Wars. The Royal Naval Museum at Portsmouth has purchased twelve of these.

Geoff was elected to membership of the Royal Society of Marine Artists in 1989, and has served as Hon. Treasurer since 1992. In 1994–6 he was chair/co-ordinator of the RSMA's Publishing Committee, responsible for creating *A Celebration of Marine Art: Fifty Years of the Royal Society of Marine Artists* (Blandford, 1996).

MARK MYERS

in his youth. He trained as an historian, graduating from Pomona College in 1967.

A self-taught artist, his first one-man exhibition of marine paintings was mounted by the San Francisco Maritime Museum in 1967. After two more years in sail and a few more solo exhibitions, he moved to south-west England in 1971 and settled there to marry and bring up a family.

Since that time he has concentrated on marine painting and maritime historical research. Mark Myers was elected a member of the Royal Society of Marine Artists in 1975 and has served in various RSMA posts before becoming President of the Society in 1993. He is also a charter member and Fellow of the American Society of Marine Artists.

He works in a variety of media: oils, acrylics, water-colours, pastels and inks, and has some experience in lithography and etching. He has illustrated and contributed to a number of nautical books and magazines and issued series of marine art prints through various publishers. Keeping an active interest in maritime museums, he designed and co-founded the Hartland Quay Museum in 1980.